OXFORD
PLAQUE
GUIDE

ELIZABETH JEAN WARR
FOREWORD BY COLIN DEXTER

The
History
Press

For David, Ian and Clare

First published 2011

The History Press
The Mill, Brimscombe Port,
Stroud, Gloucestershire, GL5 2QG
www.thehistorypress.co.uk

British Library Cataloguing in Publication Data.
A catalogue record for this book is available from the British Library.

ISBN 978 0 7524 5687 4

Typesetting and origination by The History Press
Printed in Great Britain

CONTENTS

FOREWORD

When Jean Warr invited me to write a foreword to this book, I felt reluctant so to do, since I knew that there were two kinds of 'plaque': first, a memorial tablet commonly round in shape and usually blue in colour, and often stuck on an outside wall somewhere; second, a diseased area of saliva and bacteria festering on the teeth (ugh!). My readers will be relieved to know that my own knowledge of that secondary meaning is quite simply nil. So let us now praise famous men and women. And let me choose just a few of my own personal experiences with plaques.

THE MOST AMUSING

It was a few years ago now that Oxford – especially the south of the city – experienced serious troubles with flooding. In the midst of all this, I had an evening engagement at the bottom of the Abingdon Road. I took the bus to the centre, and was walking along St Aldate's until, most surprisingly, I came to an elaborate blockade across my progress – a barrier manned by three uniformed policemen. Conversation proceeded in this fashion:

'Where are you going, sir?'
'Down to the Four Pillars Hotel.'
'Oh no, you're not. You can see the floods. No one's allowed any further unless they live here or they've got a garage here.'
'But I'm talking at –'
'Sorry mate!'
'Look! There's about fifty American tourists there already. They're waiting for *me*, and they must have got there somehow.'
'Not through this road-block, they haven't.'
'Well, b★★★★★ me!'

We were standing outside the police station in St Aldate's, and there seemed little point in arguing my case further … or was there?

I pointed to the Blue Plaque above the main entrance, but said nothing more as the three of them looked up and read the legend: most sincerely did ITV wish to thank the Oxford City Police, and most especially the Chief Constable, for their invaluable co-operation in the filming of *Inspector Morse* episodes, etc. The plaque (the words read) had been unveiled by …

'And that was *you*?' asked the sergeant. I took a letter from my briefcase which began, 'Dear Mr Dexter, we are all hugely grateful to you for agreeing to come and talk to us …' The sergeant echoed my earlier words verbatim: 'Well, b***** me!' And as he bent down to unlock the barrier mechanism, he gave me a card showing his mobile and police telephone numbers. 'If you have any trouble,' he added, 'just give us a buzz. OK lads?' And one of the lads chimed in, 'And we'll come and rescue you with a canoe, won't we Sarge.'

The three of them were smiling as I stepped briskly down the Abingdon Road.

A MASTERLY UNVEILING

We came to live in Summertown in 1966, where almost the first thing we learned about was the Cutteslowe Wall, a formidable ten-feet high obstacle, erected in the mid-'30s and finally demolished in the late '50s. The Wall divided the Cutteslowe area into two parts: the predominantly council estate homes, and the 'posher' residential houses in the streets adjacent to the Banbury Road. The Wall aroused much controversy, especially perhaps for those who were faced with considerably lengthier journeys from their homes to the Summertown shops, and to the regular bus route to the city centre. But it was the social, 'class' implications which stuck in many people's gullets, and which had perpetuated a lasting ill-feeling. The whole matter even reached the House of Lords.

In due course, and at a specific point through which the abominable Wall had been built, a plaque ceremony was instigated by one of our most illustrious former mayors, Ann Spokes; and a crowd of local historians, friends, and well-wishers, assembled one afternoon to witness the event – an event alas temporarily disrupted by a small group of protesters waving hostile placards. But something else was happening too. Our Mistress of Ceremonies was suddenly speaking through a microphone. Quietly, coolly, calculatingly, she told the hecklers that unfortunately they had come to the wrong venue. 'We are not here today to lay a foundation stone for the resurrection of a new Cutteslowe Wall. We are here to rejoice, and to recall the demolition of the *old* Wall. Please remember that. And please, if you will, be quiet or go away.'

No more shouting. No more disruption. The protesters downed their placards, and silently departed.

A HAPPY COINCIDENCE

In the Morse Bar of the five-star Randolph Hotel, two plaques are featured on the right-hand wall as one enters; one above the other, one oblong, one round. The top one commemorates the inaugural meeting, in the hotel, of the Amateur Athletic Association (AAA), under the chairmanship of the Marquis of Exeter, who was not only an Olympic athlete, but also an educational benefactor, who endowed an annual exhibition to St John's College, Cambridge. In 1947, this exhibition was

won by my elder brother, John, who (like me) devoted his life to the teaching of Latin and Greek, and who was held in great affection by many generations of his pupils. The plaque beneath recalls a very early meeting of the Morse Society in the same hotel, under the chairmanship of Dr Antony Richards, with the plaque unveiled by (yes!) me. My brother was a considerably finer classical scholar than me, and I feel very proud to be associated, however indirectly, in this fortuitous collocation of memories – most happy memories.

In short, I love plaques – and whenever I spot one I've always felt an irresistible itch to stop and satisfy my curiosity about who, or what, is, or was, so worthy of remembrance. I can only hope, dear reader, that you feel somewhat like-minded, since, if you do, what a huge treat awaits you in this splendid volume.

Colin Dexter, 2011

ACKNOWLEDGEMENTS

I wish to thank Colin Dexter for writing the foreword to the guide and for giving so generously of his time and attention, and Sir Hugo Brunner, first Chairman of the Blue Plaques Scheme, and Eda Forbes, Secretary of the same organisation, for their valuable advice and recommendations.

Many members of my family and several friends have helped me produce the book. I would like to thank especially my husband David, whose encouragement and support have been invaluable. It is he who has produced the maps and many of the photographs in the guide. I am grateful to my son Ian Warr, and my daughter Clare Stevenson, for their professional help and suggestions, and to their partners, Annabel and James, for their kind consideration and understanding.

I am indebted to my goddaughter Louise Cameron for her invaluable help regarding publishing; to Christopher Collier for his professional advice; and to Gill Burden, who patiently checked scientific facts and made helpful suggestions regarding the plaques. I thank Malcolm Axtell for providing me with information on Symm & Co.; Alan Gill for data on the Levellers in Oxford; and my colleagues and friends in the Oxford Guild of Guides, especially Angela Baker, Susanna Evans, Charles Mould, Sheila Philips, Aileen Rogers, Sheila Wilkinson, Rob Walters and Nuala Young for their observations, suggestions and help. I wish to acknowledge the encouragement and support I have received from Peta Broadhurst, Elsie Callender, the GuRus, Digna Martinez, Jill Muir, 'R', Joyce Sleeman, Joy Stevenson, Vivien Stevenson, Elizabeth Wardleworth, Jim Warr and Jennifer Williams.

Finally, I wish to express my gratitude to Nicola Guy, Cate Ludlow, Jennifer Briancourt and all the staff at The History Press who had a hand in producing this book.

INTRODUCTION

Oxford, beautiful and stimulating, dynamic and vibrant, attracts exceptional men and women. The achievements of these talented individuals, endowed with creativity, ingenuity and brilliance, are recalled with pride and recorded in tangible form on plaques or stones. These memorials are visible both to the casual passer-by and to the more curious seeker. But a short legend in metal or marble can reveal only the briefest glimpses of lives or events, leaving the more serious inquirer still in search of additional facts. The aim of this guide is to present readers with the information they require, and in doing so instruct, enlighten and surprise.

Oxford is, of course, famous for its university, the oldest one in England. A place of learning, it acquired its reputation for excellence early in its history by nurturing intellectual brilliance. As long ago as the twelfth century, Roger Bacon, a Franciscan monk, scientist and philosopher, devoted himself to experiential research here. Today his brilliance is acknowledged by several memorials, including a plaque in the city centre. Impressive polymaths Robert Boyle, Robert Hooke and Edmund Halley, members of the seventeenth-century scientific elite, are commemorated with plaques, as are scientists from more modern times, including Howard Florey and Ernst Chain, recipients of the Nobel Prize for their work on one of the greatest discoveries of the twentieth century – penicillin – and their brilliant colleague Norman Heatley. Dorothy Crowfoot Hodgkin, another exceptional scientist to be awarded this prestigious prize – for her pioneering work on X-ray crystallography – is remembered by a plaque recording her achievements at the university's Inorganic Chemistry Laboratory, where she carried out her experiments. Other stars of the intellectual world are celebrated, amongst whom are best-selling authors C.S. Lewis and J.R.R. Tolkien, who wrote their memorable tales in Oxford; Paul Nash, the artist, who was inspired to paint what he saw in the area; and Isaiah Berlin, political theorist and philosopher, and one of the greatest minds of the age, who made his home here. And, lest one should think that only academics are lauded, Sarah Cooper, maker of exquisite marmalade, and Irene Frude, much-loved landlady, are both recipients of plaques, as is William Kimber, morris dancer extraordinaire. The University of Oxford Sports Ground, which played host to Roger Bannister when he became the first person to run the sub-four minute mile, boasts a Blue Plaque.

Although this guide is primarily about people, some of the entries refer to momentous events, buildings and structures. Memorials, crosses, clocks, statues – all these, and more, are offered to the reader in order to reveal their histories. The thread that connects them all is the impact they have had on Oxford or further afield. While most of the inscriptions are uplifting, there are some instances when memorials have been erected to remind people of the evils of intolerance, conflict and war. Plaques referring to the Jewish community, who were dispossessed of their homes and assets in the thirteenth century, can be found on the outside walls of Oxford Town Hall, while reminders of the sufferings of other religious communities, including Protestants, Catholics and Nonconformists, can be traced to sites not far from the city centre. In nearby Cutteslowe, a Blue Plaque celebrates the destruction of a wall which in recent times separated two communities from each other.

All the eminent personalities featured in the guide are real, bar one; this exception is Inspector Morse. Author Colin Dexter's imaginary detective, played by the late actor John Thaw in the famous television series, brought the world-weary policeman – and the city – to the attention of the world. Morse fully deserves his fame, and his plaque on the wall of St Aldate's police station.

What of the actual plaques themselves? The majority of them are either in, or around, the city centre, although there are a number of them on the outskirts of Oxford. The visitor to the city will notice that not all plaques conform to a colour, pattern or even size. A number of them are one-off inscriptions erected by individuals, particular colleges, the university as a whole, or various societies. There are others, however, that are round and uniformly blue. These have been installed by the Oxfordshire Blue Plaques Board, chaired by Dr Kate Tiller, Deputy Lieutenant of Oxfordshire, and administered by the Oxford Civic Society. In 1999, Hugo Brunner (publisher and Lord Lieutenant of Oxfordshire from 1996-2008), together with Edwin Townsend-Coles (then chairman of the Oxford Civic Society), initiated the Oxfordshire Blue Plaques Scheme, similar to the London one, following the suggestion by the youngest son of the eminent Indian author Nirad Chaudhuri, that his father merited such recognition. In due course, once the scheme was put in place, with Hugo Brunner as its first chairman, Dr Chaudhuri was included in it. The scheme has been a big success and has overseen the installation of an increasing number of Blue Plaques in recent years. Every year the Board, which is made up of a number of representatives from local organisations, receives several nominations. These proposals are carefully considered according to certain criteria, 'to ensure that the person, place or event commemorated is of lasting and clear significance' (Oxfordshire Blue Plaques Scheme). Not all Blue Plaques come under the scheme, however; some are erected privately by individuals or societies, as is the case with the plaques for T.E. Lawrence and Dorothy L. Sayers.

Anthony à Wood, who spent much of his life in Oxford, wrote in his diary on 29 October 1656 that he 'began to survey and transcribe the monumental

inscriptions and armes … within the city and universitie of Oxon', proving that this is an honourable and fascinating tradition that goes back hundreds of years. It probably never crossed his mind that, four centuries after his death, he himself would be honoured with a Blue Plaque.

Wood had to find his monuments by himself; readers are in the fortunate position of having a guide to help them. The city centre and university area are quite compact, and relatively easy to stroll round. The plaques' locations in the guide are marked clearly on the maps, which are divided up into separate geographic areas for ease of use. Additionally, since most of the plaques tend to be clustered in certain areas, the maps have a numbering system which proposes a logical sequence of steps. Those which are further out can be reached from the town centre by a short bus journey or cycle ride. Except for the plaque above the entrance to the Bodleian Library, which is sited in a quad and is therefore subject to some restrictions, all the plaques and memorials featured in the guide are visible from the street or footpath, and can be viewed at any time.

Oxford, which is small in comparison to many other English cities, is fortunate to have acquired more than its fair share of plaques. Perhaps the combination of gracious architecture, which lends itself to discreet adornment, and a galaxy of fascinating personalities, ensures that this commemorative tradition will continue for a long time to come. As a Blue Badge tour guide in the city for nearly twenty years, I find that Oxford never fails to entrance and intrigue. This ancient and lovely place shares her secrets generously, once the effort is made to follow the clues that are revealed in the brief inscriptions so abundantly scattered about her. The plaques have been researched. It is now up to the reader to go on a voyage of discovery.

Elizabeth Jean Warr, 2011

A-Z OF PLAQUES

AIRMEN'S BRIDGE, WOLVERCOTE *Lt C.A. Bettington; Second-Lt E. Hotchkiss*

MEMORIAL PLAQUE: AIRMEN'S BRIDGE, WOLVERCOTE, OXFORD
MEMORIAL PLAQUE OF SHEET METAL TAKEN FROM THE ACCIDENT: WOLVERCOTE
CHURCH

Today, when flying as a means of transport is taken for granted, it is easy to forget how dangerous it was to take to the air in the early days of aviation. The Royal Flying Corps had been established in April 1912, just nine years after the Wright brothers' first flight, and the two airmen to whom the plaque is dedicated were amongst the very earliest aviators in England to die whilst on manoeuvres.

On 10 September 1912, Lieutenant Claude Albemarle Bettington (a New Zealander, flying with the Royal Flying Corps), and Edward Hotchkiss (Chief Test Pilot for the Bristol Aircraft Co. and a Lieutenant in the Reserve), set off from Larkhill, near Salisbury Plain, in a Bristol-Coanda monoplane. They intended to stop at Wolvercote on the first stage of their journey to Hardwick, near Cambridge, but the monoplane (80hp Gnome engine) broke up in the air due to the accidental opening of a quick-release fastener as they were gliding at 2,000ft preparatory to landing. Both men died instantly when their aircraft came crashing down into Lower Wolvercote, just north of Toll Bridge, which was later renamed Airmen's Bridge in their honour. Lt Bettington (who was engaged to be married) was flung to his death from the aircraft and landed in the river; Lt Hotchkiss's body was found strapped to the wreckage of the plane.

The accident resulted in a temporary ban on monoplanes, which came into effect two days after the accident.

People in Wolvercote and surrounding areas were greatly shocked by the crash and contributed generously to have a plaque erected in memory of the two officers. The plaque, which was attached to the bridge, was unveiled in June of the following year. Just two days after the ceremony, however, it was found to have been deliberately chipped. A card nearby bore the words 'Votes for women'.

Sources:
 http://paperspast.natlib.govt.nz/cgi-bin/paperspast
 http://www.gracesguide.co.uk/wiki/Claude_Albemarle_Bettington

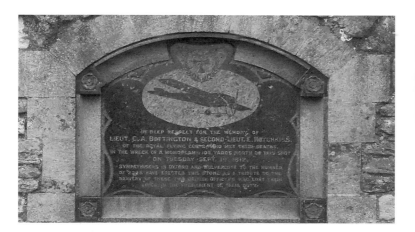

ARMS OF THE CITY OF OXFORD

The Arms of the City of Oxford show an ox crossing a ford. This device was placed on the Borough seal before the end of the twelfth century. By the end of the fourteenth century it was engraved on the mayor's seal.

In 1571, the College of Heralds granted the crest of the demi-lion (just the upper half), which was coloured gold, and a black elephant shown on the left-hand side of the shield as one faces it, with a green beaver shown against it on the right-hand side. These

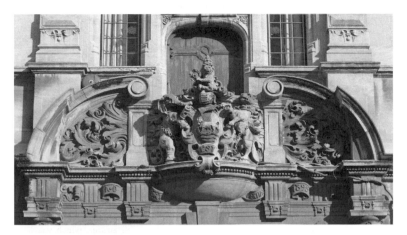

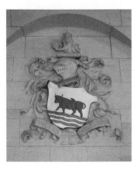

two creatures are called 'supporters' as they seem to be supporting a shield. The elephant was the crest of the Knollys family, whilst the beaver was *one* of the supporters of the Norreys family – famous Elizabethan families who held office in the reign of Queen Elizabeth I in positions of some importance, as High Sheriff, Lord Lieutenant and High Steward of the city. They were also local MPs.

The crest, always shown above the shield, is of a gold demi, or half lion, wearing a crown, and holding between its two front paws red and white, or double rose, badges of the Houses of Lancaster and Yorkshire; both are derived from the Royal Insignia. They are intended to commemorate Queen Elizabeth I's visit to the city in 1566, when she stayed at Christ Church.

The motto *Fortis est Veritas* means: the truth is strong. It dates from the time of the original grant.

Sources:

The information cited above is taken from the notes of Harold S. Rogers MA FSA under the heading: A Description of the Arms of the City of Oxford Based on a Drawing Received From the College of Arms written in 1947 (OXFO 929.6), and kept at Oxford Central Public Library, Westgate, Oxford, OX1 1DJ.

..

ARMS OF THE UNIVERSITY OF OXFORD

The Arms of the University of Oxford show a book bearing the words *Dominus Illuminatio Mea*, surrounded by three golden crowns.

According to Oxford University Archives, the university's arms were acquired round about 1400. Very little is known for certain regarding the symbolism of the seven clasps on the side of the book, which may refer to the seven subjects in the medieval curriculum, or to the Book of the Seven Seals in Revelation V, 1-5.

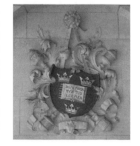

The origin of the three crowns is a matter of conjecture. Thomas Cranley, who was Chancellor of the university in 1390, adopted them for his own personal use. Richard II gave them to Robert de Vere, 9th Earl of Oxford, when he made him Duke of Ireland in 1386. Three crowns were also associated with King Edward the Martyr, King Arthur and Jesus Christ.

The words *Dominus Illuminatio Mea*, which are the opening words from Psalm 27, may be translated as 'the Lord is my light'. The related legend was in use by the second half of the sixteenth century.

The current device, which was designed in 1993, features the traditional arms within an encircling belt.

Source:

Oxford University Archives, 2005

..

ROGER BACON (*c.* 1214-1292?): *Franciscan Friar, philosopher and scientist*
'Dr Mirabilis' (Wonderful Doctor)

PLAQUE: SOUTH WALL, WESTGATE CENTRE, OXFORD.
STATUE: MUSEUM OF NATURAL SCIENCE, PARKS ROAD, OXFORD

SINE EXPERIENTIA NIHIL SUFFICIENTER SCIRI POTEST (Without experiment it is not possible to know anything adequately), from Roger Bacon's *Opus Majus*, inscribed above the entrance to Daubeny Building, the Botanic Garden, Oxford

Roger Bacon was a brilliant scholar, and one of Oxford's earliest scientists. A philosopher, teacher, mathematician, experimental scientist and linguist, he is very closely associated with Oxford, having lived in a Franciscan community in an area of town which is now part of the modern city centre. A plaque on the south wall of the Westgate Centre records his life in both Latin and English. It states:

> The Great Philosopher ROGER BACON, Known as the Wonderful Doctor who by the Experimental Method Extended marvellously the realm of science. After a long life of untiring activity Near this place, in the home of his Franciscan brethren, Fell asleep in Christ AD 1292.

Another reminder of his presence is nearby Roger Bacon Lane. The Museum of Natural History contains a fine statue in stone which represents Friar Bacon. At one time, a tower over Folly Bridge, which served as his observatory, was known as Friar Bacon's Study. It existed for several centuries but was destroyed in 1779.

Details of Bacon's early life are sparse but it would seem that he came from a wealthy family not far from Ilchester, Somerset, and was born between 1214 and 1220. He received his education at Oxford, where he obtained his Master's degree before going to the University of Paris, which was then the centre of intellectual activity in Europe, and

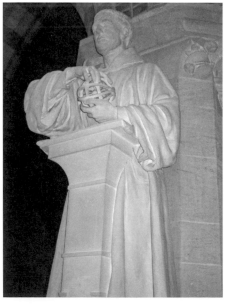

lectured there on Aristotelian treatises and grammar. He returned to Oxford in about 1247 and applied himself to experimental research in alchemy, astronomy and mathematics. Bacon studied languages, mastering Greek and Islamic texts on optics, a subject which fascinated him. For him, the importance of linguistics and scientific knowledge was as a means of understanding theology.

Bacon's focus on natural sciences was probably due to the teachings of two Oxford Franciscans, Robert Grosseteste and Adam March, who were professors at the Franciscan School in Oxford. (Grosseteste, who became the first Chancellor of the university, was an expert on cosmology and astronomy, teaching that natural phenomena can be explained mathematically.) Bacon joined the Fransciscan Order in Oxford in about 1256-57, but was not allowed to teach or publish. His superiors, suspicious of his learning and fearful that he might promulgate heresies, exiled him to Paris, where he spent the next decade. Whilst he was there, Pope Clement IV, who was aware of Bacon's intellectual brilliance, commanded him to send him a copy of his works; Bacon complied by publishing his *Opus Majus*, *Opus Minus* and *Opus Tertium*, which represented not only a collection of his major works on philosophy and science, but together made up a compendium of all the then known sciences, based on observation and experimentation.

Pope Clement died in 1268, and by 1270 Bacon was back in Oxford. Without Clement's patronage, however, he experienced difficulties with his superiors. This was not surprising since he attacked them constantly in his writings and his lectures. They, in their turn, accused him of heresy and black magic. In 1278 Jerome of Ascoli, the Minister General of the Franciscans, had Bacon confined within the Order, but allowed him to continue his work. Roger Bacon carried on writing, producing a number of treatises on a variety of subjects including the warding off of the infirmities of old age. He began his last great unfinished work, *Compendium Studii Theologiae*, when he was released from confinement in 1292, but he died in Oxford shortly afterwards. Roger Bacon's reputation as a brilliant scholar was so great that, after his death, he was given the title of Doctor Mirabilis.

Sources:

Molland, George, 'Bacon, Roger (*c.* 1214-1292?)', *Oxford Dictionary of National Biography*, Oxford University Press, 2004 (http://www.oxforddnb.com/view/article/1008, accessed 11 Dec. 2010)

http://www.oxforddnb.com/view/article/1008

http://plato.stanford.edu/entries/roger-bacon/

http://www.britannica.com/EBchecked/topic/48177/Roger-Bacon

BAPTIST MEETING HOUSE
PLAQUE: PACEY'S BRIDGE, PARK END STREET, OXFORD

The plaque, which was erected in 1953 to celebrate 300 years of Baptist presence in Oxford, also commemorates a sad incident which took place in 1715.

Baptists met at the home of Richard Tidmarsh, who was minister from 1661-1691. His house was close to the water to enable members to be baptised in the stream. However, it was burned down during the Jacobite riots of 1715.

Today, worship takes place in New Road Baptist Church, Bonn Square, on the site of the first Baptist church, which was built in 1721. Since then the church has been rebuilt and enlarged several times.

The Baptist tradition is also represented by Regent's Park College, St Giles, which is a Permanent Private Hall in the University of Oxford.

Sources:

Hibbert, C. and Hibbert, E. (Eds), *The Encyclopaedia of Oxford*, 1988

http://www.ox.ac.uk/colleges/colleges_and_halls_az/regents.html

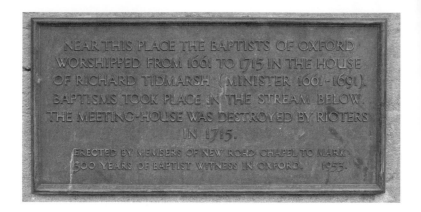

BEAUMONT PALACE SITE: BIRTHPLACE OF KING RICHARD I (THE LIONHEART), 1157, AND KING JOHN, 1167
PLAQUE: SET IN A PILLAR AT THE WEST END OF BEAUMONT STREET, OXFORD

Beaumont Palace has a colourful and fascinating history which goes back to the twelfth century, when Oxford was one of England's most important towns and conveniently close to Woodstock Manor (now Blenheim Palace) where King Henry loved to hunt. The king is known to have spent Easter 1133 at his *nova aula* (new hall), celebrating the birth of his grandson, the future Henry II, with great pomp and splendour. A few years later, two of his other grandsons, Richard (1157-1199) and John (1167-1216), were born at the palace.

By the middle of the thirteenth century the palace buildings extended over a wide area, but by the end of the century it was no longer used as a royal residence, after King Edward I, the last king to occupy it, granted it to one of his lawyers, Francesco Accorso. After changing hands twice more its fortunes declined, and, by the beginning of the fourteenth century, stone and timber taken from some parts of the building were being used to repair Oxford Castle. In 1318 the rest of the buildings were granted to the Carmelite Friars by Edward II, in fulfilment of a pledge he made to the Virgin Mary at the Battle of Banockburn, when he vowed to found a monastery for Carmelites in return for his safety.

Edward was not a popular king, and earlier that year a young Oxford clerk, John Deydras, came to the palace claiming to be the king. Alas, Deydras, who alleged that his cat was the Devil and had put him up to it, was found guilty of sedition and hanged, together with the poor animal.

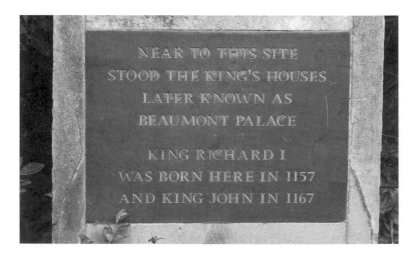

During the Dissolution of the Monasteries, when the Carmelites, together with all other monastic orders, were suppressed, the buildings on this site were dismantled and the stone was used for construction work at Christ Church and St John's College.

Sources:

Weir, Alison, *Isabella: She-Wolf of France, Queen of England*, 2006, p.117

Hibbert, C. and Hibbert, E. (Eds), *The Encyclopaedia of Oxford*, 1988

http://en.wikipedia.org/wiki/Beaumont_Palace, accessed 23 Nov. 2010

SIR ISAIAH BERLIN (1909-1997): *Historian of ideas*
BLUE PLAQUE: HEADINGTON HOUSE, OLD HIGH STREET, HEADINGTON, OXFORD

A Blue Plaque at the entrance to Headington House, a beautiful building in the heart of Headington, commemorates Sir Isaiah Berlin, philosopher, historian of ideas, and one of the most notable intellectual figures of the twentieth century. This great liberal scholar spent most of his life in Oxford, first as an undergraduate and then as a researcher, author, teacher, lecturer, professor and founding President of Wolfson College.

Isaiah Berlin was born in Riga (then part of the Russian empire), Latvia, on 6 June 1909. He was the son of Mendel Berlin, a wealthy timber merchant, and his wife Marie (*née* Volshonok). Berlin moved to London with his family in 1921, after escaping the momentous events caused by war and revolution. He was educated at St Paul's School and Corpus Christi College, Oxford, where he took Firsts in Greats (Classics) and PPE (Philosophy, Politics and Economics), before being appointed a lecturer in philosophy at New College. In 1932 he obtained an All Souls Fellowship prize, and in 1938 was elected Fellow of New College, the same year that his brilliant biography, *Karl Marx: His Life and Environment*, was published.

A gregarious and cosmopolitan man, Berlin enjoyed a wide circle of friends, and was a much-loved teacher. He was known for his rapid, idiosyncratic manner of speaking, which delighted his audiences. This certainly proved to be the case when he was posted to the British Embassy in Washington DC in 1941, where he made a number of friends, amongst whom were Philip and Katharine Graham, the publishers of the *Washington Post*. While he was there, Berlin sent witty and colourful weekly briefings to London, reporting on the political climate in the USA. Soon after the war, Berlin spent a few months in Russia, where he met Boris Pasternak and the poet Anna Akhmatova. Pasternak would entrust Berlin with the typescript copy of his novel *Dr Zhivago* when he visited him a few years later, which Berlin managed to conceal till he was back in England, when he gave it to Pasternak's sisters, who lived in Oxford.

In 1950, Berlin went back to All Souls, where he turned to the history of ideas and political theory. In 1957, he was elected to the Chichele Chair of Social and Political Theory. His fascination with the subject of freedom led him, in his inaugural lecture in 1958, to argue against 'positive' liberty which allowed individuals to be their own masters but could lead to the most appalling acts of oppression. Berlin preferred to consider freedom in 'negative' terms, as in 'freedom from enslavement by others'. Berlin believed in the notion of 'pluralism', the thesis that no individual or society should ever accept that there is one absolute value to which all other values should be subordinated.

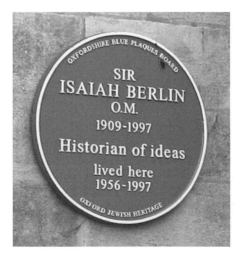

In 1966, Berlin became the founding President of Wolfson College, a new graduate college. It is possible that had he not taken

a personal interest in the project, and used his fund-raising skills to promote it, Wolfson College might never have come into existence. As it is, the college fulfils his objectives of providing a centre of academic excellence based on a strong democratic ethos.

Berlin received many accolades and awards during his lifetime. In 1957 he was knighted and became a Fellow of the British Academy, and in 1971 he received the Order of Merit. He served as President of the British Academy from 1974–1978, and was a member of the American Academy of Arts and Sciences.

Despite being complimented by Greta Garbo on his 'beautiful black eyes' and being admired by many women who enjoyed his sparkling company, Berlin did not seek matrimony until his forties when, in 1956, he married former French golf champion Aline Halban, the daughter of financier Baron Pierre de Gunzbourg. He left his very comfortable college accommodation for Headington House, the delightful home his wife had bought in 1953, and here he would remain for the next forty years.

This much-liked academic – known to many for his kindness and consideration to others, and as a devoted family man who found great happiness with his wife and stepsons – died in a nursing home in the Banbury Road, Oxford, on 5 November 1997. He is buried in Wolvercote Cemetery.

Sources:

Oxfordshire Blue Plaques Scheme

Kornberg, Hans, 'Krebs, Sir Hans Adolf (1900-1981)', *Oxford Dictionary of National Biography*, Oxford University Press, 2004; online edn, Jan. 2011 (http://www.oxforddnb.com/view/article/31327, accessed 26 Jan. 2011)

http://kenanmalik.com.reveiws/ignatieff_berlin.html

http://www.telegraph.co.uk/news/obituaries/6455138/Isaiah-Berlin-OM.html

http://www.oxfordtimes.co.uk/lifestyle/thisweek/4556523.The_gossiping_intellectual/

..

BLACKFRIARS: *The Dominican Priory of the Holy Spirit*

MADONNA AND PLAQUE: 64 ST GILES, OXFORD

The inscription below the statue of the Madonna, over the gateway of the Dominican Priory in St Giles, reads:

HUNC CONVENTUM ALTERUM NOVUM EADEM DIE QUA PRISCUS FUNDATUS EST A.D. MCCXXI FRATRES PRAEDICATORES LONGUM POST EXILIUM REDUCES POSUERUNT XVIII KAL. SEPT. MCMXXI

(The Friars of the Order of Preachers, back after long exile, set up this second new Priory on 15 August 1921, the same day of the year as that of their original foundation in 1221.)

The Dominican Friars belong to the Order of Preachers founded by St Dominic nearly 800 years ago, and are known as 'Black Friars' because of the black cloak they wear over their habits. The Order, based on the rule of St Augustine, first came to Oxford on 15 August 1221, and stayed in the town for over 300 years, before being dissolved by King Henry VIII in 1538 during the Dissolution of the Monasteries.

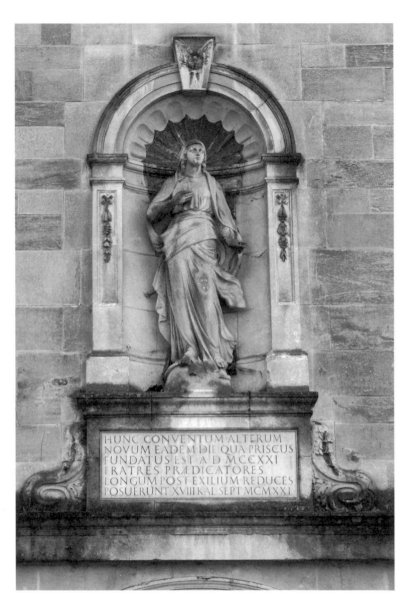

HUNC CONVENTUM ALTERUM
NOVUM EADEM DIE QUA PRISCUS
FUNDATUS EST A D MCCXXI
FRATRES PRÆDICATORES
LONGUM POST EXILIUM REDUCES
POSUERUNT XVIII KAL SEPT MCMXXI

On 15 August 1921, exactly 700 years after the first house was founded in Oxford, the Dominicans returned to Oxford when a foundation stone of a new priory was laid on the present site in St Giles. It was founded by Father Bede Jarrett and the principal donor was Mrs Charlotte Jefferson Tytus, an American widow. The chapel was consecrated on 20 May 1929 but the priory was not completed until 1954, twenty years after Father Bede's death.

The statue of the Madonna above the front entrance is by Thomas Rudge and was erected in 1924. Some individuals at the time complained that her head was too small. The lettering on the tablet beneath is by Eric Gill (1882-1940), the noted sculptor and stonecutter.

Sources:

http://www.bfriars.ox.ac.uk/about_dominicans.php

Hibbert, C. and Hibbert, E. (Eds), *The Encyclopaedia of Oxford*, 1988

THE BODLEIAN LIBRARY

The entrance to the Bodleian Library is known as the Proscholium. It was built between 1610 and 1612 to allow access to the fifteenth-century Divinity School, and to provide an extension to Duke Humfrey's Library above. In 1968 it became the main entrance hall for the Old Library.

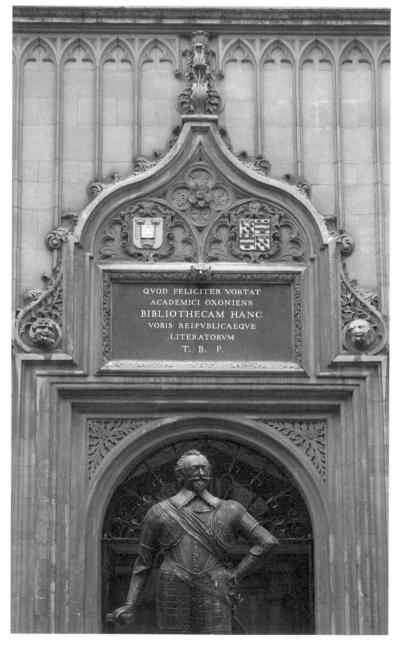

A plaque inscribed in Latin above the doorway reads:

QUOD FELICITER VORTAT
ACADEMICI OXONIENS
BIBLIOTHECAM HANC
VOBIS REIPUBLICAEQUE
LITERATORUM
T.B.P★

This translates into English as: 'May it turn out happily. Master of Oxford, Thomas Bodley placed this library here for you and for the commonwealth of the educated.' TB are Bodley's initials, followed by P (*posuit*), meaning 'Founder'.

The library is named in honour of Thomas Bodley, who re-established a university library after the dispersal and sale of the old Duke Humfrey's Library in 1550.

No books are lent to readers. Even King Charles I, in 1645, was unable to borrow a volume from the library.

Source:

The Latin translation is taken from *Latin in Oxford: Inscriptiones Aliquot Oxonienses*, compiled by Reginald H. Adams, The Perpetua Press, 1994.

..

BONN SQUARE MEMORIALS AND PLAQUES
TIRAH MEMORIAL OBELISK

BRONZE PLAQUE COMMEMORATING REOPENING OF BONN SQUARE IN MAY 2009

BRONZE SCULPTURE OF BOOKS PRESENTED TO OXFORD BY THE CITY OF BONN, 22 MAY 2009

PEACE PLAQUE

Bonn Square, situated between Queen Street and New Inn Hall Street, is named after the city of Bonn, in Germany, with which Oxford is twinned. It is very close to the old west gate of the city and was created in the early 1970s on the site of what was once the graveyard of St Peter-le-Bailey Church. After the Second World War, Oxford was the first city in England to establish ties with a German city in a gesture of friendship.

One memorial above all others seems to physically dominate Bonn Square. Known as the Tirah Memorial, it is the first war memorial in Oxford and commemorates the soldiers of the 2nd Battalion Oxfordshire Light Infantry who were killed in the Tirah Expedition or Campaign, and the North-West Frontier Campaign, in India, between 1897 and 1898. One soldier who did not die in India, but whose name is inscribed on the east side of the memorial, is Brevet-Major A.B. Thurston, who was killed by mutineers in Uganda. The regiment had fought at the Battle of Waterloo, taken part in the expedition to Egypt in 1885, and was sent to India the following year, where it was based until 1903 when the battalion came back to England.

The memorial was designed by Inigo Thomas and was erected in 1900, on what had become in 1897 a public memorial garden, with trees and benches.

A bronze plaque attached to the wall of No. 1 New Inn Hall Street records the reopening of the square in May 2009 by Councillor Mary Clarkson, Lord Mayor of Oxford, and Bezirksbürgermeister of Bonn, Helmut Kollig, following redevelopment of the site. Previously, a stone with the following inscription stood on the site:

BONN SQUARE
THE LORD MAYOR OF THE CITY OF OXFORD
COUNCILLOR MRS OLIVE GIBBS
AND THE CHAIRMAN OF
THE BONN DISTRICT COUNCIL
HERR STADTVERORDNETER REINER SCHREIBER
NAMED THIS SQUARE ON 5 OCTOBER 1974

The stone is now located in Cutteslowe Park, Oxford.

BONN SQUARE

Inaugurated October 1974
in honour of the twinning of
OXFORD and BONN
by the Lord Mayor of Oxford
Cllr Olive Gibbs and
the Mayor of Bonn

**OXFORD
CITY
COUNCIL**

Re-opened May 2009
by the Lord Mayor of Oxford
Cllr Mary Clarkson and
the Bezirksbürgermeister of Bonn
Helmut Kollig

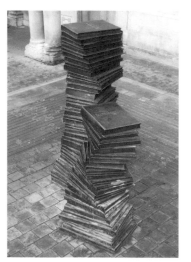

Also in May 2009, a sculpture by Diana Bell, of two piles of books, was presented to Oxford by the City of Bonn to commemorate sixty years of twinning. The books, cast in bronze from real books, are symbolic of the links between two university cities. The words 'knowledge', 'understanding', 'friendship' and 'trust' are inscribed in English on the spines of the books in the larger pile, and 'wissen', 'vertrauen', 'freundschaft' and 'verständigung' on those of the smaller pile. Diana Bell is a local artist based at Magdalen Road Studios, Oxford.

On 21 September 2010, a Peace Plaque on the wall of New Road Baptist Church was unveiled by peace campaigner, Bruce Kent. The plaque reads: 'Peace – to honour those who seek another path in place of violence and war.' The word 'PEACE' is inscribed on the plaque in four languages: English, Arabic,

Hebrew and Sanskrit, and was the idea of Canon David Partridge, a retired Anglican priest and interfaith worker in the city. The plaque was supported by Oxford City Council.

Sources:

http://monuments.oxfordshirefhs.org.uk/opb/history.htm
http://www.british-history.ac.uk/report.aspx?compid=22821#s21
http://www.dianabell.co.uk/knowledge_01.html
Hibbert, C. and Hibbert, E. (Eds), *The Encyclopaedia of Oxford*, 1988

··

ROBERT BOYLE (1627-1691) *and* ROBERT HOOKE (1635-1703): *Scientists*

PLAQUE: SITE OF BOYLE AND HOOKE'S LABORATORY, UNIVERSITY COLLEGE SHELLEY MEMORIAL WALL, HIGH STREET, OXFORD

BOYLE:

Robert Boyle, regarded today as the first modern chemist, is best known for his discovery that the volume of a gas varies inversely to the pressure of the gas (Boyle's Law). Boyle was the author of a seminal work on chemistry, *The Sceptical Chymist*, published in 1661. He was a member of the Invisible Society and founder member of the Royal Society, but unlike many other natural scientists he was educated at neither Oxford nor Cambridge.

Robert Boyle, the son of the first Earl of Lismore, was born in Lismore Castle, County Waterford, Ireland in 1627. As a child he showed a precocious appetite for learning, which in adulthood led him to devote his life to the study of science and philosophy. A respected academic, Robert Boyle was warmly accepted as a member of the Invisible College (the forerunner of the Royal Society which he helped form in 1660), a community of like-minded intellectuals or 'natural philosophers', such as John Wilkins, Christopher Wren and Robert Hooke, who would meet occasionally in Oxford.

Sometime between 1665 and 1666, Boyle moved to Oxford, possibly on John Wilkins's advice, and rented accommodation at Cross Hall in the High Street, which his sister Lady Ranelagh had checked and found suitable for his needs. (The building no longer exists. In its place is the Shelley Memorial, erected to commemorate the famous poet and alumnus of University College.) He set up a laboratory in this property in order to carry out a number of experiments, employing Robert Hooke to assist him. (A number of these researches would lead to the discovery of the law which bears his name.) With the aid of the air pump which Hooke designed, he began to study the properties of air, investigating vacuums, respiration and combustion. He began, or completed, a number of books at this time, including *New Experiments and Observations upon Cold* and *Hydrostatical Paradoxes*. During his lifetime he produced over forty books, with a number of them being published while he was living in Oxford.

In 1668, Boyle left Oxford for London. He took up residence in Lady Ranelagh's house, and continued to produce a prodigious amount of work in the fields of science, philosophy and religion. A deeply religious man, he involved himself in financing the translation of the Bible into several languages, and endowed in his will a series of Christian-based lectures which bear his name. After his health began to fail in 1689, he gave up public life, and died on 31 December 1691. It is said that he died from grief at the death of his sister just seven days before.

HOOKE:

Robert Hooke was one of the seventeenth-century's most remarkable scientists. A polymath, Hooke was not only an experiential scientist, inventor, astronomer, mathematician, teacher and author, but also a linguist, artist, musician, surveyor and architect. He is remembered for Hooke's Law of Elasticity, and as one of the major architects to have helped rebuild London after the Great Fire of 1666.

Robert Hooke was born in Freshwater on the Isle of Wight on 18 July 1635, the son of a clergyman, Revd John Hooke, and his wife Cecily (*née* Gyles). He was not robust as a child so was taught at home by his father, and occupied himself by making mechanical toys. On his father's death in 1648, he went to London as the pupil of the artist Sir Peter Lely, but was allergic to paint and left the studio to study at Westminster School, where he showed himself adept at learning languages, especially Latin and Greek, and at playing the organ. His musical ability was rewarded five years later when he became a chorister at Christ Church, Oxford. He was awarded his MA degree in 1663.

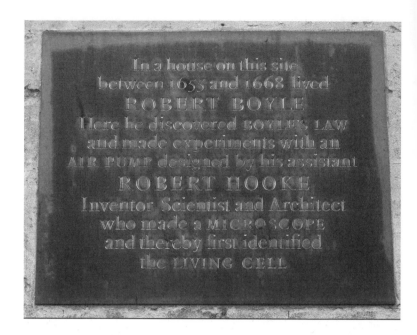

At Oxford, Hooke found himself among a group of brilliant intellectuals – men like Christopher Wren, who became his lifelong friend, and other natural philosophers such as John Wilkins, Warden of Wadham College, Robert Boyle and Seth Ward. Hooke's famous collaboration with Robert Boyle began in 1655 on the recommendation of the chemist Dr Willis, whose assistant Hooke had been. It was an inspired working partnership. Hooke learnt practical laboratory skills from Boyle and in return brought mechanical and mathematical skills to their joint researches, which resulted not only in the construction of their version of an air pump, but also in a number of experiments on the balance spring and weight of air. Seth Ward, the eminent astronomer, was impressed by Hooke's abilities, and encouraged him to study astronomy and to develop clockwork apparatus to record astronomical observations. Hooke was also greatly interested in gravitation and timekeeping at this time.

In 1662, Hooke left Oxford for London to take up the position of First Curator of Experiments at the newly formed Royal Society. This post required him to devise and set up experiments for the Society meetings. He fulfilled his brief so ably, that he was admitted as Fellow in 1663, the year he was awarded his MA degree from the university. He worked on many different areas of science simultaneously, preparing and carrying out experiments, closely observing the results, and lecturing at the Royal Society. He designed the first compound microscope, a balance wheel for watches, wheel barometers and much more.

In 1664 Hooke was appointed Gresham Professor of Geometry, with rooms in Gresham College. The following year, his ground-breaking work *Micrographia*, based on his microscopic and telescopic observations, was published and became the bestseller of its day. It was in this book, the first major publication issued by the Royal Society, that the word 'cell' was used for the first time ever to describe organisms.

After the Great Fire of London in 1666, Hooke was appointed Surveyor to the City of London and worked closely with his friend and colleague Christopher Wren to rebuild the city.

'The greatest mechanic in the world', as his friend John Aubrey labelled him, died in his rooms at Gresham College on 3 March 1703 and was buried at St Helen's, Bishopsgate, though the whereabouts of his grave are not known.

Replicas of Hooke's compound microscopes can be found at the Museum of the History of Science in Broad Street, Oxford.

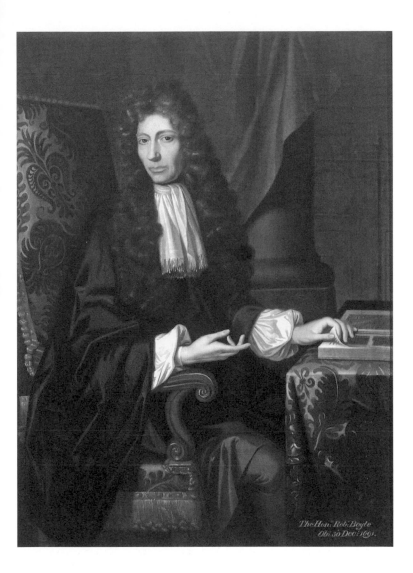

Sources:

http://www.oxforddnb.com/view/article/13693
http://www.mhs.ox.ac.uk/features/walk/loc5.htm
http://www.roberthooke.org.uk/arch2.htm

JANE BURDEN (MRS WILLIAM MORRIS) 1839-1914

BLUE PLAQUE: ST HELEN'S PASSAGE. OFF NEW COLLEGE LANE. OXFORD

To connoisseurs of Pre-Raphaelite art, Jane Burden's face and tall willowy figure are instantly recognisable. This woman, with dramatic features, full lips, dark lustrous hair and long neck, epitomised the ideal of female beauty to members of the nineteenth-century group of artists known as the Pre-Raphaelite Brotherhood, among whom were William Morris and Dante Gabriel Rossetti. She was born in a working-class area of Oxford on 19 October 1839. At the time of her birth, her father Robert worked as a stable-hand and lived with his wife Ann Maizey in a slum dwelling in St Helen's Passage off New College Lane,

29

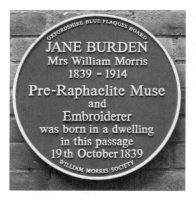

Oxford. Her home – which was given as 65 Holywell Street on her marriage certificate – no longer exists, but a Blue Plaque has been placed on the wall of a Hertford College building in St Helen's Passage, which is a near approximation of where the cottage used to stand.

Jane first came to the notice of two young artists, Dante Gabriel Rossetti and Edward Burne Jones, whilst attending a theatre performance in Oxford with her sister Bessie. As soon as they saw her, the two men immediately dubbed her a 'stunner', and lost no time in asking her to sit for them. At the time, they were busy painting murals at the Oxford Union which were based on Arthurian legends, together with some other young artists – among whom was William Morris. Jane was unsure about modelling for Rossetti, but he persuaded her to sit for him as Guinevere, King Arthur's queen. Not long after, she posed for Morris as 'La belle Iseult' (Tate Collection). It was whilst painting her that he fell in love with her, but, when he finished, he wrote despairingly on the back of the portrait, 'I love you but I can't paint you'. Indeed, he never did again.

Despite the social differences between them, Morris asked Jane to marry him, and as soon as she accepted his proposal, he arranged for her to receive private tutoring to help her feel happier about the social divide. Jane was a ready learner. She enjoyed reading and became proficient in French and Italian. She also learnt to play the piano and was an accomplished needlewoman, a skill she would subsequently use during her marriage when she helped Morris in his business. Jane Burden married William Morris at St Michael's Church, Cornmarket, Oxford, on 26 April 1859, witnessed by Jane's family, though sadly for the couple none of Morris's relations attended the wedding. The couple spent their honeymoon on a tour of Paris, Belgium and the Rhineland before returning to England. Jane never resided in Oxford again, but did return to live in Oxfordshire.

Their first home was the Red House in Bexleyheath, Kent where their daughters Jenny (1861), who was later to suffer severely from epilepsy, and May (1862) were born. It was also the birthplace of the Arts and Crafts Movement. This distinctive house, designed by Morris's architect friend Philip Webb, became a centre of furious artistic activity when Morris founded Morris, Marshall, Faulkner and Co., 'The Firm', in order to produce textiles, furnishings, and furniture. Jane, who assisted her husband in his creative activities, experimented with various materials to produce several beautiful needlework items, including a set of panels depicting famous heroines. In 1865, the Morris family moved to Bloomsbury, where she continued her embroidery work and modelled for some of Rossetti's most famous paintings, such as 'Proserpine' (Tate collection). In addition, she produced elaborately decorated books.

It was during these years that Jane, much to her husband's distress, started a romantic liaison with Rossetti which continued when the three of them, and the Morris girls, moved to Kelmscott Manor in 1871. The property was a beautiful seventeenth-century house on the Oxfordshire/Wiltshire border. Jane loved this dwelling, which was not far from her mother's village of Alvescot. Morris, who found Rossetti's company increasingly uncongenial, decided to spend most of his time in London, or visiting Iceland, leaving the pair together. The affair finally died in the mid-1870s when Jane, concerned at Rossetti's increasingly erratic behaviour, and worried by the effects it was having on her daughters, broke it off with him, although they corresponded until the end of his life in 1882. Morris, delighted by the turn of events, felt able to return again to 'the loveliest haunt of ancient peace that can be well imagined'. Rossetti, however, was not to be Jane's only lover. In the late 1880s she formed a passionate liaison with the poet Wilfrid Scawen Blunt, enjoying a friendship which would last until her death thirty years later.

William Morris outlived Rossetti by thirteen years, dying on 3 October 1895 aged sixty-one. He was buried three days later in St George's churchyard, Kelmscott village. After his death, Jane divided her time between Kelmscott, London and Lyme Regis, honouring her

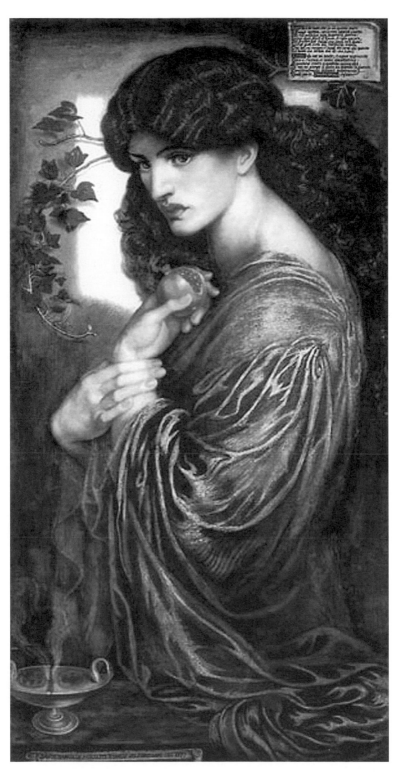

husband's memory by financing the building of a couple of new cottages and a village hall in Kelmscott (designed by Philip Webb), and helping her daughter May, a prominent figure in the Arts and Crafts Movement, produce her edition of *The Collected Works of William Morris*. Jane Morris died in Bath on 26 January 1914, and is buried with her husband and two daughters in the family grave at Kelmscott, Oxfordshire.

Sources:

Oxfordshire Blue Plaques Scheme

Sharp, Frank C., 'Morris [Burden], Jane (1839-1914)', *Oxford Dictionary of National Biography*, Oxford University Press, 2004 (http://www.oxforddnb.com/view/article/64273, accessed 2 Nov. 2010)

Harwood, David, *Portrait of a Stunner – The Story of Jane Burden*

..

CARFAX TOWER CLOCK

PLAQUE, CLOCK AND QUARTERBOYS: CARFAX, OXFORD

Carfax Tower is one of the most famous landmarks of Oxford, standing as it does in the very centre of the town. It marks the junction of the High Street, St Aldate's, Queen Street, and Cornmarket. Its name is derived from the Latin *quadrifurcus*, which means four-forked and refers to the four streets. The tower is virtually all that remains of the nineteenth-century St Martin's Church, which was built on the site of an even older church that was demolished in 1896 to make way for a road-widening scheme.

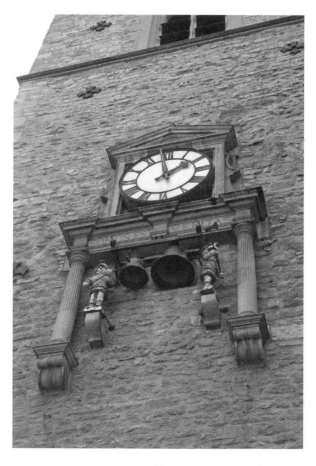

The present clock, which is electric, replaced its seventeenth-century forerunner in 1938. It is flanked by two figures known as quarterboys, dressed in Roman costume with gold-coloured helmets, holding hammers. The quarterboys stand on either side of the two quarter jack-bells, and every fifteen minutes strike the bells with their hammers. Immediately beneath the clock one can see the city's motto, *Fortis est Veritas* (the truth is strong), carved into the stone.

The tower has ninety-nine steps and is well worth the climb for the view of the city below.

Sources:

http://www.oxfordcityguide.com/TouristInfo/SightSeeing.html

Hibbert, C. and Hibbert, E. (Eds), *The Encyclopaedia of Oxford*, 1988

..

THE CATHOLIC MARTYRS OF OXFORD (DIED 1589)

GEORGE NICHOLS: RICHARD YAXLEY: THOMAS BELSON: HUMPHREY PRITCHARD

WELSH SLATE PLAQUE: 100 HOLYWELL STREET, OXFORD

Just before midnight on 18 May 1589, four men, two of them priests, were arrested at the Catherine Wheel Inn (on a site now partly occupied by Balliol College), opposite St Mary Magdalen's Church in Oxford. They were taken to Bridewell Prison, London for questioning. The priests, George Nichols and Richard Yaxley, were tortured and then brought back to Oxford for trial, together with the two laymen Thomas Belson and Humphrey Pritchard. The priests were accused of treason, under the law at the time which prohibited men who had been ordained abroad as Roman Catholics to return to this country, and forbade anyone from helping them. Belson and Pritchard, who had been accused of assisting Nichols and Yaxley, were charged with felony. Both crimes incurred the death penalty by hanging, with treason being punishable additionally by having one's body drawn (disembowelled) and quartered.

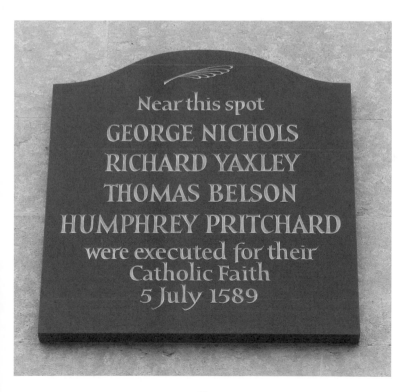

On 5 July 1589, the four Catholics were brought to the city gallows which was located in Longwall Street, not far from the junction with Holywell Street. There they were hanged. Nichols and Yaxley were drawn and quartered. The priests' heads were set up on the castle and their quarters on the four city gates. Two of the men had direct links with Oxford.

George Nichols was born in Oxford. He was a graduate of Brasenose College, Oxford (1573), after which he taught at St Paul's School, London. He converted to Catholicism after being in contact with some Catholics in England, and then went to Douai College in France in 1581 to study for the priesthood. On being ordained, he was sent to Rheims to study further and returned to Oxford on a mission to convert people to Catholicism. He was famous as the priest who had himself smuggled into Oxford Castle to reconcile a highwayman to the Catholic Church on the eve of his execution.

Thomas Belson was the younger son of Augustine Belson, a well-known Catholic landowner of Buckinghamshire. He was born in Brill in 1565 and educated at St Mary's Hall, Oxford, which was part of Oriel College, Oxford, and Douai College, Rheims. Belson came back to England in 1584, and by June 1585 was imprisoned in the Tower of London for 'conveying intelligence' for a Catholic priest. He was released five months later on condition that he leave the country, but some time before 1589 he was back in Oxford, joining Father Nichols.

The two other men came from further afield. Richard Yaxley was from Boston, Lincolnshire. He was ordained at Rheims and returned to England sometime between 1585 and 1586. Pritchard, a Welshman and a convert, was a servant at the Catherine Wheel Inn.

The four men were among the eighty-five martyrs of England and Wales beatified by Pope John Paul II on 22 November 1987. In October 2008, a plaque was erected at the site of the town gallows to commemorate their names. Since 2005, the Latin Mass Society has held a pilgrimage to Oxford with a procession following the route taken by the martyrs from Bocardo prison (no longer there) to the gallows.

There is a separate plaque to the Ven. George Napier at Oxford Castle.

A plaque commemorating all the martyrs of the Reformation in Oxford, both Catholic and Protestant, can be found inside the University Church of St Mary the Virgin, High Street, Oxford. It is inscribed with the names of twenty-three people who died for their faith between 1539 and 1681.

Sources:
http://www.newadvent.org/cathen/11065c.htm
http://englishmartyrs.blogspot.com/

..

NIRAD C. CHAUDHURI (1897-1999): *Writer*
BLUE PLAQUE: 26 LATHBURY ROAD, OXFORD

Nirad C. Chaudhuri is considered by many to be one of India's most distinguished writers in English of the twentieth century. Deeply rooted in Bengali culture and highly affected by English literature and European thought, he focussed his writing on the grand themes of civilisation and nationalism, culture and identity. His first book was written when he was fifty-three, and his last completed in his ninety-ninth year.

Nirad Chaudhuri was born into a middle-class Hindu family in Kishoreganj, Bengal (now Bangladesh) on 23 November 1897. His father, Upendra Narayan, and his mother Sushila, provided him and his siblings with an intellectual environment and a comfortable lifestyle, which allowed Chaudhuri to immerse himself in English literature. This love for books was to be a lifelong passion.

After graduating from Calcutta University, Chaudhuri took up a series of jobs. The most important post he held at this time was that of secretary to Sarat Chandra Bose, the brother of Subhas Chandra Bose, the Nationalist leader. He grew increasingly disapproving of the direction that Indian Nationalism was taking and, in 1941, he left for Delhi to work as a political commentator at All India Radio, a job he lost on publication of his first book *Autobiography of an Unknown Indian*, published in 1951. It caused great offence in post-colonial India, not least because of its contentious dedication to the memory of the British Empire in that country, and because of the author's acerbic views on politics and culture in India.

Chaudhuri found himself in the unenviable position of being a pariah in his own country, unable to work because of a government ban on his writing, so in 1955 he accepted an invitation from the British Council and the BBC to come to England to write a series of talks for the BBC. In 1959 these articles were published, together with some others, as *A Passage to England*, and showed that he did not reserve his criticisms for India alone but castigated the British for what he judged to be a lowering of moral standards and a decline in cultural ideals. Chaudhuri continued to write in English and was awarded the Duff Cooper Memorial Prize in 1965 for *The Continent of Circe*. His last book, *Three Horsemen of the New Apocalypse*, was published when he was 100. By this time he had been made CBE (1992), received an honorary DLitt from the University of Oxford, and was a recipient of the Deshikottama, the highest honorary degree of the University of Visva Bharati.

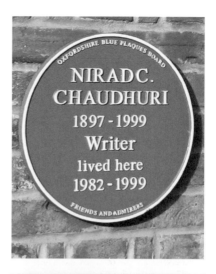

Despite Chaudhuri's pessimism about the future of English culture, he left India for England in 1970, moving first to Wheatley, Oxfordshire. He and his family then set up home at 41 Harefields, Oxford, before finally settling in a rented flat at 20 Lathbury Road, Oxford in 1982. It was here that he wrote various works, including biographies of Max Mueller and Clive of India, and the second volume of his autobiography, *Thy Hand, Great Anarch!* (1987). As well as writing, Chaudhuri would listen to classical music with great pleasure. He was passionately fond of nature and took special delight in tending the roses in his garden. He was also a dapper dresser and

would take walks in and around Oxford, where he became a familiar figure, attired in an elegant three-piece suit, sporting a jaunty hat and carrying a stylish cane.

Nirad Chaudhuri lived to the grand old age of 101 and died at home in Lathbury Road on 1 August 1999 after suffering a stroke. He was possibly the oldest author, at the age of ninety-nine, ever to have had his work published.

Although Chaudhuri was a controversial writer of strong iconoclastic opinions, his work has been reassessed and is now accepted in India as well as in the western world. V.S. Naipaul judged *Autobiography of an Unknown Indian* as 'maybe the one great book to have come out of the Indo-British Encounter' (The *Independent*, 3 August 1999).

Sources:

Oxfordshire Blue Plaques Scheme

Chatterjee, Niladri Ranjan, 'Chaudhuri, Nirad Chandra (1897-1999)', *Oxford Dictionary of National Biography*, Oxford University Press, 2004; online edn, May 2006 (http://www.oxforddnb.com/view/article/72657, accessed 20 Nov. 2010)

http://www.bookrags.com/wiki/Nirad_C._Chaudhuri

CAPTAIN NOEL GODFREY CHAVASSE VC & BAR MC (1884-1917) *Royal Army Medical Corps*

BLUE PLAQUE: MAGDALEN COLLEGE SCHOOL, COWLEY PLACE, OXFORD

Noel Godfrey Chavasse is known for his feats of extraordinary bravery as a medical officer. He was the only man to be awarded Britain's highest military honour, the Victoria Cross, twice during the First World War, and is still one of only three men in history to have ever achieved such a distinction. His humanity and care for others is recognised by two cities, Oxford and Liverpool, which have both erected Blue Plaques in his memory.

Chavasse, one of seven children and an identical twin, was born with his brother Christopher on 9 November 1884 at 36 (now 38) New Inn Hall Street, Oxford to Revd Francis Chavasse, rector of St Peter-le-Bailey Church, and his wife Edith (*née* Maude). In 1897, he and his brother were admitted to Magdalen College School, but left in 1900 when their father was appointed Bishop of Liverpool. They continued their education at Liverpool College before gaining admission to Trinity College, Oxford, where they both distinguished themselves at sports and represented Great Britain in the 400 metres event in the 1908 Olympic Games. Noel Chavasse graduated with First Class Honours in philosophy, went on to study medicine at Liverpool, qualified as a doctor in 1912, and subsequently specialised in orthopaedics. Chavasse cared deeply about the plight of the poor in the city and treated them for free.

After joining the Royal Army Medical Corps in 1913, Chavasse was attached to the 10th King's Battalion of the Liverpool Regiment as Surgeon Lieutenant. Shortly after war broke out in 1914, Lieutenant Chavasse and his battalion landed in France, where he witnessed the appalling conditions under which the forces had to serve. He worked tirelessly to ameliorate the lives of his men, treating both their physical and mental wounds with great sympathy and skill. In 1915 he won the Military Cross for gallantry at Hooge in Belgium. In August 1916 he was promoted to the rank of Captain and, in November that year, Chavasse was Mentioned in Despatches. This did not prevent him from being critical of the way that the war was being conducted.

Chavasse was awarded his first Victoria Cross for his actions at the Battle of Guillemont, France, on 9 August 1916 where, despite being injured and in great danger from enemy fire, he saved the lives of at least twenty men. His second Victoria Cross was awarded posthumously, following his outstanding bravery and exemplary selflessness during the 3rd Battle of Ypres, at Wieltje, Belgium. Despite being wounded early in the fighting, and exhausted from lack of food, he made repeated efforts by day and by night, under heavy fire, and with no thought for his own safety, to save the lives of wounded men. It was while tending to the sick that he was badly wounded by an exploding shell and died in hospital two days later on 4 August 1917. He is buried at Brandhoek New Military Cemetery, Belgium. His headstone is carved with representations of two Victoria Crosses.

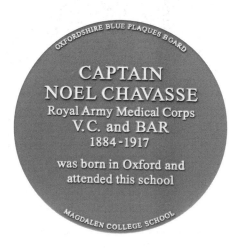

36

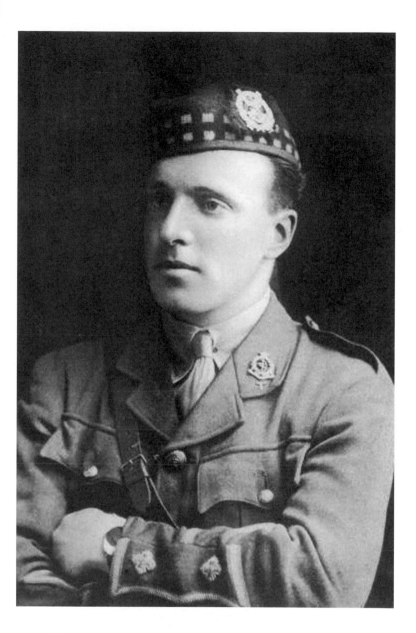

As well as being commemorated by a Blue Plaque in Oxford, Captain Chavasse's memory is honoured by a second Blue Plaque and a bronze memorial in Abercromby Park, Liverpool, which depicts him, together with a Liverpool Scottish stretcher-bearer, attending a wounded soldier. His medals are on display at the Imperial War Museum.

Sources:

Oxfordshire Blue Plaques Scheme

Clayton, Ann, 'Chavasse, Noel Godfrey (1884-1917)', *Oxford Dictionary of National Biography*, Oxford University Press, 2004 (http://www.oxforddnb.com/view/article/55355, accessed 26 Nov. 2010)

http://blog.guidedbattlefieldtours.co.uk/2010/02/24/captain-noel-chavasse-vc-and-bar/

http://www.mcleanscotland.co.uk/victoriscrosstwice.asp

CHRIST CHURCH WAR MEMORIAL GARDEN
PLAQUE: ON THE PAVING, IN FRONT OF CHRIST CHURCH GARDEN GATE, ST ALDATE'S, OXFORD

The War Memorial Garden, which is entered from St Aldate's and is open to the public, was laid out in 1926 to commemorate members of the House (although Christ Church is a college, it is never referred to as such) who lost their lives in the First World War. The plaque, which is set into the paving close up to the wrought-iron gates in the War Memorial Garden, contains a metal sword, above which is a verse from John Bunyan's *Pilgrim's Progress*, inscribed in a semi-circular pattern, which reads: 'MY SWORD I GIVE TO HIM THAT SHALL SUCCEED ME IN MY PILGRIMAGE.'

Source:
 Hibbert, C. and Hibbert, E. (Eds), *The Encyclopaedia of Oxford*, 1988

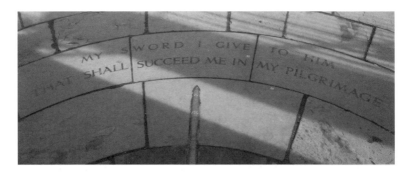

CITY OF OXFORD HIGH SCHOOL FOR BOYS (1881-1966)
PLAQUE TO THOMAS HILL GREEN (1832-1882): EDUCATIONALIST, OXFORD UNIVERSITY FACULTY OF HISTORY: GEORGE STREET, OXFORD

Nemo repente sapit, or 'No one suddenly becomes wise', is a motto which generations of pupils who once attended the City of Oxford High School in George Street would have no trouble recognising. The school, which opened in 1881, was housed in a very elegant building designed by Thomas Jackson, and was roomy enough for its first forty-seven day-boys, but when the numbers increased to 360 the premises were no longer suitable. In 1966, the school, which had counted T.E. Lawrence (of Arabia) and Ronnie Barker amongst its pupils, would merge with Southfield Grammar School, in East Oxford, to become Oxford Grammar School. After undergoing several changes, the school is now a state-funded co-educational secondary school.

The school was founded thanks to the efforts of educationalist Thomas Hill Green, who was eager that local boys should have the opportunity to achieve academic success through a good education, which would prepare them for university. Green, a Fellow of Balliol College, and Whyte's Professor of Moral Philosophy at Oxford, was involved in local politics as a Liberal councillor for many years. He was the first ever member of the university to serve on Oxford City Council. A radical thinker, he adopted a number of causes, including national franchise and advocacy of temperance (his brother was an alcoholic). He was especially keen to break down class barriers and saw education as a way of achieving a fairer society. To that end, he endowed the school with £200 towards its building programme, and founded a scholarship for children from the elementary schools of Oxford. He left the school a legacy of £1,000 on his death, which occurred only a few months after it opened. Green died on 26 March 1882 at 35 Beaumont Street, Oxford, and is buried at St Sepulchre's Cemetery.

The old school building is now occupied by Oxford University Faculty of History. There is a brass memorial plaque to T.E. Lawrence near the bottom of the main staircase. Lawrence was a pupil at the school between 1896 and 1907. (*See* Lawrence plaque, 2 Polstead Road, Oxford.)

THOMAS HILL GREEN (1832 - 1882), EDUCATIONALIST, FELLOW OF BALLIOL, WHITE'S PROFESSOR OF MORAL PHILOSOPHY, ELECTED (1876) FIRST UNIVERSITY MEMBER OF OXFORD CITY COUNCIL TO HELP FOUND AND ESTABLISH THE HIGH SCHOOL FOR BOYS (1881-1966), THEREBY COMPLETING THE CITY'S 'LADDER OF LEARNING' FROM ELEMENTARY SCHOOL TO UNIVERSITY — A PROJECT DEAREST TO HIS HEART. THUS WERE UNITED TOWN AND GOWN IN COMMON CAUSE.

Sources:

Hibbert, C. and Hibbert, E. (Eds), *The Encyclopaedia of Oxford*, 1988

http://www.oxforddnb.com/view/article/11404

...

THOMAS COMBE (1796-1872) *and* MARTHA COMBE (1806-1893): *Founders of St Barnabas, philanthropists of the Pre-Raphaelite Brotherhood*

BLUE PLAQUE: ST BARNABAS' CHURCH, JERICHO, OXFORD

PORTRAIT OF COMBE: ASHMOLEAN MUSEUM, OXFORD

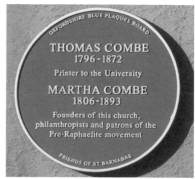

OXFORDSHIRE BLUE PLAQUES BOARD

THOMAS COMBE
1796-1872
Printer to the University

MARTHA COMBE
1806-1893
Founders of this church, philanthropists and patrons of the Pre-Raphaelite movement

FRIENDS OF ST BARNABAS

Oxford owes an inestimable debt of gratitude to Thomas Combe and his wife Martha, for promoting and commissioning Pre-Raphaelite works of art when it was unfashionable to do so. Without their generous patronage, there would be no Pre-Raphaelite paintings. The city's Victorian architecture, too,

would have been the poorer if St Barnabas' Church, in Jericho, had never been built. These two philanthropists provided funds for many good causes and were much liked by their friends, who included individuals such as John Everett Millais and William Holman Hunt. Martha Combe was herself an accomplished watercolour artist.

Thomas Combe was born in Leicester on 21 July 1796. His father, also Thomas, earned his trade as a successful bookseller in the city, and was married to Theodosia (née Dalby). Combe, one of six children, was educated at Repton School, Derby, before joining his father in the book trade. In 1824 he moved to Oxford to work in Joseph Parker's bookshop in the Turl, where he resided with one of his sisters in St Mary Hall Lane (now Oriel Street). It was there that he came across two other lodgers in the house – John Henry Newman and Edward Pusey – who were to inspire him to become a lifelong adherent of the Oxford Movement (or Tractarian) wing of the Anglican

Church. His religious views would affect all his philanthropic actions, and would lead him to promote architecture and art which accorded with his beliefs.

Combe didn't stay long in Oxford, leaving to work in London for a short while, and then returning to Leicester to help in his father's business. However, in 1838 he came back to the city to take up the post of Superintendent of Oxford University Press, living in North House, one of the buildings which belonged to the Press in Walton Street, which would become his home for the rest of his life.

The 1840s and '50s were eventful years for Combe. In 1840 he married Martha Edwards, the daughter of a local ironmonger. Newman, who officiated at their wedding, had introduced them to each other knowing that they shared the same religious sentiments and ideals. The following year, Combe, who had entrepreneurial flair, bought shares in the lucrative Bible side of Press and built up his business holdings over the years until he became senior partner. Under his management, and thanks to a booming economy and a huge demand for Bibles, the Press flourished to a considerable degree financially, enabling the university to devote funds to large building projects such as the Natural History Museum. In 1859, a grateful university awarded Combe an honorary MA degree. Combe, by now a very wealthy man, purchased Wolvercote Paper Mill in order to ensure good-quality paper for Bible printing.

Combes' links with the Pre-Raphaelites began in 1850 when he came across two young artists, John Everett Millais and Charles Allston Collins, painting in nearby woods. The meeting would be momentous for all concerned. Combe commissioned Millais to paint his portrait, and extended an invitation to both artists to North House while the painting was being executed. The Combes, encouraged by Millais, and in tune with the religious themes of Pre-Raphaelite art, acquired a number of paintings, including Millais' 'The Return of the Dove to the Ark' and Collins' 'Convent Thoughts', where the garden in the background of the picture was inspired by the Combes' own garden. (Both paintings are now in the Ashmolean Museum.) After meeting William Holman Hunt, whom they invited to Oxford on several occasions, they commissioned him to paint 'The Light of the World', for which they paid him 400 guineas in 1853. Mrs Combe then presented it to Keble College. (The college was founded in memory of John Keble, a prominent Tractarian.)

The Combes' philanthropy extended to providing funds for several buildings in the area, including schools, and St Luke's Chapel at the Radcliffe Infirmary, designed by Sir Arthur Blomfield.

The same architect was commissioned to design St Barnabas' Church, a beautiful Italianate church, with a campanile and an interior based on the cathedral at Torcello in the Venetian lagoon. It is decorated with glowing mosaics and exquisite furnishings of the best craftsmanship, and includes two delightful carvings, one of Thomas Combe himself and the other of his dog Jessie, at the base of one of the pillars in the Lady Chapel. The church was consecrated in 1869.

Thomas Combe died of angina on 29 October 1872 and was buried in nearby St Sepulchre's Cemetery on 6 November 1872. Martha, who continued providing funds for philanthropic causes, lived for another twenty-one years before dying on 27 December 1893. She is buried with her husband.

Martha bequeathed most of her Pre-Raphaelite paintings to the university, and these are now in the Ashmolean Museum, with the notable exception of 'The Light of the World', which is at Keble College.

Sources:

Oxfordshire Blue Plaques Scheme

Hughes, Colin, 'Combe, Thomas (1796–1872)', *Oxford Dictionary of National Biography*, Oxford University Press, 2004 (http://www.oxforddnb.com/view/article/6021, accessed 21 Jan. 2011)

http://www.sbarnabas.org.uk/pdf%20files/St.%20Barnabas%20Guide.pdf

COMBE'S CHARITY SCHOOL

PLAQUE: ST THOMAS'S CHURCHYARD, OXFORD

In 1702, John Combe donated a schoolhouse and garden to be used in the parish of St Thomas, Oxford, for the education of ten poor boys, who were to be chosen by the vicar and churchwardens. He did not, however, furnish them with funds to run the enterprise. It wasn't until 1714 that they were able to count on regular income, when parishioner Ann

Kendall died and left £1 a year to help pay the schoolmaster's salary. In order to make ends meet, the schoolmaster took in paying pupils in addition to the ten boys, and by 1800 there were thirty-three fee-paying schoolboys. By 1868 the school was flourishing with several more fee-paying pupils, who were taught by a master and three pupil teachers.

Source:
 http://www.british-history.ac.uk/report.aspx?compid=22826#s2

SARAH JANE COOPER (1848-1932): *Marmalade maker and grocer*
BLUE PLAQUE: 83 HIGH STREET, OXFORD

One day in 1874, a young woman living in Oxford decided to make a huge batch of marmalade with a large quantity of surplus Seville oranges which she had obtained from her husband's grocery store. She made her preserve according to an old family recipe and filled earthenware jars with the mixture, which she then gave to her spouse to sell in his shop. The marmalade proved to be so popular that she was encouraged to make more. From that moment on there was to be no turning back. The fortuitous combination of her culinary skills and her husband's business acumen ensured that the fledgling enterprise

would become a monumental success. The woman was Sarah Jane Cooper, and her orange conserve, which sold under her husband's name, is famous to this day as Frank Cooper's Oxford Marmalade.

Very soon afterwards, the Coopers found a ready market for their marmalade – not only in Oxford, where academics and students were taking to it with great gusto, but much further afield. It became the mainstay of the English breakfast table and was to be found in all corners of the British Empire. Indeed, it was awarded a Royal Warrant and was enjoyed by several members of the royal family. The great and the mighty of the age followed suit. When Captain Scott went on his ill-fated expedition to the Antarctic, tins of the conserve were found among his provisions after his death.

Sarah Jane was born in 1848 at Beoley, near Redditch, Worcestershire. Her father, John Gill, was a farmer who had originally come from Oxford and still had connections in the city. Her husband, Frank Cooper, whom she married in Bristol in 1872, and with whom she had five children, was born in Oxford, where he had inherited a grocery business located at 83-84 High Street, on the premises of what had once been a coaching inn called the Angel Hotel. The Cooper family lived above the shop until 1907, when they moved to a newly built house in the Woodstock Road, Oxford, but continued to sell their marmalade from their High Street store.

Within a few years, however, with an ever-growing demand for their product both at home and abroad, the Coopers were obliged to move the manufacturing side of the business to a larger building, better suited to producing preserves in large quantities. In 1909, Frank Copper Ltd – as the enterprise had now become – moved to a purpose-built factory (Victoria Buildings in Park End Street, opposite the railway station) where, besides making the world-famous marmalade, it also produced jams, chutney and horseradish sauce. In 1947, the business left this site for another in the Botley Road, before leaving Oxford altogether in 1967 after merging with Brown & Polson Ltd. Today the business is owned by the Premier Group, whose headquarters are in St Albans, Hertfordshire, but the marmalade still bears its distinctive name, which will always be synonymous with Oxford.

The two premises which housed the Coopers' grocery business changed hands several times over the years. Today, the Oxford Bus Co. has a small office at No. 83 High Street. In the 1980s, Frank Cooper Ltd once again took over No. 84 High Street, and established a small museum there. They also sold marmalade, but the enterprise closed a few years later. In 1998, the Grand Café set up a coffee shop on the premises.

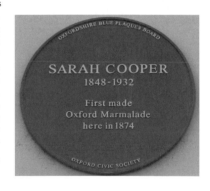

The Coopers prospered greatly from their business. Right up to the end of his life, Frank took an interest in the company and regularly appeared at the factory. He died at home in Oxford on 26 July 1927, and Sarah Jane died five years later.

Sources:

Oxfordshire Blue Plaques Scheme
Allen, Brigid, 'Cooper, Frank (1844-1927)', *Oxford Dictionary of National Biography*, Oxford University Press, 2004 (http://www.oxforddnb.com/view/article/38994, accessed 19 Nov. 2010)
http://www.headington.org.uk/oxon/high/tour/south/084.htm
Hibbert, C. and Hibbert, E. (Eds), *The Encyclopaedia of Oxford*, 1988

CUTTESLOWE WALLS (1934-1959)
BLUE PLAQUE: 34 ALDRICH ROAD, OXFORD

The plaque attached to the wall of 34 Aldrich Road, in what is now a quiet road about 200 yards east of the Banbury Road, celebrates something that no longer exists. It commemorates the destruction of the socially divisive walls which once separated two Oxford communities.

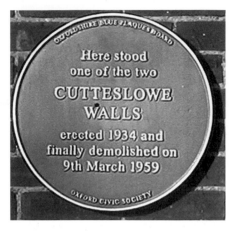

This real-life tale of strife started in the 1930s, when the Corporation of the City of Oxford began building a council estate in Cutteslowe. The estate was built in two phases, the first one completed in 1932, the second in 1934. In the meantime, in 1933, before the second phase was complete, the Corporation sold a strip of land between the estate and the Banbury Road to The Urban Housing Co. for private development. The Managing Director of this company, Clive Saxton, had gone ahead with the purchase of the land after apparently being reassured by the Corporation that no 'slum-clearance' families would be moved into council houses. However, on learning that twenty-eight such families had in fact been settled in these houses, the company proceeded to have two walls erected between the council estate and the private housing, each over two metres high and topped with dangerous spikes. The north wall divided Wolsey Road from Carlton Road; the southern wall did the same for Wentworth Road and Aldrich Road, effectively cutting the council tenants off from direct access to the Banbury Road and obliging them to make a detour of nearly a mile to and from their houses.

In 1935, Abe Lazarus aka 'Bill Firestone', a Communist party member and trade union activist, decided to take up the cause of the council tenants. He produced pamphlets offering help and exhorting Oxford people to pull down the walls. On 11 May that year, witnessed by over 2,000 onlookers, Lazarus, accompanied by a brass band and a group of children, and leading a procession of men shouldering picks, marched to the walls. They were stopped by a cordon of policeman and warned by the Chief Constable to proceed no further. The demonstrators, unable to achieve their objective, dispersed.

In the next few years, the City Council tried to find legal ways of resolving the situation but was thwarted at every turn by different interpretations of the law. In 1938, a Parliamentary Committee ordered the company to demolish the walls, but they refused. Exasperated by the company's intransigence, the council took matters into its own hands and had the walls knocked down. The following day, the company men returned to rebuild the walls, but each time a brick was laid it was pushed over by a council worker. This farcical state of affairs could not continue. Saxton took his case to the High Court, which found in the company's favour, and, once again, the walls were rebuilt. However, they did suffer damage from time to time. Both walls were hit by cars, and during the Second World War one of them was destroyed by mistake when a tank on manoeuvres slammed into it. Each time anything happened, the wall would be rebuilt.

After the war, the Urban Housing Co. sold its remaining assets in the estate to another company, and the City Council, thanks to new compulsory purchase powers given to local government, was able to buy the 9in-strips of ground on which the walls stood. On 9 March 1959, these infamous sources of conflict, hostility and exasperation, finally came down, watched by a jubilant group of local residents, councillors and children.

Sources:

Oxfordshire Blue Plaques Scheme

http://www.bbc.co.uk/oxford/content/articles/2009/03/26/cutteslowe_feature.shtml

http://www.eyes-and-ears.co.uk/pennine/details.asp?Title=The%20Cutteslowe%20Walls

DARWIN PLINTH

In June 1860, the Museum of Natural History in Oxford hosted a debate concerning
Darwin's theory of evolution. To commemorate this event 150 years later, a plinth designed
as part of a competition by Poppy Simonson, a pupil at St Helen and St Katherine's School,
Abingdon, and carved by Oxfordshire sculptor Alec Peever, was unveiled on 11 September
2010 by Professor Andrew Hamilton, Vice Chancellor of Oxford University. The plinth,
which stands outside the main entrance of the museum, is made of limestone and shows
birds, reptiles and animals which feature in Darwin's writings.

Sources:
 http://www.oxfordtimes.co.uk/news/features/8376833.print/
 http://oxford.greatbritishlife.co.uk/article/oxford-preservation-trust-26634/

St Edmund of Abingdon

The first Master and Theologian of this University to
become Archbishop of Canterbury taught in and around
this Church of St Peter-in-the-East during the years
1195-1201 and 1214-1222.

This statue by Rodney Munday was presented by the
St Edmund Hall Association in 2007 on the fiftieth anniversary
of the Royal Charter being granted to the College.

ST EDMUND OF ABINGDON (1175-1240): *Archbishop of Canterbury (1234-1240)*

PLAQUE: ON WALL IN QUEEN'S LANE, FACING ST EDMUND HALL LIBRARY (FORMER
CHURCH OF ST PETER-IN-THE-EAST), OXFORD

STATUE OF ST EDMUND IN GARDEN OF ST EDMUND HALL: VISIBLE FROM QUEEN'S
LANE, OXFORD

Edmund of Abingdon, who became the thirteenth Archbishop of Canterbury, was born in
Abingdon on 20 November 1175. His father, Edward (or Reginald) 'Rich', was a wealthy
merchant and his mother, Mabel, was so pious and austere that her husband preferred in
later life to live in a monastery at Eynsham rather than at home. Edmund was encouraged
by Mabel to fast on bread and water once a week and to wear a hair shirt. Edmund may
have been educated at Abingdon, but it is on record that he spent some years studying
and teaching at Paris as well as Oxford. Edmund was drawn to theology and entered
the priesthood, becoming a Doctor of Divinity. He was famous for his lectures, but a
few years later, tiring of scholasticism, he left Oxford for Salisbury Cathedral where he
became treasurer. In 1227, he preached throughout England in favour of the sixth Crusade.
In 1233 he was appointed Archbishop of Canterbury by Pope Gregory IX, and was
consecrated in 1234. Edmund fell out with King Henry III over the king's appointment of
foreigners to important offices of Church and state. He also promoted the English Church's
independence from Rome and fought against corrupt practices by the clergy. When the
Pope ignored his pleas for ecclesiastical reform, Edmund gave up the fight on behalf of the
National Church and retired to Pontigny Abbey in France. He died on 16 November 1240
at Soisy-Bouy, and his body was brought back to Pontigny for burial. A good and kind man,
who fought corruption wherever he saw it, he was generous to the poor while heedless of
his own comfort. Edmund was canonised in 1247.

St Edmund Hall, or Teddy Hall as it is known within the university, is named after
Edmund of Abingdon. It is the sole survivor of the medieval halls of Oxford and became

a college in relatively recent times (1957). It is believed that when Edmund was a Regent Master in the Arts in the 1190s, he resided and taught in a house located at the western end of the present quadrangle. A seated bronze statue of Edmund, by the distinguished British sculptor Rodney Munday, can be seen from the garden gate in Queen's Lane. It was presented by the St Edmund Hall Association in 2007 to mark the fiftieth anniversary of the Royal Charter being granted to the college.

Sources:

http://www.seh.ox.ac.uk/index.php?section=26
http://www.rodneymunday-sculptor.co.uk/biography.htm
http://www.newadvent.org/cathen/05294a.html
http://www.berkshirehistory.com/bios/erich.html

DANIEL EVANS (1769-1846) AND JOSHUA SYMM (1809-1887): *Oxford builders*

BLUE PLAQUE: 34 ST GILES, OXFORD

That Oxford is one of the world's most beautiful cities goes without saying. What is hardly ever acknowledged is that the charm of the city and university is due in no small measure to those architects and builders who have served her so well. Amongst the best of these have been Daniel Evans and Joshua Symm, who arrived in the city in the nineteenth century and proceeded not only to erect new buildings at Hertford College (then Magdalen Hall), and Exeter College (where the Gilbert Scott Chapel was being built), but took pride in caring for the fabric of some of its most treasured edifices, like the Bodleian Library and Christ Church Cathedral.

DANIEL EVANS:

The details of Daniel Evans's early life are somewhat obscure, but it is thought that he was born possibly in Fairford, Gloucestershire, in about 1769. His first contact with Oxford was as an apprentice to an upholsterer in the High Street, but no one knows when or where he first acquired his building skills. What is known, however, is that he became a Methodist and worked on several chapels for Revd William Jenkins, a Methodist minister and architect. It was through him that Evans undertook his first assignment in Oxford, the building of the Methodist church on a newly acquired site in New Inn Hall Street. The church was begun in 1916 and finished the following year, bringing Evans to the notice of the local community. A series of commissions soon followed, starting with the building of Magdalen Hall in Catte Street (now Hertford College), and several restoration projects, including work on Magdalen College's medieval chapel. In 1829 he leased a large plot of land from John Bull, an eye surgeon, on which he built a block of three elegant houses, faced with Bath stone, and chose to live at No. 34. He established a builders' yard beyond his back garden to store his materials, provide workshop space for his workmen, and stable his horses. Evans died at No. 34 in November 1846 and was buried in the graveyard of the church he built. Today, Nos 34, 35 and 36 St Giles are Grade II listed buildings.

JOSHUA SYMM:

Joshua Robinson Symm, also a Methodist, was born in Allandale, Northumberland in 1809. A stonemason by training, he joined Evans sometime in the 1830s and became his foreman, marrying his only daughter, Elizabeth, and eventually joining him as partner. When Evans died, Symm was able to develop the business still further, under the name of Symm Partnership. The firm constructed several major buildings for both the town and the university, amongst which were George Gilbert Scott's new chapel for Exeter College, Christ Church's Meadow Buildings, designed by T.N. Deane (commissioned by Dean Liddell, father of Alice in Wonderland), and the Head Post Office in St Aldate's, designed

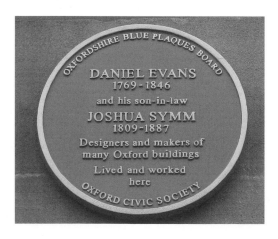

by E.G. Rivers. As a prominent Methodist in the city, Symm was chosen to build a new Methodist chapel in front of the existing one, which had become too small for its ever-growing congregation. The new building in the Gothic style reflected craftsmanship of the first order. One of its stained glass windows was given by Symm in memory of his only daughter Hannah, who died in 1875. Symm died in July 1887, near Allandale, but is buried with his wife and daughter in the Wesleyan chapel he had built. The partnership passed on to Thomas Axtell and Benjamin Hart, who continued to build on the firm's excellent reputation. Symm & Co. became acknowledged experts on stonework and carpentry and were contracted to do restoration work on historical buildings in Oxford, such as the Radcliffe Infirmary and Lincoln College dining hall.

The Axtell family is still strongly connected to the firm. Malcolm Axtell, a fourth generation member of the family, retired in 2010 after forty-nine years with the company, and today the Symm Board Group includes James (Malcolm's elder son) and Tony Byrne (the late Peter Axtell's son-in-law). The Axtell family retain a major shareholding in the firm.

Sources:
 Oxfordshire Blue Plaques Scheme
 Malcolm Axtell in conversation with the author
 Law, Brian R., *Building Oxford's Heritage*, 1998

...

FIRST WESLEYAN MEETING HOUSE AND JOHN WESLEY'S OXFORD
PLAQUE: 32-34 NEW INN HALL STREET, OXFORD

On 14 July 1783, John Wesley, the founder of the Methodist Church, preached a sermon at what is now 32-34 New Inn Hall Street, the first Methodist meeting house in Oxford. He described the building, which belonged then, as now, to Brasenose College, as 'a lightsome, cheerful place, and well fitted with rich and poor, scholars as well as townsmen'. He would return to this attractive location several times more. With an ever-growing congregation, the preaching house grew cramped and, in 1817, a new one was built across the street, on a site behind the present Wesley Memorial Methodist Church.

One cannot write of the Meeting House without reflecting on John Wesley's connection with Oxford, and the part that the city and the university played in his life. As he himself stated, he came 'to love the very sight of Oxford' and established many links with the place. The son of a Church of England rector, Samuel Wesley, and his wife Susanna, he was educated at home and at Charterhouse School, before obtaining an exhibition to Christ Church to read Classics and Logic in 1720, when he was seventeen years old. He enjoyed his undergraduate life, and favoured pastimes such as writing poetry, playing cards and dancing. Wesley graduated in 1724 and was ordained deacon in Christ Church Cathedral the following year. It was at this time that he started to keep a diary in an old red notebook as a means of self-examination in the pursuit of holiness.

In 1726, Wesley was elected Fellow of Lincoln College, much to his father's delight. He found the college a most agreeable and friendly place, despite occupying somewhat cramped rooms in Chapel Quad, facing Turl Street. He obtained his MA in 1727 and was

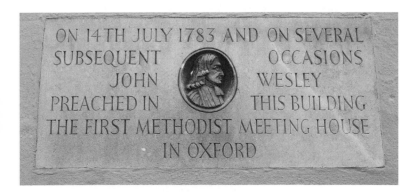

ordained priest on 22 September 1728. Whilst at Lincoln, he would record in his diary the services he took and the daily happenings. For a short time, Wesley helped his father at Wroot, near Doncaster, but returned in November 1729 as tutor in Greek Testament, at what would become a turning point in his life. That same month he joined a small group of individuals from different colleges – led by his younger brother Charles – who met on a regular basis to read the Bible, discuss religious matters, and perform good works, which included daily visits to prisoners in Oxford Castle and Bocardo Prison. It wasn't long before John Wesley was elected leader of 'the Holy Club', or 'Methodists' as this group of men would be called. (The latter term was first used in 1732 to describe those individuals who advocated a certain way, or method, by which to live one's life.)

Wesley preached in many of Oxford's churches, but is mainly associated with St Mary the Virgin, in the High Street, where he gave the University Sermon seven times. However, people were beginning to consider his dedication to religion extreme. Unsparing of himself, he expected very high levels of commitment from others, which led to accusations from academics and others of Methodist excesses. Some members of the group defected and his reputation as a tutor began to suffer.

In 1735, Wesley, accompanied by his brother Charles, set sail for America, where he had accepted a post as chaplain to the English community in Savannah, Georgia. Three years later he was back in England. He underwent an evangelical conversion at a meeting in London, where he felt his heart 'strangely warmed'. This episode marked a change of ideology. From this time on he began his itinerant ministry, preaching the message of salvation by faith alone. Despite being faced with suspicion and hostility wherever he went, he preached in the open air (since he was increasingly being banned from some churches for his beliefs) as he looked upon the whole world as his parish. In 1744 he preached the University Sermon for the last time and was made to feel unwelcome. He didn't sever his official links with Oxford, however, until he married Marie Vazeille in 1751, as married men were not accepted as Fellows at the time. This left him free to pursue his vision of strengthening the Methodist movement, which he did by organising his followers into small 'societies' and establishing chapels in Bristol, London, and of course Oxford, and annual conferences, starting with the first one in London in 1844. The conference would become the ruling body of Methodism.

This early supporter of the anti-slave campaign and champion of the needy was himself a poor man when he died on 2 March 1791. However, he left behind a flourishing Church, not least in Oxford. The present Wesley Memorial Church in New Inn Hall Street was designed by the architect Charles Bell and built by Joshua Symm. It was opened for worship in 1878.

Sources:

Rack, Henry D., 'Wesley, John (1703-1791)', *Oxford Dictionary of National Biography*, Oxford University Press, 2004, online edn, May 2009 (http://www.oxforddnb.com/view/article/29069, accessed 6 Jan. 2011)

http://www.linc.ox.ac.uk/index.php?page=famous+alumni%3Ajohn+wesley+(1703+-+1791)

http://www.methodist.org.uk/

FIRST WORLD WAR MEMORIAL
ST MARGARET'S CHURCH, KINGSTON ROAD, OXFORD

This poignant war memorial stands at the junction of St Margaret Road and Kingston Road. It is based on the Flemish shrines, which troops would have come across when serving in Flanders during the First World War, and was erected soon after the end of the war to remember the forty-seven men of the parish who lost their lives. Most of these men were little more than boys when they died, and some fell as far afield as Turkey, Egypt and Palestine. Twenty-one of them have no known grave.

The figure of Jesus, hanging on the cross under a wooden dome, is made of cast iron. The base is made of limestone and has two bronze plaques inscribed with the names of the forty-seven men.

Sources:

 http://www.headington.org.uk/oxon/stmargaret/
 http://www.stmargaretsoxford.org/thechurch/347/the-war-memorial
 http://www.oxfordmail.co.uk/news/8346411.War_memorial_on_verge_of_collapse/

IRENE FRUDE: *Landlady*

PLAQUE: SOUTH SIDE, WALTON STREET END OF LITTLE CLARENDON STREET, OXFORD

A small plaque set in a wall in a service entry extols the praises of Irene Frude, a much-loved landlady who, for many years, provided very comfortable lodgings for students of Keble College. Alas, the plaque is not well cared for, but it is still possible to discern the Latin inscription, which states:

> HOC IN LOCO IRENE FRUDE COLLEGII KEBLENSIS ALUMNORUM BENIGNISSIMA ALTRIX INGENTISSIMA JENTACULA XXXV FERME PER ANNOS COTIDIE SUPPEDITAVIT CUJUS REI BENE MEMORES EIDEM ALUMNI HOC MONUMENTUM FACIENDUM CURAVERUNT A.D. IV KAL. NOV. MCMLXXVI

'On this site Irene Frude, the most kindly landlady of undergraduates of Keble College, provided each day for almost thirty-five years enormous breakfasts. Some with fond memories of this undertook the placing of this tribute to her on 9 November 1976.'

Source:

 Dr Charles Mould

 Latin translations taken from *Latin in Oxford, Inscriptiones Aliquot Oxonienses*, 1994, compiled by Reginald H. Adams

GANDHI MEMORIAL PLAQUE

PLAQUE: UNIVERSITY PARKS, OXFORD

In 1999, a small memorial plaque placed by a tree and bearing the words 'This tree Koelreuteria Paniculata (Pride of India) was planted to commemorate the 125th anniversary of the birth on 2nd October 1869 of M K Gandhi – an inspiration to us all', was unveiled on 13 July that year. It was the first time that permission was ever given for a plaque to be sited in the University Parks.

 The plaque, which is made of slate, was designed and made by Martin Jennings, a local sculptor, and was unveiled by the late Mr Richard Symonds, an Oxford academic who knew Mr Gandhi personally.

 The Indian Independence leader had links with Oxford and visited Balliol twice in 1931.

Sources:

 http://www.ox.ac.uk/gazette/1998-9/weekly/240998/news/story_3.htm
 http://www.martinjennings.com/sculpture.html

GATHORNE ROBERT GIRDLESTONE (1881-1950): *Pioneering orthopaedic surgeon*

BLUE PLAQUE: NUFFIELD STAFF ACCOMMODATION, 72-74 OLD ROAD, HEADINGTON, OXFORD

A man of great humanity and kindness, G.R. Girdlestone was revered and highly respected, not only for his exceptional skills as an orthopaedic surgeon, but also as a brilliant organiser and administrator. He was largely responsible for setting up both the Nuffield Orthopaedic Centre and the Churchill Hospital in Headington, Oxford. Girdlestone, or GRG as he was known, was the author of several papers, and author of a seminal book *Diseases of the Bone and Joint*, which is still relevant in the field of orthopaedics today. He was instrumental in greatly advancing many musculoskeletal surgical techniques; promoting strict hygienic conditions in hospitals, and improving the recovery of patients.

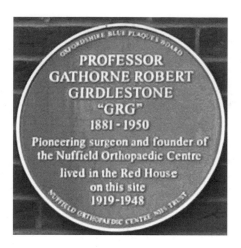

Gathorne Robert Girdlestone was born on 8 October 1881 at Wycliffe Hall, Banbury Road, Oxford where his father, Revd R.B. Girdlestone, was Principal. He was educated at Charterhouse School, and New College, Oxford, where he read medicine. He subsequently did his clinical training at St Thomas's Hospital, London, and, shortly after qualifying in 1908, moved to Oswestry, Shropshire, with his wife Ina Mabel Chatterton, whom he had married in 1909.

It was in Oswestry, whilst working as a general practitioner and surgeon, that he came across Robert Jones and Agnes Hunt at nearby Baschurch Orthopaedic Hospital; their pioneering work with children who had been crippled by tuberculosis was a revelation to him. Influenced by their groundbreaking treatments, he decided to specialise in orthopaedic surgery, which at that time was a little-known branch of medicine.

During the First World War, Girdlestone served in the Royal Army Medical Corps, and found himself back in Oxford in charge of the military orthopaedic centre established at the Wingfield Convalescent Home in Headington. After the war, with fewer older people needing help, it was decided to admit disabled children to this auxiliary hospital which, in 1921, was renamed the Wingfield Orthopaedic Hospital.

In 1920, Girdlestone and his wife moved to the Red House, in nearby Old Road, so that they could be close to the hospital, and it was here that one day in 1930 Ina Girdlestone opened her door to find a stranger on the doorstep. This man was William Morris (later Lord Nuffield). Morris had heard of Girdlestone's orthopaedic work and had decided to support the hospital. The strong friendship which ensued between the two men was to bring enormous benefits to the local community. On Girdlestone's advice, Morris extended his generosity to encompass several schemes, including the rebuilding of the Wingfield, which was opened in 1933 and renamed the Wingfield-Morris Orthopaedic Hospital (later renamed the Nuffield Orthopaedic Hospital). When Morris gave £2,000,000 to establish five medical Chairs at Oxford University, Girdlestone became the first Nuffield Professor of Orthopaedic Surgery in 1937. When he retired from the Chair in 1940, he was elected President of the British Orthopaedic Association. He was also adviser to the Ministry of Pensions and consultant to the army.

When Girdlestone retired fully in 1948, he and Ina decided reluctantly to leave the Red House, which had been their home for twenty-eight happy years, to settle in the village of Frilford Heath. Ever mindful of other people's welfare, Girdlestone arranged for Nuffield to buy his old home in order to donate it to the hospital. The Red House served as housing for nursing staff before being demolished in 2005 to make way for health worker accommodation.

After living a full life of service and dedication to others, which was underpinned by a strong Christian faith, G.R. Girdlestone died in 1950. Two streets in Headington, Gathorne and Girdlestone, which are named after him, bear witness to the high esteem in which he was held. *See* also William Morris, Lord Nuffield entry.

Sources:

Oxfordshire Blue Plaques Scheme

Seddon, H.J., 'Girdlestone, Gathorne Robert (1881-1950)', rev. *Oxford Dictionary of National Biography*, Oxford University Press, 2004 (http://www.oxforddnb.com/view/article/33413, accessed 19 Jan. 2011)

http://www.clinorthop.org/journal/11999/466/2/82_10.1007_s11999-007-0082-6/2007/Acute_Pyogenic_Arthritis_of_the_Hip_An_Operation_.html

http://www.headington.org.uk/history/famous_people/girdlestone.htm

http://web.jbjs.org.uk/cgi/reprint/30-B/1/187.pdf

EDMUND ARNOLD GREENING LAMBORN (1877-1950): *Headmaster, local historian*

BLUE PLAQUE: 34 OXFORD ROAD, LITTLEMORE

Edmund Arnold Greening Lamborn, one of Oxford's most remarkable sons, spent the whole of his life in and around Oxford. His passion for nature, history and old buildings in the local environment led him to amass an abundance of fascinating and scholarly facts, which he generously shared with academics and laymen alike. What is surprising is that Greening Lamborn did not have the benefit of a university education, but was so respected by the academic community that in 1921 he was awarded an honorary Oxford University MA.

Greening Lamborn, the son of Arnold Edwin Lamborn and Susanna Greening, a farmer's daughter, was born in 1877 and brought up in what was then the sleepy village of Cowley. He started his working life as a pupil teacher and showed such an aptitude for teaching that he soon became headmaster of St Mary Magdalen Boys' School, Gloucester Green, moving to East Oxford Council Boys' School, Collins Street in 1909. A man of formidable intellect, Greening Lamborn was a progressive teacher who expected high academic standards. Known affectionately to his pupils as Ikey, he was once described as the greatest teacher in England. People interested in education came from far and wide to inspect his school and study his methods.

Greening Lamborn's interests were many. He was passionate about history, heraldry, archaeology and architecture, publishing a number of articles and books on his favourite subjects. One of the most popular is *The Story of Architecture in Oxford Stone*, published in 1912. Greening Lamborn showed his understanding of other areas of knowledge, such as

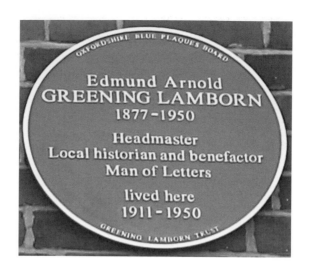

poetry and grammar, when publishing such books as *The Rudiments of Criticism* in 1923. He liked to be known as a 'man of letters'. He was also most particular regarding his name. If anyone spelt it incorrectly on an envelope then he would not read the contents, which makes it somewhat ironic that a road in Oxford which is named after him is spelt Lambourn.

Greening Lamborn lived at 34 Oxford Road, Littlemore, from 1911 until 1950, the year of his death. Today, his name is kept alive by the Greening Lamborn Trust, which seeks to 'promote public interest in the history, architecture, old photographs, and heraldry of Oxford and its neighbourhood'. Greening Lamborn's learning and scholarship has been of inestimable value to individuals and societies involved in the study of local history. His careful researches have been a major source of information and knowledge.

'The best self-trained archaeologist in the British Isles regarded as the greatest antiquary since Antony Wood' is how Edmund Arnold Greening Lamborn was described in his obituary in *The Oxford Times*. This was a fitting tribute to a man who, by his own admission, had spent his whole life dealing directly with local themes.

Sources:
http://www.oxfordshireblueplaques.org.uk/plaques/lamborn.html
http://oxoniensia.org/oxo_links.php
http://news.bbc.co.uk/local/oxford/hi/people_and_places/history/newsid_9005000/9005847.stm

..

J.S. HALDANE (1860-1936): *Physiologist*
BLUE PLAQUE: 11 CRICK ROAD, OXFORD

John Scott Haldane was a brilliant scientist with a keen and questioning mind. Haldane was not satisfied with purely theoretical research, and conducted several dangerous experiments on himself, the most hazardous of which were the ones connected with the effects of carbon monoxide on his own body. He was an authority on respiration, pulmonary diseases and bacterial contamination. His studies in physiology, and his expertise in observing the hazardous nature of some occupations, led him to design life-saving equipment for miners, divers and mountain climbers. He also invented the first gas mask to be issued during the First World War.

J.S. Haldane was born at home in Edinburgh on 23 May 1860. His father Robert was a member of a prominent Scottish family, and his mother Mary Elizabeth was the sister of the eminent Oxford scientist John Robert Burdon-Sanderson, the first Waynflete Professor at Oxford University. Haldane was educated at Edinburgh Academy and at the Universities of Edinburgh and Jena, Germany, and qualified as a medical practitioner in 1883.

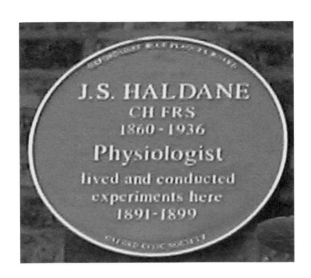

He moved to Oxford for the first time in 1884, when his uncle, J.R. Burdon-Sanderson, invited him to be one of his demonstrators in the Department of Physiology at Oxford. His research at the university excited his interest in the field of physiology, and would later lead him to apply his scientific findings to industrial occupations such as mining and diving. After a short spell away from the university, working on the analysis of air quality at University College, Dundee, Haldane returned to work in the same department in 1887. His long association with Oxford was to last a further twenty-six years, during which time he was elected lecturer, Fellow of New College and Reader in Physiology at the university.

In 1891 he married Louisa Kathleen Trotter. The couple moved to 11 Crick Road, where they lived for the next eight years, and it was here that Haldane did much of his important early work on gases. It was during this time that the Haldane children were born – John in 1892, and Naomi in 1897. John became an eminent scientist, and Naomi, under her married name of Mitchison, became a prolific writer and poet. The family moved to a larger house, 'Cherwell' in Linton Road, where, in 1907, a laboratory was added so that Haldane could conduct experiments from home. 'Cherwell' has since been demolished and the site is now part of Wolfson College.

The years in Oxford were very busy ones for Haldane. He was by now involved in researching industrial diseases and inventing safety equipment to protect workers. Haldane investigated mining disasters, where fire and explosions were causing severe loss of life amongst miners, and discovered that many of them were dying mainly from carbon monoxide poisoning following the blasts, and not from the initial explosion. In order to improve safety, he developed the use of canaries and mice in mines as a way of detecting dangerous levels of this gas, as these small creatures succumbed more quickly than humans to carbon monoxide in the atmosphere. He also designed safety equipment for rescuers. He was Director of the Mining Research Laboratory and was elected President of the English Institution of Mining Engineers in 1924.

After studying the effects of decompression sickness, or 'the bends', on deep-sea divers – which was caused by nitrogen bubbles in the blood – Haldane produced the first decompression tablets for divers' use and designed apparatus to help them come to the surface safely. Haldane also turned his attention to altitude sickness, examining the effects of low atmospheric pressure on respiration. Other investigations centred on the effects of contaminated air in enclosed spaces. He was also co-founder of the *Journal of Hygiene*.

Haldane was working right up to his death at the age of seventy-five. He was taken ill with pneumonia, but, despite being treated in an oxygen tent, which was one of his inventions, the years of excessively hard work, late nights, and hazardous experiments on his own person took their toll on his body, and he died at home at midnight on 14 March 1936.

J.R. Haldane was an exceptional scientist, whose many achievements were reflected in the various senior posts to which he was appointed, the numerous honorary degrees he was

awarded and the prestigious honours conferred upon him. He was a Fellow of the Royal Society and holder of the prestigious Copley Medal; in 1928 he was made Companion of Honour for his scientific work.

Sources:

Oxfordshire Blue Plaques Scheme

Sturdy, Steve, 'Haldane, John Scott (1860-1936)', *Oxford Dictionary of National Biography*, Oxford University Press, 2004 (http://www.oxforddnb.com/view/article/33642, accessed 19 Jan. 2011)

http://www.oxfordtimes.co.uk/lifestyle/food/profiles/4466307.Send_in_the_canaries/

. .

EDMUND (*also* EDMOND) HALLEY (1656-1742): *Astronomer and mathematician*
PLAQUE: 7 NEW COLLEGE LANE, OXFORD

Were it not for the very handsome plaque commemorating the name of one of Oxford University's most eminent seventeenth-century scientists, the astronomer Edmund Halley, the casual visitor could be excused for ignoring the unobtrusive building in New College Lane which was once his residence and observatory. It was in this building that Halley did much of his astronomical observations, leading to the 1705 publication of *A Synopsis of the Astronomy of Comets*. In this work he calculated the orbit of the comet which now bears his name, and predicted its return.

Halley, whose father was a wealthy merchant, was born on 8 November 1656. He showed an early interest in astronomy at St Paul's School and, soon after entering Queen's College, Oxford, published papers on the solar system and the stars. His excellent work brought him

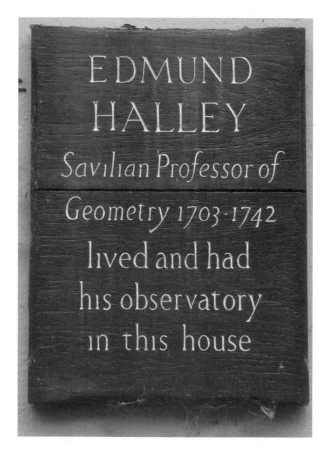

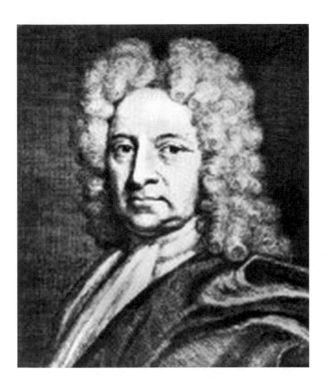

to the notice of John Flamsteed, Britain's first Astronomer Royal, who encouraged him in his observations and research. Halley, too, was inspired by Flamsteed's catalogue of the stars of the northern hemisphere, and left the university without a degree in 1676, to spend two years mapping the southern skies on the island of St Helena. On his return to England in 1678, he catalogued his findings and published them in 1679 as *Catalogus Stellarum Australium* – much to Flamsteed's dismay. Flamsteed criticised his findings for being too rushed, and from that time on the two men would never again collaborate. That same year, Halley's Oxford University degree was conferred on him by command of King Charles II, and he was elected Fellow of the Royal Society at the very young age of twenty-two.

Halley did not restrict his studies to astronomy but worked on a number of other subjects. The breadth of his interests included investigating such diverse fields of study as the Earth's magnetic field, the optics of the rainbow, and ways of staying underwater (he built one of the earliest ever diving suits). He also made the first map of the world's winds and invented a magnetic compass. Halley collaborated with a number of other eminent scientists, including Christopher Wren, Robert Hooke and Isaac Newton. The latter would not have published his seminal work *Principia Mathematica* without Halley's encouragement. Indeed, Halley paid for the book to be published.

In 1704 he was appointed Savilian Professor of Geometry at Oxford, a post which included living accommodation in New College Lane. David Gregory, the Savilian Professor of Astronomy, was meant to live in the house that Halley was offered, but preferred another dwelling in the lane, which allowed Halley to move into the one which is now No. 7. Halley had the use of this house till 1740, the year that he was appointed Astronomer Royal, a position which he was to hold until his death at Greenwich on 14 January 1742. He was buried with his wife Mary, who had predeceased him, in the churchyard of St Margaret's, Lee, not far from the observatory.

Sources:

http://www.oxforddnb.com/view/article/12011
http://www.mhs.ox.ac.uk/features/walk/intro.htm
http://en.wikipedia.org/wiki/Savilian_Professor_of_Geometry

NORMAN HEATLEY (1911-2004): *Biochemist, key member of Oxford penicillin team*
BLUE PLAQUE: 12 OXFORD ROAD, OLD MARSTON, OXFORD

'Without Fleming no Florey or Chain, without Chain no Florey, without Florey no Heatley, without Heatley no penicillin.' These words, uttered in a speech in 1998 by Sir Henry Harris, sum up the immeasurable debt the world owes to Norman Heatley. As a key member of Howard Florey's research team of scientists at Oxford University's School of Pathology in the 1930s and '40s, this quiet, modest man helped establish penicillin as the miracle drug of the twentieth century.

Norman Heatley, the son of veterinary surgeon Thomas Heatley and his wife Grace, was born in Woodbridge, Suffolk, on 10 January 1911. While still a boy, his interest in science was sparked by a guest speaker at his school. This lifelong passion for science was fostered by an excellent teacher when he later attended Tonbridge School. It was only natural, therefore, that when he went to Cambridge University he would graduate in Natural Sciences and stay on to do research for a PhD in Biochemistry. Soon afterwards he was invited to join a group of interdisciplinary scientists, who were busy working on the development of penicillin at the Sir William Dunn School of Pathology, under the leadership of the brilliant Australian pathologist Howard Florey.

A few years before, Alexander Fleming had discovered penicillin by accident but hadn't pursued his findings further, and it was left to this team to develop the antibiotic and surmount the challenge of producing it in large quantities. Before penicillin was developed, blood poisoning and fevers would routinely lead to amputations or death.

Heatley, a brilliant scientist and technical wizard, rose to the numerous challenges faced by the team. He devised an assay method to measure precisely the activity of penicillin, now known as the 'Oxford unit', and developed a way of extracting penicillin from its mould and purifying it. He was also able to increase the concentration of its final form. These successful outcomes enabled the scientists to check the antibiotic's efficacy by observing its effects on mice. Satisfied that penicillin was effective on small animals, the next objective was to produce sufficient quantities of it to try on human patients – but finding enough equipment to grow the penicillium culture in the 1940s, when Britain was at war, proved somewhat difficult. Heatley improvised by making use of discarded old tins, and hospital bedpans, before designing his own ceramic 'bedpans', which were then specially made for the laboratory. The culture grown in these receptacles supplied a small amount of penicillin, which the team was able to trial on patients at the Radcliffe Infirmary. These trials confirmed that the antibiotic was indeed viable for treating humans. However, the amounts of penicillin produced were still minute, so Florey and Heatley travelled to the USA in July 1941 to ask for assistance in producing large-scale quantities, since no pharmaceutical companies in the UK at the time were able to help. Heatley stayed in the

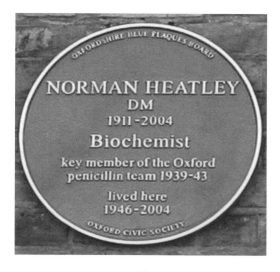

States for several months, working in laboratories in Peoria, Illinois and at Merck & Co. in Rahway, New Jersey, before returning home in July 1942.

On his return to Oxford, fearing that his contract had come to an end, Heatley accepted a post elsewhere, but was persuaded by Florey to continue researching antibiotics at Oxford. In 1948 he became one of the first Penicillin Fellows at Lincoln College, where he remained until his retirement in 1978, the year he was awarded an OBE. In 1991, Heatley was awarded an honorary doctorate in medicine from the University of Oxford, one of only two non-medical people in the university's history to have been so honoured.

Heatley's contributions to the penicillin project were vital, and there are many scientists and others who are convinced that he should have been the third member of the team, alongside Howard Florey and Ernst Chain, to have been awarded the Nobel Prize. Heatley, a very modest man, was less concerned that the award had eluded him than that he had helped alleviate human suffering. As a key member of the team which had contributed greatly to the development of penicillin, he was aware that the drug has benefited countless millions of people round the world. A humanitarian to the end of his life, he was always looking for ways of helping others. His last compassionate charitable enterprise was to send penicillin to sick children in Iraq.

In retirement, Heatley continued to live at the family home at 12 Oxford Road, Old Marston, together with his devoted wife Mercy, a paediatric psychiatrist. The couple moved to this house in 1946, shortly after their marriage in 1944, and raised their children there. Heatley was a loving family man and a wonderful host, welcoming generations of students and friends to his home. Ever practical, he enjoyed spending time in his shed, making or amending gadgets. He also took great delight in birdwatching. This modest, kind and considerate man died on 5 January 2004. He was buried in a biodegradable coffin, after a service at St Nicholas' Church, Marston.

Sources:

Oxfordshire Blue Plaques Scheme

Sidebottom, Eric, 'Heatley, Norman George (1911-2004)', *Oxford Dictionary of National Biography*, Oxford University Press, Jan. 2008; online edn, Jan. 2011 (http://www.oxforddnb.com/view/article/93128, accessed 12 Dec. 2010)

http://www.headington.org.uk/history/marston_history/famous_people/heatley_norman.html

DOROTHY CROWFOOT HODGKIN (1910-1994): *Chemist*
PLAQUE: PHYSICAL CHEMISTRY LABORATORY, SOUTH PARKS ROAD, OXFORD

Dorothy Hodgkin was a truly remarkable woman. An outstanding chemist, who through her pioneering work in X-ray crystallography was able to reveal the structures of biologically important molecules in penicillin, Vitamin B12, cholesterol and insulin, she was the first British woman scientist to be awarded the Nobel Prize for Chemistry in 1964. She was also a much-loved teacher and colleague, and a staunch champion of humanitarian causes.

Dorothy Mary Hodgkin (*née* Crowfoot) was born on 12 May 1910 in Cairo, Egypt. Her father, John Winter Crowfoot, worked in the Education Service in Egypt and the Sudan. He was an accomplished archaeologist, becoming in time Director of the British School of Archaeology in Jerusalem. Her mother, Grace Mary (Hood), known as Molly, became an expert in her own right in early weaving techniques, and was a talented amateur botanist. Dorothy, who was the eldest of four daughters, spent much of her childhood with relatives in Norfolk, whilst her parents were abroad.

At an early age she developed a flair for chemistry, which she studied at her secondary school, the Sir John Leman School in Beccles. At the time it was considered a subject exclusively for boys, despite the fact that the teacher was a woman, but Dorothy was allowed to take it up. When she visited her mother during the vacation, Molly gave her a chemistry book, *Concerning the Nature of Things*, by Sir William Bragg, which explained the use of X-rays in examining atoms and molecules. A family friend in Khartoum, Dr A.F. Joseph, encouraged her further still by giving her a box of chemicals and a mineral analysis kit, which she made use of to analyse the mineral ilmenite.

Dorothy came up to Somerville College, Oxford, in 1928 to read chemistry, studying X-ray crystallography – a relatively new technology – in her fourth year. Whilst studying for her undergraduate degree she took an active interest in archaeology, and analysed some ancient coloured glass sent to her from Palestine by her parents. As an undergraduate at Somerville, Dorothy became devoted to Margery Fry, the Principal of the college and a friend of her family, who supported several social causes, including penal reform and world peace. Her ideals would influence Dorothy's own view of the world. All her life she would advocate peace, becoming President of the Pugwash Conferences on Science and World Affairs in 1975, and joining the Campaign for Nuclear Disarmament.

After graduating from Oxford with a First Class Honours degree, Dorothy went to Cambridge in 1933, where she began her doctoral studies under John Bernal, who had trained under Sir William Bragg. Together they worked on using crystallography to determine the three-dimensional structure of several complex organic molecules (up to that time, crystallography had been used on inorganic molecules), taking the first X-ray photographs of single crystals of the protein pepsin.

National Historic Chemical Landmark

The work of Dorothy Crowfoot Hodgkin
at the University of Oxford

In this building from 1956–1972 and at other times elsewhere in the Oxford Science Area, Professor Dorothy Crowfoot Hodgkin, (1910–1994) OM, FRS, Nobel Laureate, led pioneering work on the structures of antibiotics, vitamins and proteins, including penicillin, vitamin B12 and insulin, using X–ray diffraction techniques. Many methods for solving crystal structures were developed taking advantage of digital computers from the very earliest days. The work provided a basis for much of present day molecular structure driven molecular biology and medicinal chemistry.

14 May 2001 RS•C

In 1934, Dorothy was back in Oxford as a tutor and Fellow, continuing the work begun at Cambridge with Bernal, forming a research group in X-ray analysis and increasing the number of students studying natural sciences at Somerville. It was during this time that she produced the first X-ray photograph of insulin. Her work on insulin would take her thirty-four years to complete, but in 1969 she solved the structure of insulin. Ever a pioneering scientist, she was an early proponent of computers, using them in her research into insulin.

In 1937 she received her PhD. It was a very momentous year for her. While visiting Margery Fry in London, she met Thomas Lionel Hodgkin, who had just left the Colonial Office and was training to become a teacher. Despite being in love with Bernal, who was already married, she accepted Hodgkin's proposal and married him on 16 December 1937. She and Hodgkin went on to have three children: Luke, Elizabeth and Toby. The family lived in a flat in Bradmore Road, north Oxford, moving to a large house in the Woodstock Road in 1957. In the early years of their marriage, Hodgkin worked away from Oxford during the week and Dorothy employed help so that she could carry on working. In 1945 Hodgkin, a member of the Communist Party, was back in Oxford, having obtained a post as secretary to the university's delegacy of extramural studies, but resigned a few years later in order to devote himself to the history and politics of the African world, becoming Director of the Institute of African Studies at the University of Ghana. Dorothy shared her husband's profound interest in Africa and would visit him during vacations. Hodgkin died in 1982.

Dorothy continued her work on insulin in the 1940s, at the same time collaborating with Ernst Chain and Edward Abraham in establishing the structure of penicillin, describing the arrangements of its atoms in three-dimensions. This very important finding in 1945 was followed in 1948 with research into the structure of vitamin B12 (a lack of which caused pernicious anaemia), which was an enormously complex molecule. It wasn't until 1957, however, that Dorothy and her colleagues were able to solve the full structure of vitamin B12. In 1947, at the comparatively young age of thirty-seven, she was elected a Fellow of the Royal Society. In 1960 she was appointed Wolfson Research Professor by the Royal Society.

In 1964, Dorothy Hodgkin was the first British woman scientist to be awarded the Nobel Prize for science, in this case, chemistry. It was given in recognition of 'her determinations by X-ray techniques of the structures of important biochemical substances', namely

penicillin and vitamin B12. In 1965 she was awarded the Order of Merit. Apart from these awards, she was a recipient of the Copley Medal of the Royal Society and the Lenin Peace Prize, and was Chancellor of Bristol University from 1970-1988. From 1977-1978 she was President of the British Association for the Advancement of Science.

Dorothy retired from her university post in 1977, but would still work in the crystallography department, continuing her work on insulin until 1988 when she gave up most of her commitments because of ill health. Her arthritis made it increasingly difficult to walk and she started to use a wheelchair to get round. In 1993 she made a supreme effort to visit China, but on 29 July 1994, two weeks after a fall, she died at home at Crab Mill, Ilmington Warwickshire. She was buried in the churchyard of St Mary, in Ilmington, and a memorial service was held for her at the University Church of St Mary the Virgin, in Oxford. Many eminent individuals, including Baroness Thatcher (who, as Margaret Roberts, had been her one-time student), Sir Isaiah Berlin and Max Perutz, joined her family and friends to celebrate the life of a brilliant scientist and a compassionate humanitarian.

Sources:

Ferry, Georgina, 'Hodgkin, Dorothy Mary Crowfoot (1910-1994)', *Oxford Dictionary of National Biography*, Oxford University Press, 2004; online edn, May 2009 (http://www.oxforddnb.com/view/article/55028, accessed 20 Jan. 2011)

MLA style: 'Dorothy Crowfoot Hodgkin – Biography'. Nobelprize.org. 20 12 2010 http://nobelprize.org/nobel_prizes/chemistry/laureates/1964/hodgkin-bio.html

INSPECTOR MORSE

PLAQUE: OXFORD POLICE STATION, ST ALDATE'S, OXFORD

It could be argued that the fictional Inspector Morse, hero of author Colin Dexter's series of best-selling novels and star of thirty-three feature-length films for the small screen, has done more for Oxford's reputation as a centre of learning than many a fusty old academic – even if the body count in the city is somewhat excessive! With his sharp and incisive intellect, love of classical music and ale, and expertise in solving crimes and crosswords, Morse, as portrayed in films by the late John Thaw, is the embodiment of a certain type of complex, world-weary but very attractive Englishman.

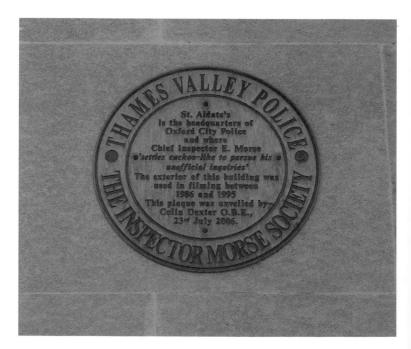

Morse and Oxford are synonymous with each other. The character of Inspector Morse may have been killed off in 1999 in 'The Remorseful Day', but the memory of the man is commemorated by a plaque at St Aldate's police station, Oxford. The plaque was the idea of the Inspector Morse Society, and was unveiled by Colin Dexter on 25 July 2006, to the delight of the many fans from all over the world who still come flocking to the police station in the hope of seeing their favourite detective.

Colin Dexter, who enjoyed making cameo appearances in the films, has lived in Oxford since 1966, and his love of the city is reflected in the way it is portrayed in his novels. He too enjoys music and crosswords but, unlike his most famous character, he is genial and approachable. In 2000 he was awarded an OBE for his services to literature.

..

CECIL JACKSON-COLE (1901-1979): *Philanthropist and founding member of Oxfam*
BLUE PLAQUE: 17 BROAD STREET, OXFORD

PLAQUE COMMEMORATING THE FIRST MEETING OF OXFAM IN THE OLD LIBRARY OF ST MARY THE VIRGIN CHURCH: 25 HIGH STREET, OXFORD

Cecil Jackson-Cole, a self-made man and devout Christian, spent most of his working life involved with charitable work. He was a man of vision, whose aim was to relieve suffering in the world by improving the lives of the needy and disadvantaged through links with the business world. Jackson-Cole was instrumental in establishing links between charities and the world of commerce, in order to bring the latter's expertise to the aid of the former. He worked tirelessly to encourage individuals with public-spirited ideals, especially young Christian men and women, to play a part in the running of charities, and to this end he formed links between businesses, trusts and charities. Jackson-Cole was a founder member of Oxfam.

Cecil Jackson-Cole (baptised Albert Cecil Cole) was born on 1 November 1901 at Forest Gate, London. His father, Albert Edward, was a furniture dealer; his mother, Nellie Jackson, was his father's cousin, and Cecil was devoted to her. (On her death in 1927 he added her maiden name to his surname and believed she was in contact with him, a belief he would carry all his life.) The nature of his father's business meant that his family led a peripatetic lifestyle, with the young Cecil moving from house to house and school to school. Jackson-Cole started work at the age of thirteen, where he showed an early flair for business. By the time he was eighteen he owned the first of his four shops – a furnishings store, Andrews, in Islington – followed later by two others in London and one in Oxford.

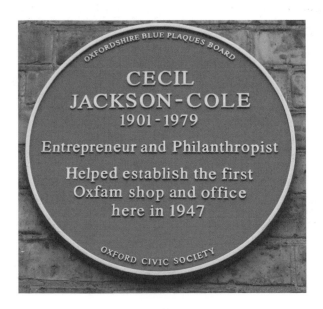

Having set up a successful business, Jackson-Cole turned his energies to study and, at the age of twenty-seven, enrolled as an external student at Balliol College, Oxford, where he read economics for a year. In 1937 he married his cousin, Phyllis Emily Cole (died 1956).

In 1942 Jackson-Cole, who was a pacifist and lived by his deep-felt Christian ideals, was greatly affected by the plight of the people of Greece, who were dying of starvation as a result of their country's occupation by the Axis Powers during the Second World War and the ensuing Allied blockade. He joined forces with a number of other concerned citizens, including Canon Theodore Milford (1896-1987) and a group of Oxford Quakers, to form the Oxford Committee for Famine Relief, now known as Oxfam. At the first public meeting of the new charity, which was held at the University Church of Saint Mary the Virgin in Oxford (where Canon Milford was then vicar), Jackson-Cole was elected Secretary, a post he held till his death. In the early years, the charity's work took place in

Europe, but thanks to his brilliant organisational skills and innovative approach, Oxfam expanded into a global charity. The charity's name was changed to Oxfam International in 1995, to reflect its role as a confederation of fifteen international members. These are: Australia, Belgium, Canada, France, Germany, Great Britain, Hong Kong, India, Ireland, Mexico, the Netherlands, New Zealand, Quebec, Spain and the United States.

In 1947, Oxfam opened its first shop at 17 Broad Street, Oxford. It is still in business today, where it is a popular port of call for locals, students and visitors. The site also served as Oxfam's headquarters, but once the charity expanded it was obliged to move to larger premises in Banbury Road. Today, Oxfam's head office is in Cowley Business Park.

Shortly after the war, Jackson-Cole set up an estate agency, Andrews & Partners, where he employed a number of individuals who shared his philanthropic ideals. He encouraged them to establish and maintain strong links with charities. His ethical values are embedded in the company's business philosophy to this day. He also established and funded several philanthropic trusts and charities. He founded Help the Aged (now merged with Age Concern to form Age UK) and the Anchor Housing Association (now known as Anchor) to provide sheltered accommodation for the elderly.

Cecil Jackson-Cole retained his links with Oxfam right up to the year of his death. A man of strong principles, he ignored any honours he was offered and died at Burrswood, Groombridge, Kent, on 9 August 1979, attended by his second wife, Mary Theodora Handley.

Sources:

Oxfordshire Blue Plaques Scheme

http://www.oxforddnb.com/view/article/31280

http://www.oxfam.org/en/about/history

http://www.andrewsonline.co.uk/about-us/unique-history.aspx

··

JEWISH OXFORD

PLAQUES. TOWN HALL, ST ALDATE'S, OXFORD; BLUE BOAR STREET, OXFORD
PLAQUE COMMEMORATING JEWISH CEMETERY: BOTANIC GARDEN, OXFORD
PLAQUE COMMEMORATING JACOB'S COFFEE SHOP: 84 HIGH STREET, OXFORD

Oxford's Jewish history goes back to Norman times and encompasses both the city and the university. Jews first arrived in England at the invitation of William the Conqueror, who valued their mercantile expertise. Most of these merchants came from Rouen and settled in London to begin with, and then went to other towns. By the 1140s there was a well-established Jewish community in Oxford, with Jews settling mainly in the area called Great Jewry. This area is known today as St Aldate's, and extends from Carfax to Folly Bridge.

Two plaques on the Town Hall's walls, one in St Aldate's, the other in Blue Boar Street, confirm the presence and importance of the Jews in medieval Oxford. The plaque in St Aldate's is inscribed with the information that the area known as Great Jewry contained a number of properties belonging to the community. This neighbourhood would have included the synagogue, which lay to the north of Christ Church's Tom Tower. (In the thirteenth century, Copin, a prominent member of the Jewish community, owned a number of houses near this site, some of which he probably rented out to St Frideswide's Priory.) The second plaque, in Blue Boar Street, refers to the fact that the Town Hall itself stands on land that was once at the heart of the medieval Jewish Quarter. One part of it belonged to Moses, son of Isaac. In 1229, the king gave it to the town so that the merchants could build a guildhall. The other side was owned by David of Oxford until his death, after which the income which was generated from the site was used to maintain the House of Converts in London. On the opposite side of the street, where today's St Aldate's meets Carfax, a building known as Jacob's Hall used to stand. It was one of the grandest thirteenth-century properties of Oxford and belonged to a wealthy businessman, rabbi and scholar.

More Jewish properties were to be found in Pennyfarthing Lane, now Pembroke Street, where Rabbi Moses of Oxford, a great Jewish scholar, once lived; Lombard Lane, now Brewer Street; and other parts of central Oxford. Outside the eastern city gate, on what is today the Botanic Garden and part of Magdalen College, land was acquired for a Jewish cemetery. A plaque attached to the gates of the Botanic Garden reminds visitors of the fact.

> This extension to the Town Hall stands on land
> at the centre of the Anglo-Saxon town, later the
> heart of the Medieval Jewish Quarter and fronts
> a new street laid out by Christ Church in 1553.
>
> This plaque records a joint project by
> Oxford City Council and Amey Building,
> November 1995.

On exiting the garden via the gate in Rose Lane, the path that is followed along the back wall of Merton College is known as Deadman's Walk because Jewish funeral processions would proceed from Great Jewry to the burial ground along this route. Part of the site on which Merton College now stands, known at the time as Bek's Hall, was sold to the founder of the college, Walter de Merton, in 1266, by Jacob of London.

In medieval times, many trades and professions were barred to Jews, but they were allowed to be doctors, landowners, moneylenders and pawnbrokers. They were also accepted as teachers of Hebrew. Judaic scholars, such as Rabbi Moses, were highly respected and esteemed by academics at the university – men like Robert Grosseteste and Roger Bacon, who were interested in the interpretation of Hebrew texts and who admired their learning.

Oxford's Jewish community, although prosperous, was subject to heavy taxation and confiscation of property by the Crown. By the thirteenth century, everyday life became increasingly difficult, with punitive taxes which impoverished many and led others to flee the country, so that by 1290, when King Edward I expelled the Jews from England, fewer than 100 resided in the town.

Jews returned to Oxford in the seventeenth century, after they were readmitted to England in 1655 under Cromwell's Protectorate. At first the community, which included merchants, was very small. It included Jacob – who established the first coffee house in England in 1651, at what was then the Angel Inn and is now 84 High Street – and Cirques Jobson, who opened another on the corner of Queen's Lane and High Street in 1654. By the 1730s, a small community of Jews was established at St Clements, where they integrated with the local population. The modern community, however, dates from the nineteenth century. After the University Reform Act of 1854 allowed non-Anglicans to enter the university and receive degrees, a number of Jewish students started studying at Oxford, and, after 1871 when all clerical restrictions were lifted, the way was open for them to hold Fellowships. In 1972, Yarnton Manor, just outside Oxford, was founded to expand Hebrew and Jewish studies at the university.

A number of very eminent academics have been connected with Oxford, including Sir Hans Krebs, Sir Isaiah Berlin and Sir Francis Simon (*see* individual entries), and one of the world's greatest collections of historic Jewish books and Hebrew manuscripts is housed in the university's Bodleian Library.

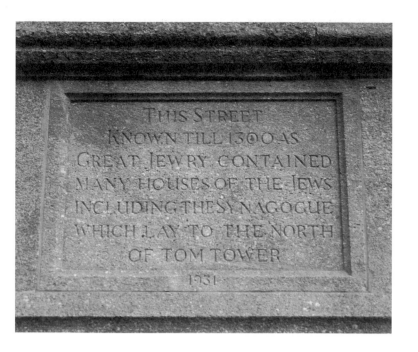

THIS STREET
KNOWN TILL 1300 AS
GREAT JEWRY CONTAINED
MANY HOUSES OF THE JEWS
INCLUDING THE SYNAGOGUE
WHICH LAY TO THE NORTH
OF TOM TOWER
1931

In 1893 a synagogue was built in Richmond Road, Oxford, by John Jacob Gardner. In 1974, the present Oxford Synagogue and Jewish Centre was built on the site of the previous one. The synagogue houses the Oxford Jewish Congregation, which is made up separately of Orthodox, Masorti, Progressive and Reform Jewish groups, all of whom have equal rights to use the synagogue.

Sources:

http://www.oxfordchabad.org/templates/articlecco_cdo/aid/450812/jewish/A-Brief-History-of-Jews-of-Oxford.htm

http://www.jtrails.org.uk/trails/oxford/places-of-interest

http://www.jewishgen.org/JCR-uk/Community/oxford1/index.htm

Hibbert, C. and Hibbert, E. (Eds), *The Encyclopaedia of Oxford*, 1988

WILLIAM (MERRY) KIMBER (1872-1961): *Morris dancer*

PLAQUE: ENTRANCE TO HORWOOD CLOSE, ON SITE OF SANDFIELD COTTAGE, HEADINGTON, OXFORD

On Boxing Day 1899, a group of morris men − with William Kimber on the concertina − decided to perform in front of a large house in Headington Quarry. It was lucky for them that Cecil Sharp, a music teacher and composer, happened to be staying there over Christmas. Sharp was especially interested in the folk music traditions of the British Isles, and, when he came upon these morris dancers, he was riveted both by the dancing and the music. Thanks to the fortuitous meeting between Kimber and Sharp, an age-old folk tradition − which looked like dying out even before 1899 − is today a popular and flourishing practice.

Kimber, who was described in the *Musical Times* of March 1911 as being 'like a Greek statue' for the grace of his movements, first danced with the Headington Quarry morris dancers in 1887, the year that they dispersed. They were encouraged to reform in 1899 and Kimber sometimes joined them, which is how he came to be playing his concertina at Sandfield Cottage, Headington, when Sharp saw him, and asked him to return the following day. Sharp wrote down the tunes Kimber played for him, and from that moment on he started collecting folk tunes. It wouldn't be until 1907, however, after Kimber had

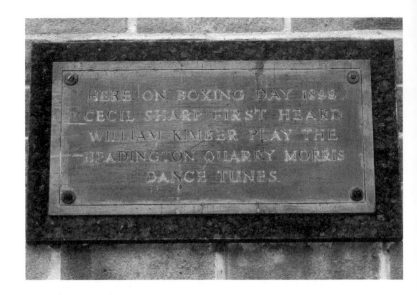

taught girls at the Esperance Girls' Club in London to dance, that the two men combined forces. Kimber would demonstrate the dancing at Sharp's lectures on the subject. He also helped Sharp reconstruct the dances of other groups. This collaboration lasted until Sharp's death in 1924. Meanwhile, Kimber busied himself teaching others how to dance, including adults and children in Headington Quarry, and a police group in Oxford. He became so noted for his dancing that he danced in front of King Edward VII and Queen Alexandra, at the Mansion House and at the Royal Albert Hall. He was also awarded a gold medal by the English Folk Society and a concertina by the Worshipful Company of Musicians, which he greatly treasured. Unfortunately, he had to give up dancing in old age, but kept on playing the concertina and made recordings of his music. The very last time he appeared with his morris dancers was a few weeks before he died, at the age of eighty-nine, in 1961.

William Kimber was born in Old Road, Shotover, on 8 September 1872 and was baptised at Holy Trinity Church, Headington Quarry, on 25 January 1873. His father, also William, was a bricklayer and morris dancer, married to Sophia Ann Kimber (probably related) from nearby Horspath. William, who was their eldest son, received schooling until the age of nine when he started work as a bird-scarer. He literally followed in his father's footsteps by becoming a Headington Quarry morris dancer, and a bricklayer. He married Florence Cripps, who was his first wife, in 1894 and settled in Headington, where their eight children were born. Kimber was a skilful craftsman and built for himself and his family a house in St Anne's Road, Headington, which he named 'Merryfield' after his nickname of Merry (now 42 St Anne's Road). Florence died in 1917, and in 1920 William married a widow, Mrs Bessie Clark, who had an only daughter. He lived at Merryfield for the rest of his life and died at home on 26 December 1961, the sixty-second anniversary of his momentous meeting with Sharp. Kimber was buried in Headington Quarry church, his coffin borne by six morris men dressed in full morris garb. The stone above his grave in the churchyard is carved with a concertina on top of a pair of morris dancing bells pads.

Two years before his death, Kimber unveiled a plaque on 26 December 1959 commemorating his legendary meeting with Sharp. This was attached to the wall of Sandfield Cottage, but when the house was demolished in 1965 it was transferred to the house at the entrance to Horwood Close. Kimber is also commemorated by William Kimber Crescent, Headington Quarry, a street named in his honour.

Sources:

Heaney, Michael, 'Kimber, William (1872-1961)', *Oxford Dictionary of National Biography*, Oxford University Press, 2004; online edn, May 2006 (http://www.oxforddnb.com/view/article/37635, accessed 28 Jan. 2011)

http://www.headington.org.uk/history/famous_people/kimber.htm

..

SIR HANS KREBS (1900-1981): *Biochemist and Nobel Laureate*
BLUE PLAQUE: 27 ABBERBURY ROAD, OXFORD

Sir Hans Krebs, one of the greatest biochemists of the twentieth century, is best known for his identification of two important metabolic cycles: the urea cycle and the citric acid cycle, also known as the Krebs cycle, for which he received the Nobel Prize in 1953.

Krebs, the son of Professor Georg Krebs (an ear, nose and throat specialist) and Alma Davidson, was born at Hildesheim, Germany on 25 August 1900. Following his prominent father's example, he studied medicine, attending the Universities of Göttingen, Freiburg-im-Breisgau and Berlin. In 1925 he obtained his MD from the University of Hamburg, before spending a whole year studying chemistry in Berlin.

Krebs's long and distinguished career in the field of biochemistry started in earnest in 1926, when he was appointed assistant to the eminent biochemist Otto Warburg. He gained valuable training in research techniques in Warburg's laboratory, which gave him the impetus to follow a career in biochemistry after leaving the laboratory five years later, despite his mentor's advice to the contrary. It was by using Warburg's methodology at Freiburg (where a year later he secured a post) that Krebs made his first major breakthrough. Aided by Kurt Henseleit, a medical student, he discovered the urea, (or ornithine) cycle, revealing the chemical processes that enable animals to produce urea. The publication of his findings in 1932 brought him international acclaim, but the following year his contract was terminated by the Nationalist Socialist Government and Krebs, a Jew, was no longer welcome in his homeland. Accepting an invitation from Sir Frederick Gowland Hopkins to work as Demonstrator of Biochemistry at Cambridge, and with financial support from the Rockefeller Foundation, Krebs left Germany in 1933.

He stayed at Cambridge for only two years before going to Sheffield University as Lecturer in Pharmacology; in 1945 he became the first Professor of Biochemistry at the university, supervising the Medical Research Council's Unit for Research into Cell Metabolism. It was here that he and his specially trained team did their groundbreaking work on the citric acid cycle (carboxylic cycle), now known as the Krebs cycle. This discovery led to Krebs being awarded the 1953 Nobel Prize in Physiology or Medicine, shared with Fritz Lipmann. The other major award he received while at Sheffield was Fellowship of the Royal Society in 1947.

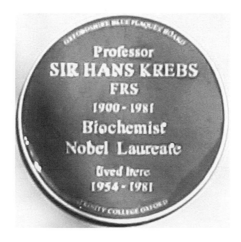

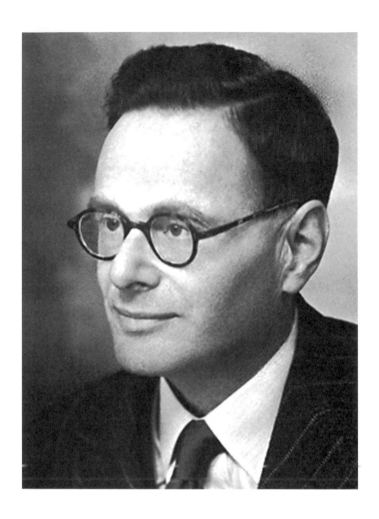

Krebs's connection with Oxford began in 1954 with his appointment as Whitley Professor of Biochemistry at Oxford University – where he and his MRC team continued their work on metabolism – and election as a Fellow of Trinity College. His reputation was such that many gifted young scientists from all over the world were attracted to Oxford, inspired and encouraged by his example. For much of his professional life Krebs was the recipient of several medals and honours, including a knighthood in 1958, but this kindly and civilised man remained modest and approachable, inspiring much affection and loyalty in those who worked with him. In 1967 he retired from the Oxford Chair but not from work. He simply moved to a laboratory which had been set up for him at the Radcliffe Infirmary, taking his research team with him, unable and unwilling to give up work. For the next fourteen years he continued his scientific explorations, publishing more than 100 papers.

'Home is not always where one was born, and brought up. Home is where one strikes roots,' Krebs is quoted as saying on several occasions. He would establish his deepest roots at 27 Abberbury Road, Iffley. He and his wife Margaret moved into the large and elegant house, with its beautiful garden, in 1954, on his arrival in Oxford, and it was here that they brought up their daughter Helen and their two sons, Paul and John. A warm and caring family man, Krebs delighted in his family and took much pleasure in his home life and in his garden. He remained in his home at No. 27 for the rest of his life, and died at the Radcliffe Infirmary on 12 October 1981.

Sources:

Oxfordshire Blue Plaques Scheme

Kornberg, Hans, 'Krebs, Sir Hans Adolf (1900-1981)', rev. *Oxford Dictionary of National Biography*, Oxford University Press, 2004; online edn, Jan. 2011 (http://www.oxforddnb.com/view/article/31327, accessed 28 Nov. 2010)

http://www.shef.ac.uk/library/special/krebpape.html

http://nobelprize.org/nobel_prizes/medicine/laureates/1953/krebs-bio.html

New Scientist, 11 Feb. 1982

..

T.E. LAWRENCE ('LAWRENCE OF ARABIA') (1888-1935): *Author, scholar, soldier*

UNOFFICIAL BLUE PLAQUE: 2 POLSTEAD ROAD, OXFORD

PLAQUE: DEPARTMENT OF PHYSIOLOGY, OXFORD

BUST OF LAWRENCE: JESUS COLLEGE CHAPEL, OXFORD

PORTRAIT OF LAWRENCE: JESUS COLLEGE DINING HALL

ARAB GOWN AND OTHER EFFECTS: ASHMOLEAN MUSEUM, OXFORD

CAMERA USED IN DESERT: MUSEUM OF THE HISTORY OF SCIENCE

T.E. Lawrence was a legend in his own lifetime. A brave, intrepid, highly intelligent man, who spent much of his early life in Oxford, he was a distinguished scholar, great military strategist, and writer of exquisite prose. Yet Lawrence was an enigma to many of his contemporaries and remains so today. He was a fascinating man who assumed different names in order to conceal his identity. Known to his family as Ned, he was born Thomas Edward Lawrence but was known also as T.E. Lawrence, Lawrence of Arabia, T.E. Shaw, Airman Ross and Private Shaw. Although Lawrence spent relatively little time in Oxford in the latter part of his life, his most formative years were spent in the city, where many objects relating to his life can still be seen.

Thomas Edward Lawrence was born in Tremadog, North Wales, the second of five sons of Sir Thomas Chapman and Sarah Junner. The family moved to Oxford in 1896 and settled at 2 Polstead Road, a semi-detached red-brick house, typical of many in the area. As the children grew, the house was deemed to be too small to accommodate the whole family, so a two-roomed bungalow was built at the bottom of the garden to help resolve family tensions, especially with young Ned. (Lawrence would occupy this house when studying for his final examinations at university, enjoying the privacy and quiet of the place, which was helped, no doubt, by covering the walls with green cloth to diminish noise.) He was educated at Oxford High School for Boys in George Street, where he developed a great interest in medieval history. He won prizes in Greek, Divinity and English, and showed skill at sport, especially athletics, running and cycling. In 1906 he cycled round northern France, exploring the castles of the area.

The following year he went up to Jesus College, Oxford, to read modern history, but did not associate much with his fellow students, preferring instead to live at home. When he wasn't studying, he liked to test his own endurance by setting up physical challenges for himself, such as navigating the underground streams of the city in a canoe. In the summer vacations of 1907 and 1908, he toured France – again on bicycle – inspecting castles, which he measured, drew or photographed. In 1909 he travelled round Syria and Lebanon on foot, covering over 1,000 miles of ground in search of the castles of the region, and learning the culture and customs of the area. When he came back to Oxford, he submitted his thesis entitled 'The Influence of the Crusades on European Military Architecture – to the end of the 12th century', based on his experiences in France and the Middle East, and graduated with a First Class Honours degree in History.

Lawrence's passion for archaeology led him, in 1914, to join the British Museum dig at the ancient Hittite city of Carchemish, where he spent four very happy years looking for artefacts. This would end at the outbreak of war in 1914, when he was posted to Cairo to work for British Intelligence, bringing with him his knowledge of the Arab language and Arabic culture. In 1916 he was attached to the Arab Bureau in Cairo, where Lord Kitchener and others were keen to obtain Arab guerrilla support to fight Turkey. Lawrence was very sympathetic to the cause of Arab independence and hostile to Turkish dominance in the area. He was suspicious too of French imperial aspirations. With an eye to the post-war

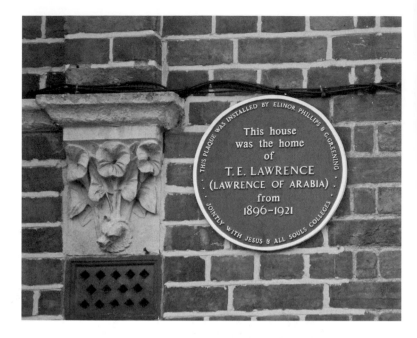

future of the Middle East, he consolidated his links with Arab leaders, especially Emir Feisal, son of Grand Sharif Hussein, leader of the Arab Revolt. In 1916, Lawrence joined Feisal and other tribal leaders waging guerrilla warfare on the Turks for two years, and in the process taking the port of Aqaba on the Red Sea, cutting their communications and finally capturing Damascus. In 1918 he was promoted to Lieutenant-Colonel. It was in that same year that the 'Lawrence of Arabia' legend took hold in the public's imagination, after the American war journalist, Lowell Thomas, highlighted Lawrence's achievements in his reports and film.

In 1919, Lawrence returned to England to promote the cause of Arab independence, but was frustrated by the politicking that took place at the Paris Peace Conference and returned to Oxford in 1920, where he had been elected to a Fellowship at All Souls' College. He also worked at rewriting his account of the desert campaigns – which would be published in 1926 as *The Seven Pillars of Wisdom* – having lost the first draft at Reading railway station.

At the end of 1920, Churchill invited Lawrence to join the Colonial Office to work on a solution to the question of Arab independence. In the event, the British Government, advised by Lawrence, effected a resolution at the 1921 Cairo Conference, when it was agreed that Feisal would be king of Iraq and his brother, Abdullah, king of Transjordan (now Jordan).

In July 1922, Lawrence enlisted in the RAF under the name of John Hume Ross, in order to assume a new identity and escape from the public gaze. Unfortunately, his identity was discovered by the press, which necessitated his leaving the RAF and joining the Army Tank Corps at Bovington Camp, Dorset, as T.E. Shaw. Whilst serving with the army, Lawrence found a cottage called Clouds Hill, which was the ideal place to spend his free time and offered him a haven where he could work on his revision of *The Seven Pillars of Wisdom*, and its abridged form *Revolt in the Desert*, published in 1927 – both of which received great acclaim. However, this was a time of great psychological turmoil for Lawrence, who longed to be back in the RAF. Thanks to his prominent friends, he found himself readmitted to the Air Force in 1925, which assigned him to a remote base in India the following year. He returned to England in 1928 and continued serving in the RAF until his retirement in March 1935.

On 13 May 1935, whilst riding his powerful motorcycle near Clouds Hill, Lawrence swerved to avoid two boys cycling on the road and was thrown violently over the handlebars. He fractured his skull, and, after being unconscious in hospital for five days, died on 19 May. A number of distinguished mourners attended his funeral two days later, amongst whom were Winston Churchill, General Wavell and Siegfried Sassoon. He is buried in the churchyard of St Nicholas' Church, Moreton, Dorset.

T.E. Lawrence received the following awards in his life: Companion of the Order of the Bath, Distinguished Service Order, Chevalier de la Légion d'Honneur, and the Croix de Guerre. He has been portrayed on film several times, perhaps most memorably by Peter O'Toole in the 1962 film *Lawrence of Arabia*. He has also been the subject of plays, including Terence Rattigan's *Ross* (1960-1961) starring Alec Guinness.

Sources:

James, Lawrence, 'Lawrence, Thomas Edward [Lawrence of Arabia] (1888-1935)', *Oxford Dictionary of National Biography*, Oxford University Press, 2004; online edn, Jan. 2011 (http://www.oxforddnb. com/view/article/34440, accessed 21 Dec. 2010)

http://news.bbc.co.uk/local/oxford/low/people_and_places/history/newsid_8130000/8130638.stm

http://telawrence.info/telawrenceinfo/life/biog_biog.shtml

THE LEVELLERS (DIED 18 SEPTEMBER 1649)

PRIVATE BIGGS: PRIVATE PIGGEN

PLAQUE: ON WALL BY TAXI RANK, FACING GLOUCESTER GREEN, OXFORD

On 18 September 1649, two Leveller soldiers, Private Biggs and Private Piggen, were executed for their part in a mutiny against Oliver Cromwell. They were shot in Broken Hayes (an area of Oxford which linked what is now George Street with Gloucester Green) and their bodies were then flung down Oxford's Castle mound.

During the English Civil War, troops of the Parliamentary garrison mutinied against Oliver Cromwell, having been inspired to do so by Colonel William Eyres – a Leveller who had been imprisoned earlier that year in Oxford.

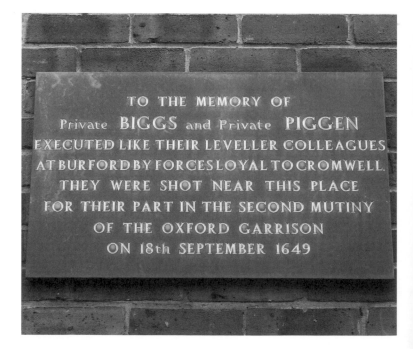

TO THE MEMORY OF
Private BIGGS and Private PIGGEN
EXECUTED LIKE THEIR LEVELLER COLLEAGUES
AT BURFORD BY FORCES LOYAL TO CROMWELL.
THEY WERE SHOT NEAR THIS PLACE
FOR THEIR PART IN THE SECOND MUTINY
OF THE OXFORD GARRISON
ON 18th SEPTEMBER 1649

The Levellers were members of a radical political group of free-thinkers who emerged between 1465 and 1469 under the leadership of men such as John Lilburne, William Walwyn, Richard Overton and others (*see* Henry Marten entry). Amongst their demands were the abolition of the monarchy and the House of Lords, an extension of franchise and an appeal for religious tolerance. The movement – which had started in the City of London – took root in some units of the New Model Army. The Levellers were loyal to Cromwell, but after Charles I's execution felt let down by Cromwell and the Council of State for not implementing more radical policies, and for their refusal to settle arrears of pay. Nor were they pleased at plans to invade Ireland. Cromwell quickly suppressed the Leveller mutinies that ensued. In early May 1649, mutinous troops and Levellers who had marched to the town found themselves under attack in the deep of night. The surprise raid was led by none other than Cromwell himself. The mutineers were rounded up and incarcerated in Burford church, and on 17 May 1649 three of the Levellers – Cornet Thompson, Corporal Perkins and Private Church – were taken out into the churchyard and executed by firing squad.

When Oxford garrison mutinied five months later, Colonel Richard Ingoldsby, Cromwell's cousin, took no chances and quickly quelled it, making an example of Privates Biggs and Piggen.

Sources:

'Mutineers or martyrs?' *The Oxford Times*, Friday, Jan. 8 1988

http://www.british-civil-wars.co.uk/glossary/levellers.htm

http://en.wikipedia.org/wiki/Levellers

..

C.S. LEWIS (1898-1963): *Academic and author*

BLUE PLAQUE: THE KILNS, LEWIS CLOSE, HEADINGTON QUARRY, OXFORD, OX3 8JD

COMMEMORATION STONE: ADDISON'S WALK, MAGDALEN COLLEGE, OXFORD

PLAQUE TO INKLINGS: EAGLE AND CHILD PUB, ST GILES, OXFORD

PLAQUE: CHURCH PEW, HOLY TRINITY CHURCH, HEADINGTON QUARRY, OXFORD

PLAQUE: JOY DAVIDMAN, WIFE OF C.S. LEWIS, 10 OLD HIGH STREET, HEADINGTON, OXFORD

DOOR WITH CARVING OF LION, SAID TO BE THE INSPIRATION FOR ASLAN IN *THE LION, THE WITCH AND THE WARDROBE*: BRASENOSE COLLEGE, RADCLIFFE SQUARE, OXFORD

In the early summer of 1929, a young man travelling on a bus in Oxford underwent a dramatic mystical experience whilst going up Headington Hill. This encounter with the numinous would alter the course of his life forever, and reconvert him to the Christian faith he had been born into but had abandoned as a schoolboy. It would inform all aspects of his life, including his published works. The young man in question was C.S. Lewis, scholar and author of the popular *Narnia* stories and other works.

Clive Staples Lewis (Jack) was born in Belfast on 29 November 1898, the younger son of Albert, a solicitor of Welsh descent, and Florence Augusta Hamilton, the daughter of a clergyman. Both his parents possessed a deep love of literature, and Florence, who had a degree in Mathematics and Logic from Queen's College, encouraged Lewis not only to read books but to study French and Latin. Tragically, Lewis's mother died when he was only nine years old, after which he and his older brother Warnie (Warren) were sent to boarding schools in England, an experience they both heartily disliked. At Malvern College, which he attended for a short while, he found solace in poetry and in Norse mythology – and became an atheist. His unhappy schooldays would end in 1914 when he left Malvern to be privately tutored by his father's old teacher W. T. Kirkpatrick, a former headmaster. Kirkpatrick, an excellent tutor, not only helped Lewis win a scholarship to University College, Oxford, in 1917, but encouraged him especially to think for himself.

Unable to take up his scholarship until 1919 because of the First World War, and having chosen to volunteer for military service, Lewis's very first experience at Oxford was in the Officers' Training Corps prior to seeing active service in France, where he was wounded.

On his return to Oxford he resumed his studies, where he excelled in several subjects including English, obtaining Firsts in his exams and thereby assuring himself of an academic career; in 1925 Lewis was elected Fellow and Tutor in English Language and Literature at Magdalen College. It was in his rooms in the New Building that Lewis knelt down to pray after his conversion on Headington Hill, and it was here that his friend J.R.R. Tolkien and other members of the 'Inklings' group met for discussions and readings of their texts.

For the next twenty-nine years Lewis would occupy these rooms at Magdalen, but the place he loved most was The Kilns, in Headington Quarry, only three miles away – the property that he had purchased together with his brother Warnie, and Mrs Janie Moore (Minto). (Mrs Moore's son Paddy, a friend of Lewis's, had died during the war, and Lewis felt responsible for her and for her daughter Susanna.) He moved into the gabled red-brick house in 1930, together with the two women, and his brother joined them two years later on his retirement. Lewis cherished his home, inspired by the beauty of its 8 acres of woodland and the peace of his surroundings. Here, he could indulge in his favourite pastime of walking. In summer he would swim or row in the lake in the grounds, and all year round he would observe the wildlife around him with delight. When he became a professor at Magdalene College, Cambridge, in 1950, he couldn't bear to be away from his beloved home and would return every weekend.

The Kilns played a significant role in his life for the thirty-three years he would live there, providing the inspiration for the *Narnia* stories, and much of his other work. The house features in *The Lion, the Witch and the Wardrobe*, a story about four children who leave war-torn London for the safety of a professor's house, where they discover a magical wardrobe through which they pass into the land of Narnia. In real life, several young evacuees did, in fact, come to stay at the Kilns during the war.

Another very important person connected with the house was his wife Joy Gresham (*née* Davidman), an American, whom he married on 23 April 1956, to enable her to claim British citizenship and stay in England. A year later, on discovering she had cancer, Lewis brought her to live with him at The Kilns so that he could look after her. They spent three very happy years together whilst she was in remission, before she succumbed to her illness. Lewis was disconsolate after her death and died at The Kilns only three years later on 22 November 1963. He is buried at Holy Trinity Church, Headington Quarry – the church that he and Warnie regularly attended. Warnie remained in the house until his death in April 1973 and is buried with his brother.

Today, Lewis's books, especially the *Chronicles of Narnia*, are published in their millions, and his life continues to be a source of interest and fascination to individuals the world over. People come to Oxford to visit the places he knew and to follow in his footsteps. A play, *Shadowlands*, portraying the story of his marriage to Joy, was a big success and was later made into a film. His beloved home is now owned by the C.S. Lewis Foundation of California, who have carefully restored it very much as it was in Lewis's day, whilst the woodland and pond are now part of the C.S. Lewis Reserve and are under the care of The Berkshire, Buckinghamshire & Oxfordshire Wildlife Trust (BBOWT).

There are several plaques to Lewis in and around Oxford. Apart from the Blue Plaque, there is a centenary stone at Magdalen College in Addison's Walk; at the Eagle and Child pub, where he and the Inklings used to meet, there is a brass plaque to commemorate the group; and in Holy Trinity Church there is a small plaque on the pew where he habitually sat during services. On the wall of the church there is a map of Narnia and a stained glass window on a Narnia theme, which was installed in memory of two young children. Joy, his wife, is commemorated by a plaque in Headington High Street, in the home she lived in before her marriage to Lewis.

Sources:

Oxfordshire Blue Plaques Scheme

Bennett, J.A.W., 'Lewis, Clive Staples (1898-1963)', rev. Emma Plaskitt, *Oxford Dictionary of National Biography*, Oxford University Press, 2004; online edn, May 2008 (http://www.oxforddnb.com/view/article/34512, accessed 20.11.2010)

http://www.factmonster.com/spot/narnia-lewis.html

http://mhf39.modhist.ox.ac.uk/siteimage/The%20Development%20of%20Local%20History%20in%20Oxfordshire.pdf

SIR HENRY MARTEN (c. 1601/2-1680): *Regicide, Parliamentarian*
PLAQUE: 3 MERTON STREET, OXFORD

Henry Marten, known to his friends as Harry, was a colourful and controversial individual. A hero to many because of his republican views which advocated the destruction of the monarchy, he was considered a libertine and a drunkard by others, including Charles I who allegedly castigated him for his profligacy after seeing him at a race meeting at Hyde Park. Charles is reputed to have said: 'Let that rascall be gonne out of the Parke, that whore-master, or els I will not see the sport.' If this incident did in fact take place, then it is not surprising that Marten harboured deep resentment for the monarch, leading him in 1649 to be included amongst the most prominent of the fifty-nine signatories of Charles I's death warrant.

Henry Marten was born in a house opposite Merton College, Oxford in about 1601. He was the eldest son of Sir Henry Marten, a successful lawyer, judge of the Admiralty Court and landowner, and his wife Elizabeth. Facts relating to his early life are somewhat sketchy, but it is on record that he went to school in Oxford before attending University College, Oxford. He graduated in 1620 and was admitted to Inner Temple in 1619. According to John Aubrey (1626-1697), the author of *Brief Lives*, Marten travelled to France, where he was exposed to a different culture and to new ideas and philosophies. He enjoyed the high life, and with a colourful personality and a ready wit he made a number of friends, including the writer and politician Mildmay Fane, 2nd Earl of Westmorland.

Marten married twice. His first wife was Elizabeth Lovelace, with whom he had three daughters. Elizabeth died in April 1634, soon after the birth of their third child, and the following year Marten, on the advice of his father, reluctantly married Margaret Staunton, a widow, but this second marriage was an unhappy one. He and Margaret went on to have two daughters and a son, Henry. The 1630s appear to have been relatively uneventful years for him, apart from looking after his father's estates, which extended from Hinton Waldrist right up to Shrivenham on the Wiltshire border.

IN THIS HOUSE WAS BORN
Col. HENRY MARTEN
GENTLEMAN COMMONER OF
UNIVERSITY COLLEGE,
OXFORD
MP FOR BERKSHIRE
REPUBLICAN AND WIT.
1602 ~ 1680

In 1640, Marten was elected to both the Short Parliament and the Long Parliament as MP for Berkshire, and it was then that he decided to make Longworth House his official residence, although most of the time he preferred to live in London. When war broke out in 1642, Marten, who was appointed Governor of Reading, donated money to the Parliamentary cause. As an MP, Marten sided with those who wanted the king's powers greatly reduced and more control given to Parliament. In fact, he was expelled from Parliament for three years in 1643, and imprisoned in the Tower of London for advocating the abolition of the monarchy. He argued that it should be replaced by a republic. In 1644 he was made Governor of Aylesbury and took an active part in the siege of Donnington Castle.

On his return to Parliament in 1646, Marten's views were as radical as ever. Apart from his extreme antagonism towards the king, he wrote pamphlets against the Presbyterians and gave his support to the New Model Army, which was made up mainly of Puritans and Dissenters (*see* entry on Levellers). Within some regiments of the NMA there was

support for the Levellers, a radical political movement which called for significant changes to society. Marten collaborated with the Leveller leaders, especially John Wildman, who was related to him by marriage, and John Lilburne. He even raised his own, unauthorised, Leveller regiment, which was later incorporated into the New Model Army.

Marten played a leading role in organising Charles II's trial after the Royalist defeat in the Second Civil War, and went on to sign the king's death warrant. It is reported that he and Oliver Cromwell flicked ink at each other during the signing. He was one of the main individuals instrumental in abolishing the monarchy and in establishing the Commonwealth. However, he fell out with Cromwell – whom he now saw as a dictator – in 1653, and this in effect marked the end of his political career. Financially, too, he was ruined, having lost most of his estates and money. He disappeared from public life until 1659 when he joined the reassembled Long Parliament, just before the Restoration of Charles II in 1660. After the Restoration, Marten was found guilty of regicide and sentenced to death, but this was commuted to life imprisonment, possibly because he had dealt fairly with Royalists during the Commonwealth years.

Although his wife never visited him in prison, preferring to stay in Longworth, his long-time mistress, Mary Ward, who had lived with him for several years and borne him three daughters, stayed loyal to him, moving with him to several prisons before he was finally transferred to Chepstow Castle in Wales in 1668, where he remained in relative comfort until his death on 9 September 1680 after choking while eating his supper. He was buried in Chepstow Anglican church.

His son Henry led an uneventful life in Longworth.

Sources:

Barber, Sarah, 'Marten, Henry (1601/2–1680)', *Oxford Dictionary of National Biography*, Oxford University Press, 2004; online edn, Jan. 2008 (http://www.oxforddnb.com/view/article/18168, accessed 12 Jan. 2011)

http://www.british-civil-wars.co.uk/biog/marten.htm

http://freepages.genealogy.rootsweb.ancestry.com/~amandataylor/pafg15.htm

..

WALTER DE MERTON (*c.* 1205-1277): *College founder, Lord Chancellor of England, Bishop of Rochester*

PLAQUE: ABOVE FRONT DOORWAY, MERTON COLLEGE, MERTON STREET, OXFORD
STATUE: ABOVE DOORWAY OF COLLEGE

Above the elegant doorway of one of Oxford's oldest colleges is a fifteenth-century carving depicting St John the Baptist in the wilderness, accompanied by Walter de Merton, the founder of the college, wearing a bishop's mitre and kneeling by the Book of the Seven Seals. Around them is an assortment of animals, including a unicorn, a lion and several rabbits. St John is featured in the stone plaque to indicate that a parish church of the same name stood on the site prior to the building of Merton Chapel.

Walter de Merton, twice Lord Chancellor of England and Bishop of Rochester, was known originally by his father's family name of Basingstoke. One can only speculate on what his college, which is one of the oldest in Oxford, might have been called had he kept to his original name! He came from a wealthy landowning family in Surrey and was left comfortably off when his parents died. As the only son in a family of eight children, and aware of his duty towards his kin, he later founded his institution partly to provide for the education of his many male relatives.

After Merton entered holy orders, a normal career for young men in the thirteenth century, his fellow clerics noticed that he showed a remarkable talent for administration. As a result, he was promoted to a number of increasingly important posts in the Church, culminating in his elevation to the bishopric of Rochester in 1274. His organisational skills brought him to the attention of the court and, over the years, he became one of King Henry III's most trusted advisers. The king rewarded him for his loyal service by twice appointing him Lord Chancellor.

In 1264 Merton fulfilled his ambition to found an educational institution. He was especially keen to nurture talent for the benefit of the wider community and to make his foundation both self-governing and self-educational. To this end he founded a college, first

at Malden, Surrey and then at Oxford, as a permanent house, in 1274 – which made it, in effect, the first example of collegiate life at the university. Prior to this, students would study in halls run by masters who could close them at any time. His institution was built on the site of the parish church of St John, whose advowson he had acquired in the early 1660s, together with some adjoining properties. The site was somewhat narrow, which limited what could be built. Nevertheless, care was taken over the placement of buildings, so that they appear, even today, to blend seamlessly into one another. Merton devoted a great deal of his energies to his college and spent the last three years of his life travelling between Oxford and Rochester. It was on one such journey, when he was returning from Oxford, that his horse stumbled while crossing the River Medway, throwing him into the water. He didn't recover from the accident and died from his injuries two days later on 25 October 1277. He is buried at Rochester Cathedral.

Sources:

Hibbert, C. and Hibbert, E. (Eds), *The Encyclopaedia of Oxford*, 1988

http://www.oxforddnb.com/view/article/18612

http://www.newadvent.org/cathen/15544a.htm

..

WILLIAM RICHARD MORFILL (1834-1909): *First Professor of Russian and Slavonic Languages*

BLUE PLAQUE: 42 PARK TOWN, OXFORD

William Richard Morfill, a remarkable linguist and much-liked academic, was associated with Oxford for most of his adult life. In 1900 he became the first Professor of Russian and Slavonic languages at Oxford University, having acquired a reputation as an outstanding expert in these languages.

William Richard Morfill was born on 17 November 1834 in Maidstone, Kent, the son of William Morfill, a professional musician, and his wife Elizabeth (*née* Couchman). He was

educated at Maidstone Grammar School and at Tonbridge School. An exceptionally bright pupil, he became head boy and won a scholarship to Corpus Christi College, Oxford in 1853. That same year he moved to Oriel College on winning an open classical scholarship there. Morfill looked set for a brilliant academic career and was expected to get a First Class degree, but ill health put paid to his ambitions when he was taken seriously ill during his finals and managed only a pass degree. Nevertheless, he decided to stay in Oxford and make a living as a private tutor, teaching from his rooms in Oriel Street.

On 6 September 1860, Morfill married Charlotte Maria Lee, the daughter of a grazier from Welton, Northamptonshire, and brought her to Oxford, where not long afterwards they moved to 4 Clarendon Villas, now 42 Park Town. Morfill had by this time become an expert on Russian and had published the first of his many translations from that language, although it would take another ten years before he actually visited the country. In the meanwhile, between 1865 and 1869, he lectured in philosophy and modern history at Charsley's Hall, one of Oxford's private halls. In his spare time he taught himself other Slavonic languages, and in the 1870s travelled round the countries where they were spoken. Since the study of languages was not represented at any British university at the time, his home became a quasi-faculty and meeting point for scholars, both local and visiting. When his beloved wife died in 1881 he drew comfort from the familiar surroundings, hosting regular gatherings of his friends on Sunday afternoons, when they would engage in intellectual debate and stimulating conversation.

Morfill's expertise in Slavonic languages was recognised by the university when he was invited to give the newly endowed Ilchester Foundation lectures at the Taylorian Institute in 1870, 1873 and 1883. Following publication of Morfill's grammars of Polish, Serbian and Russian, and his work on Georgian literature in the 1880s, Oxford University appointed him Reader in Russian in 1889. He worked tirelessly during those years, publishing grammars of Bulgarian and Czech, and histories of Russia and Poland, and translated, together with Dr R.H. Charles, the Slavonic version of the ancient *The Book of the Secrets of Enoch*.

In 1900, when Morfill was sixty-six years old, he finally received official recognition for his extraordinary ground-breaking work when he was appointed Professor of Russian and Slavonic Languages at Oxford, the first British university to recognise the importance of these studies. In 1904, Russian was accepted as a degree subject at Oxford.

Morfill was elected a Fellow of the British Academy in 1903 and awarded an honorary doctorate by Charles University, Prague, in 1908. One year later, on 9 November 1909, he died of a weak heart at his home in Park Town. After a funeral service at St Philip and St James' Church, he was buried in the same grave as his wife in St Sepulchre's Cemetery, Walton Street, Oxford.

Sources:

Oxfordshire Blue Plaques Scheme

Stone, Gerald, 'Morfill, William Richard (1834–1909)', *Oxford Dictionary of National Biography*, Oxford University Press, 2004; online edn, Oct. 2009 (http://www.oxforddnb.com/view/article/35099, accessed 31 Dec. 2010)

WILLIAM MORRIS, VISCOUNT NUFFIELD (1877-1963): *Car-maker, philanthropist*

BLUE PLAQUE: 16 JAMES STREET, COWLEY, OXFORD

BAS-RELIEF MONUMENT: OXFORD CROWN COURT, ST ALDATE'S, OXFORD

A quiet and modest man, William Morris, Viscount Nuffield, the car-maker, became the wealthiest self-made millionaire of 1940s' England. He made his wealth through a combination of hard work, shrewd judgment, and business acumen, donating a large part of it to charitable causes. He endowed a number of foundations in Oxford, including the Nuffield

Orthopaedic Centre, the Nuffield Institute for Medical Research, and Nuffield College. Outside Oxford he founded the Nuffield Foundation in 1943, with an endowment of £10,000,000, in order to advance medical, scientific and social research. Morris also brought industry and employment to Oxford, transforming the outskirts of the city into an important industrial centre.

William Morris was born in Worcester on 10 October 1877. Both his father, Frederick, and his mother Emily (née Pether) were from Oxfordshire, and when Morris was three they returned to the county so that Frederick could work as bailiff on his father-in-law's farm in Headington. Morris spent most of his early years in the area, and, a year after leaving his village school in Cowley at the age of fifteen, he set up a bicycle-repair business in his father's shed in the garden of 16 James Street, Cowley, with £4 of capital. When it proved a success, he started up as bicycle maker at 48 High Street, Oxford, before acquiring stables in Longwall Street, in which he hoped to manufacture motorcycles. In the event, after selling his cycle business in 1904 he established the Morris Garage motor car business, hiring and selling cars on the premises. An astute businessman, Morris could see that the future lay in motor construction, and to this end he designed a car in 1911 which became the Morris Oxford, with the first models going into production at a new factory in Cowley in 1913. Inspired by Ford's example in the United States, he became the first car-maker to pioneer production line assembly in Britain, and between 1919 and 1925 established factories at Abingdon, Birmingham and Swindon, in addition to the one at Cowley. Thanks to their reliability and affordability, by 1925 Morris cars accounted for a third of all cars made in Britain.

In 1938, Morris acquired some of his competitors, including Riley and Wolseley, which he added to his company, rebranding the group the Nuffield Organisation. In 1952 it merged with the Austin Motor Co. to become the British Motor Corporation.

Despite being an extremely wealthy man, Morris and his wife Elizabeth, who was also from Oxford, lived quite modestly at their home Nuffield Place, Nuffield, close to Huntercombe. Morris's bedroom floor, for example, was covered by a rug made of sewn together pieces of carpets intended for the interiors of cars, and he and Elizabeth had smaller bedrooms than the ones their guests were offered when they came to stay. The home was comfortable, however, and had good quality furniture, and on occasion Morris could be extravagant. In 1926 he bought Huntercombe Golf Course because of his enjoyment of the game. He bought his home in order to be near the golf club and, in 1938, when he was made Viscount, Morris took his title from the name of the village.

Morris kept up with all his benefactions, especially the medical ones which were so close to his heart. He lost interest in Nuffield College, however, hurt at the University of Oxford's decision to ignore his appeal for a centre of excellence in the field of engineering and industry, and provide instead a post-graduate college for the study of social sciences.

His wife Elizabeth, whom he had married in 1904, died in 1959. Morris survived her by four years and died at his home on 22 August 1963, following surgery. His ashes were buried at Nuffield parish church. William Morris was one of the greatest philanthropists the UK has ever seen, or is likely to see, and all his benefactions are still flourishing today, so many years after his death.

Sources:

Oxfordshire Blue Plaques Scheme

Overy, R.J., 'Morris, William Richard, Viscount Nuffield (1877-1963)', *Oxford Dictionary of National Biography*, Oxford University Press, 2004; online edn, Jan. 2011 (http://www.oxforddnb.com/view/article/35119, accessed 1 Feb. 2011)

http://www.nuffield-place.com/Save%20Nuffield%20Place.htm

..

MRI SCANNER (1980): *Magnetic Resonance Imaging*
BLUE PLAQUE: KING'S CENTRE, OSNEY MEAD, OXFORD

Today, over 60 million MRI investigations are carried out every year in hospitals all over the world, and countless lives have been, and are being, saved, thanks to this brilliant technology. Magnetic Resonance Imaging, MRI, is one of the greatest breakthroughs in modern medical diagnosis. It is an imaging technique used to obtain high quality pictures of the internal structures of the human body. Instead of using radiation, as in X-rays or CAT scans, MRI makes use instead of very strong magnet and radio waves.

In the late 1950s, Martin Wood, the Senior Research Officer at the Clarendon Laboratory at Oxford University, saw a need to provide specialist equipment for research scientists. At the time, he had been specialising in very low temperature physics and very high magnetic fields, which gave him a great deal of experience in the design and construction of magnets. So, in 1959, Wood, together with his wife Audrey, established Oxford Instruments, and in 1961 they began manufacturing their first superconducting magnets. This enterprise would become the university's first spin-off company.

At first the company was run from the Woods' home in North Oxford, in true cottage-style fashion, with sheds and coal cellars being utilised, and then from other premises including a stables and a disused slaughterhouse in Middle Way, Summertown. From there it moved to an old boat-building shed near Osney Lock, after which a purpose-built factory on the Osney Mead Industrial Estate was erected in 1971.

In 1980, the first commercial MRI scanner was manufactured at the factory, following the pioneering work that was being carried out in the field of nuclear resonance imaging by Dr (now Sir) Peter Mansfield at Nottingham University, and Professor Paul Lauterbur in the USA. (These two scientists were awarded the Nobel Prize for Medicine in 2003 for their achievements in this field.) Dr Raymond Damadian in the USA was also working on MRI at the time. The scanner was set up at Hammersmith Hospital in London, under the supervision of Dr (now Professor) Ian Young, and Professors Robert Steiner and Graeme Bydder, where they were able to demonstrate the efficacy of this cutting-edge diagnostic tool in their clinical trials. The Imaging Laboratory of the University of California also acquired whole body superconducting magnets.

Thanks to the success of the MRI whole body scanners, Oxford Instruments was able to diversify into other areas of medical and scientific diagnostics. In 1983, the company was floated on the Stock Exchange, and moved to a new home in Tubney Woods, near Abingdon, Oxfordshire, not too far from the scientific hubs of Harwell and Culham. According to company information supplied on their Internet site, Oxford Instruments today produces high technology tools and systems for industry and research, and is the world's leading supplier of superconducting materials.

Sir Martin Wood was knighted in 1986 and was elected a Fellow of the Royal Society the following year. He and Lady Audrey are now involved in a number of philanthropic undertakings, including the Martin and Audrey Wood Enterprise Awards for entrepreneurship, established in 2005.

Sources:

Oxfordshire Blue Plaques Scheme

http://www.oxford-instruments.com/Pages/home.aspx

http://www.oxfordtimes.co.uk/lifestyle/people/5016194.The_birth__of_MRI/

SIR JAMES MURRAY (1837-1915): *Lexicographer and Editor of the OED*
BLUE PLAQUE: 78 BANBURY ROAD, OXFORD

James Murray had a prodigious talent for languages, and made a close study of dialects. He became a teacher when only seventeen years old, and a headmaster at the age of twenty. Murray was appointed Editor of the Oxford English Dictionary in 1873 and continued working on it until his death over thirty years later.

James Augustus Henry Murray was born on 7 February 1837, in Denholm, Scotland, the eldest child of Thomas Murray, a tailor and his wife, Mary. A very intelligent child, Murray was educated first at his local school – where he excelled in all subjects – and then at nearby Minto school, where he showed an aptitude for languages, including classical Greek. At the age of seventeen he worked as a teacher at Hawick Grammar School before being appointed headmaster of Hawick Academy, a private school. In his spare time he continued to study up to twenty-five extra languages, according to his own reckoning, and pursued the science of philology with great enthusiasm.

In 1873, when Murray was a master at Mill Hill School, London, he was appointed Editor of the OED and entrusted with the task of producing a monumental work of reference. He believed that the dictionary would be completed by 1891, but in fact it was not finished until 1928, several years after his death. He assembled a huge army of volunteer readers from all over the English-speaking world, who would send in slips of papers for individual words which then had to be collected, sorted and checked before being edited. One of the readers was William Chester-Minor, an American army surgeon, who was imprisoned in Broadmoor Asylum for having committed murder whilst suffering from a psychiatric disorder. This man alone produced 12,000 quotations. The first part of the dictionary – A to Aunt – was published in 1879, the second – Ant to Batten – in 1885, after which Murray left Mill Hill School so that he could devote all his time to the dictionary.

Murray, together with his wife Ada Agnes and their eleven children, first came to Oxford in 1885; they settled at Sunnyside, 78 Banbury Road, Oxford. In the garden of this house, he constructed a purpose-made corrugated iron building to accommodate the slips of paper on which the dictionary entries were written. In time these pieces of paper collectively weighed three tons. Murray would work in his cold, damp scriptorium for the next thirty years, together with a small band of assistants, including his children. The volume of mail was eventually so great that the Post Office placed a special pillar box outside his home to collect it. It is still there today.

Murray was knighted in 1908 for his work on the dictionary and received honorary degrees from nine universities, including one from Oxford, just a year before his death in 1915. After a long illness, during which he insisted on working on the dictionary, he died at his home on 26 July from heart failure. He was buried in nearby Wolvercote Cemetery.

The OED was completed in 1928. Murray had been responsible for about half of the whole work.

Sources:

Oxfordshire Blue Plaques Scheme

Burchfield, R.W., 'Murray, Sir James Augustus Henry (1837-1915)', *Oxford Dictionary of National Biography*, Oxford University Press, 2004; online edn, May 2007 (http://www.oxforddnb.com/view/article/35163, accessed 10 Dec. 2010)

Hibbert, C. and Hibbert, E. (Eds), *The Encyclopaedia of Oxford*, 1988

BLESSED GEORGE NAPIER (1550-1610): *Catholic priest and martyr*
OXFORD PRESERVATION TRUST PLAQUE: OXFORD CASTLE

George Napier (sometimes called Napper) was born in Holywell Manor in 1550, the son of Edward Napper, a former Fellow of All Souls, and Anne Peto. An undergraduate at Corpus Christi College, Oxford, he was expelled in 1568 for being a recusant (meaning a 'refuser') Roman Catholic. In 1580 he was arrested for his Catholic sympathies, imprisoned for eight years and finally released after declaring allegiance to Queen Elizabeth I. He went to France, where he trained for the Catholic priesthood at the English College at Douai, a college which had been founded in 1569 to educate Roman Catholics who were fleeing the English on the re-establishment of Protestantism under Elizabeth. Napier was ordained

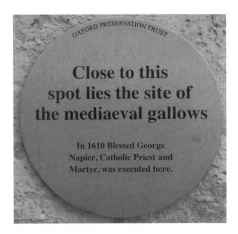

OXFORD PRESERVATION TRUST

Close to this spot lies the site of the mediaeval gallows

In 1610 Blessed George
Napier, Catholic Priest and
Martyr, was executed here.

a secular priest in 1596, and in 1603 returned to England as a missionary for the Catholic cause, entrusted with re-establishing the Church in this country.

This was a very dangerous time for Catholics, and especially priests. In 1585, an Act of Parliament had been passed which made it a treasonable offence, punishable by death, to be a Catholic priest in England, or to give shelter or aid to one. Napier came back to Oxford and lived very quietly, some of the time with his brother William and his family at Holywell Manor, and at other times in the countryside where he ministered to his flocks. For several years he managed to go about his duties without being stopped, but on the morning of 16 July 1610 he was arrested at Kirtlington, and found to have holy oils, consecrated hosts and a small reliquary on his person. This was seen as conclusive proof of his priesthood.

Napier was brought back to Oxford Castle and indicted for being a priest. He was condemned, but his friends hoped to get his sentence commuted to one of banishment. Napier, however, reconciled a highwayman named Faulkner (who shared his cell with him) to the Catholic Church, and refused to swear an oath of allegiance. These two defiant acts sealed his fate. In the early afternoon of 9 November 1610, after having said Mass that morning, he was hanged, drawn and quartered. According to the seventeenth-century historian Anthony à Wood, Napier's body parts were placed on the four gates of the city, while his head was impaled on a spike on Christ Church gate. Soon afterwards, a man, believed to be connected to his family, collected them and had them buried in the chapel of Sandford Manor (now a barn).

George Napier was beatified by Pope Pius XI in 1929, and a plaque in his honour was unveiled at Oxford Castle on 23 October 2010, 400 years after his death.

The name of Napier is preserved by a little bridge over Holywell Mill Stream, at the bottom of Manor Road, which is still known as Napper's Bridge.

Sources:

http://www.catholic.org/encyclopedia/view.php?id=8329
http://www.oxfordtimes.co.uk/leisure/8492145.Memorial_for_a_Catholic_martyr/Chris Koenig
http://www.balliolmcr.com/history
http://www.live.com/

PAUL NASH (1889-1946): *Artist*
BLUE PLAQUE: 106 BANBURY ROAD, OXFORD
PAUL NASH PAINTINGS: ASHMOLEAN MUSEUM, BEAUMONT STREET, OXFORD

Oxford is fortunate to be linked to one of the most significant British artists of the twentieth century. Paul Nash is that rare being – a painter whose work was much acclaimed during his lifetime and whose reputation today, so many years after his death, has continued to soar. Renowned for war, Surrealist and landscape paintings, his art reflects an almost mystical,

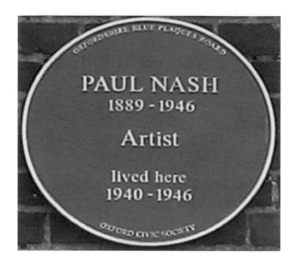

mysterious feeling for landscape, combined with ideas of modernism and the avant-garde; attributes which he used to great effect in his war paintings.

Nash's links with Oxford were established towards the end of his life, his reputation having been established during the First World War with his angry artistic responses to the brutality of war. In 1939, aged fifty, Nash moved to Oxford with his wife Margaret, herself an Oxford-educated campaigner for Women's Suffrage. They lived in rented accommodation in Beaumont Street and Holywell Street, before settling in a ground-floor flat at 106 Banbury Road. Soon after moving, Nash set up the Arts Bureau for War Service and, in 1940, the Ministry of Information and the Air Ministry again appointed him as an official war artist (having been one in the First World War). It was during these final years of his life, living in Oxford during the Second World War, that Nash produced the dramatic paintings 'Battle of Britain' (1941, Imperial War Museum, London) and 'Totes Meer' (1940-41, Tate Collection), depicting wrecked German aircraft at Oxfordshire's Cowley Dump, an aircraft salvage site during the Second World War.

Paul Nash was born in London on 11 May 1889. His father, William Harry Nash, was a successful barrister whose first wife, Caroline Maude Jackson, was Nash's mother. Caroline had naval connections and Nash was expected to enrol in the navy, but did not pass his entrance exams. He returned to finish his schooling at St Paul's School, London, before deciding, aged seventeen, to take up art as a career. He studied first at Chelsea Polytechnic School of Art, from 1906-1908, and at the Slade School of Fine Art, where he met Stanley Spencer, Mark Gertler, Ben Nicholson and a host of other brilliantly talented young artists – but the course disappointed him and he left after a year to concentrate on landscape painting, at which he excelled.

An early source of artistic inspiration for the young Nash was Oxfordshire's Wittenham Clumps. He was fixated by the power of this ancient landscape; it featured strongly in a series of drawings in his first show at London's Carfax Gallery in 1912, and was to be a place he would visit and paint all his life. In these early works, Nash demonstrates a debt to the English Romantic movement, and especially to the art of Rossetti and Samuel Palmer, and the poetry of William Blake. These landscapes have a sense of indefinable mystery and strangeness about them – or, to use his own words, 'genius loci' (spirit of a place). As Nash later said:

> Ever since I remember them the Clumps had meant something to me. I felt their importance long before I knew their history. They eclipsed the impression of all the early landscapes I knew … They were the Pyramids of my small world.

(Extract from *Outline* by Paul Nash)

Nash's art took on an altogether darker, brooding quality as a result of his military experiences during the First World War. His stark observations of conflict were to influence his art for the rest of his life, and resulted in some of the most hard-hitting and enduring images of the effects of war. In 1917, when serving as official war artist, Nash produced the powerful and desolate 'The Menin Road', one of his most famous paintings, which reflected his anger and despair at the carnage and futility of conflict.

Later, between the wars, when Nash found himself 'a war artist without a war', he allowed himself to return to his favourite subjects of ancient monoliths and clumps of trees. He taught at the Royal College of Art, and immersed himself in several artistic projects, designing posters, textiles and ceramics, as well as printmaking and photography. He also gained a reputation as a distinguished art critic and essayist. Nash was instrumental in setting up the short-lived but influential Unit One, a group consisting of Henry Moore, Barbara Hepworth, Ben Nicholson, and others, who wished to promote modern architecture and the arts. In 1935, he was commissioned by John Betjeman to compile and write *Dorset: Shell Guide* for the Shell-Mex series.

The idyll of peace was not to last, and, once again, in 1939, Nash (who was now in Oxford) found himself a witness to another savage war and involved in producing war art. The depressing turn of events weighed heavily on him. In poor health and suffering from chronic asthma, Nash became a frequent visitor at the Acland Nursing Home in the Banbury Road, not far from his home. He gained solace from his garden, however, and it was here that he was inspired to paint his famous symbolic sunflower painting.

In 1945, Nash's health took a turn for the worse as a result of the chronic asthma that had afflicted him since childhood. A year later he contracted pneumonia and, on 11 July 1946, aged fifty-seven, he died in his sleep while on holiday in Boscombe, near Bournemouth. He is buried in Langley, Buckinghamshire.

Sources:

Oxfordshire Blue Plaques Scheme

Lisle, Nicola, *Oxford Limited Edition* magazine

Myfanwy Piper, 'Nash, Paul (1889-1946)', rev. Andrew Causey, *Oxford Dictionary of National Biography*, Oxford University Press, 2004; online edn, May 2009 (http://www.oxforddnb.com/ view/article/35186, accessed 18 Nov. 2010)

http://www.tate.org.uk/liverpool/exhibitions/nash/chronology_html.htm

http://www.cercles.com/n1/bowen.pdf

··

THE OLD FIRE STATION
STONE PLAQUE: GEORGE STREET, OXFORD

Before 1870, the fire services in Oxford were mostly privately owned or belonged to the university and colleges, but in that year two people died in a fire. As a result, a volunteer fire brigade was created which worked in conjunction with the local police. In 1873-1874, a headquarters and engine house were built in New Inn Hall Street, followed in 1896 by a new station in George Street manned by sixty firemen. In 1941 the firemen, now professionals, were assimilated into the National Fire Service. In 1948 they were back under local government control. They remained in George Street until 1971 when they moved to new headquarters in Rewley Road.

The building in George Street was conceived as a fire station and a corn exchange. It was designed by H.W. Moore and erected by two separate builders. T.H. Kingerlee built the fire station, and Thomas Axtell the corn exchange. The fire station comprised 'an engine room, drill shed, watch room and workshop, with a tower about 60 feet high for hanging hose pipes'.[1] It also contained rooms on the upper floors and a house for the resident fireman.

After the premises were vacated in 1971 they were used by various arts-based enterprises. At the time of writing, Oxford City Council, together with Crisis Skylight Oxford, are redeveloping the Old Fire Station as an arts-focused space and Crisis Skylight Centre.

Sources:

1. *Jackson's Oxford Journal*, 4 May 1895, taken from http://www.headington.org.uk/oxon/george_street/fire_station.html

http://www.british-history.ac.uk/report.aspx?compid=22819#s8

Hibbert, C. and Hibbert, E. (Eds), *The Encyclopaedia of Oxford*, 1988

http://www.crisis.org.uk/pages/crisis-skylight-oxford.html

THE OLD SCHOOL (CENTRAL BOYS' SCHOOL) 1898-1934
PLAQUE: ON FRONT OF BUILDING IN GLOUCESTER GREEN, OXFORD

In 1868, the Congregationalists built an undenominational school for boys on the east side of Gloucester Green, which they opened in 1871 as the Central Boys' School. The school flourished and gained an excellent reputation, with pupil numbers rising from thirty-three on its opening to 192 in 1898, when it was taken over by the school board. The board then built another school, designed by Leonard Stokes, on the north side of Gloucester Green, between 1898 and 1900. In 1912, the school changed its entry requirements. From then on boys were expected to take an entrance exam. They would not be admitted under the age of ten and would have to leave at the age of sixteen. In 1932, plans were put forward to turn part of Gloucester Green into a car park. That prospect, together with insufficient space, led to the school being closed, with the pupils transferred in 1934 to the newly opened Southfield School. The building was then used as a bus waiting room, and in recent times housed the Tourist Information Centre, before its move to Broad Street. It is now a restaurant.

Sources:

http://www.british-history.ac.uk/report.aspx?compid=22826#s34

Hibbert, C. and Hibbert, E. (Eds), *The Encyclopaedia of Oxford*, 1988

OXFORD CASTLE REGENERATION PROJECT
PLAQUE: OXFORD CASTLE AND FORMER PRISON SITE

Oxford Castle was built by Robert D'Oilly, a Norman baron, between 1071 and 1073, in order to dominate the Anglo-Saxon population and to give the Normans control of the Upper Thames Valley. It contains St George's Tower, which is one of the oldest buildings in Oxford, and the Castle Mound. Both date from the eleventh century. In recent years, the Tower was on the English Heritage At Risk Register, before it was repaired, the work being completed in 2005.

In its earlier years, the castle was used by royalty and was a backdrop to a number of dramatic events. One of the most exciting of these incidents concerns the Empress Matilda, daughter of King Henry I of England and his rightful heir. Matilda was staying at Oxford Castle during the harsh winter of 1142, when her cousin, Stephen, who was fighting her for the Crown, entered the town with his army and laid siege to the castle. Aware of the danger she was in, Matilda camouflaged herself in a white cloak, and, accompanied by three knights, also clothed in white, fled into the snowy landscape and managed to reach safety at nearby Abingdon.

Centuries later, the castle was used as an administrative centre and as a prison. In 1785 the old gaol site was redeveloped with two wings – one for debtors, the other for felons – with St George's Tower being used to house condemned prisoners. In 1788 a house of correction, with separate wings for men and women, was added, and later alterations provided exercise yards. The prison was enlarged once again in 1850. In 1888 it became HM Prison Oxford, and closed in 1996 when it was converted into a hotel.

On 5 May 2006, Her Majesty Queen Elizabeth II unveiled a plaque to celebrate the restoration of the castle and former prison site. The restoration was carried out under the auspices of the Oxford Preservation Trust, with key players Oxfordshire County Council (landowner of the site), the Heritage Lottery Fund, SEEDA (South East England Development Agency), the Osborne Group and Trust for Oxfordshire's Environment contributing financially to the project.

Today, the 5-acre site contains several attractive public spaces, around which are a heritage visitor attraction, an education centre, several restaurants and bars, and a number of residential apartments.

Sources:

Hibbert, C. and Hibbert, E. (Eds), *The Encyclopaedia of Oxford*, 1988

http://www.oxfordpreservation.org.uk/projects/castleyard/index.php

http://www.princes-regeneration.org/sustainableheritage/content/case-study-oxford-castle-oxford-0

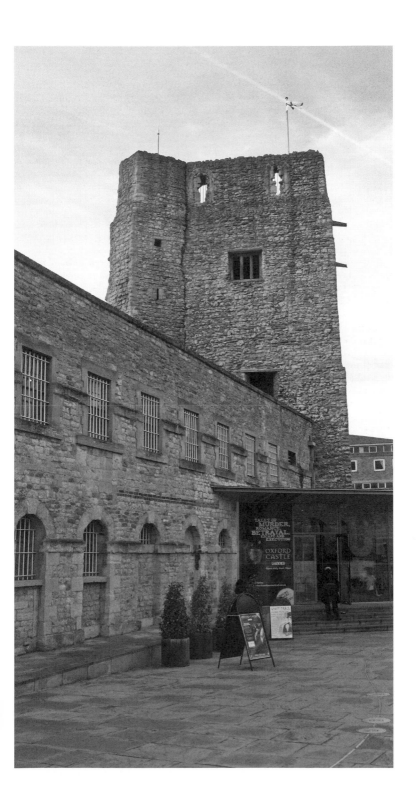

OXFORD PLAYHOUSE FIRST AUDITORIUM 1923-1938
BLUE PLAQUE: 12 WOODSTOCK ROAD. OXFORD

In 1906, Charles Victor Peel, a big game hunter, opened a private museum of natural history and anthropology to promote the outdoor life and big game hunting. Amongst his collection of stuffed animals were elephants, a hippo, a polar bear and Gerald the Giraffe (or George, as he was previously known). In order to accommodate Peel's 'trophies', the building was erected to somewhat unusual specifications. It measured 70ft long by 42ft, the side walls being 20ft high to the roof plate. When Peel left Oxford for Exeter in 1911, the collection was acquired by the Royal Albert Memorial Museum in Exeter, which now gives Gerald pride of place as the museum mascot. Before leaving, Peel sold the building to George Layton, who wanted it as a motor garage, and he in turn sold it to the auctioneer Alfred Ballard.

Alfred Ballard intended to use his building for auctions, and, because he was a keen amateur actor, as an auditorium for the City of Oxford Dramatic Club. At the same time, Jane Ellis, a young London actress eager to establish a repertory company in Oxford, invited J.B. Fagan, the eminent director, to run the new company, and persuaded Ballard to join them and rent out his auditorium to them. Ballard agreed, and in 1923 the Woodstock Road auditorium became the Oxford Playhouse, with the company of actors now renamed The Oxford Players. What no one had foreseen, however, was opposition to the theatre from the university in the person of the Vice-Chancellor Dr Lewis Farnell, who feared for the students' morals. However, after some persuasion from Lord Curzon, the Chancellor of the university, he allowed the theatre to put on its first play.

On 22 October 1923, the Playhouse opened with a production of George Bernard Shaw's *Heartbreak House*, with the playwright himself attending the first performance, which had Tyrone Guthrie, Flora Robson, John Gielgud, Raymond Massey, Margaret Rutherford and Robert Donat amongst the players. Other highbrow productions followed, and in time more variety crept into the programme in order to attract a wider audience, but it was always a struggle to keep the theatre going. The Playhouse received little support from the public or the university, and in 1929 Fagan resigned. Apart from competition from the New Theatre and the cinemas in the city, the Playhouse was lacking in amenities and it became clear that a new venue would have to be found. Eric Dance, co-director with Stanford Holme in 1936, helped finance the new venue by investing a large part of his inheritance in the project and mounting a successful fund-raising campaign. Thanks mainly to his efforts, the new purpose-built Playhouse Theatre in Beaumont Street opened in October 1938, with a production of J.B. Fagan's play *And So To Bed*, in homage to its first director.

Twelve Woodstock Road now houses Oxford University Language Centre, which is part of Academic Services and University Collections.

Sources:

Oxfordshire Blue Plaques Scheme

Chapman, Don, *Oxford Playhouse, High and Low Drama in a University City*, University of Hertfordshire Press, 2008

Hibbert, C. and Hibbert, E. (Eds), *The Encyclopaedia of Oxford*, 1988

OXFORD TOWN HALL
FOUNDATION STONE: CORNER OF ST ALDATE'S AND BLUE BOAR STREET

The foundation stone of the present Town Hall was laid by Mayor Thomas Lucas on 6 July 1893 and is inscribed with the names of the Mayor and Sherriff of Oxford, as well as the architect and builder. The stone, which weighed half a ton, had to be re-laid when the original builder, John S. Chapel, went bankrupt and was replaced by John Parnell & Son.

The present Town Hall, designed by Henry T. Hare, was opened by the Prince of Wales, later King Edward VII, on 12 May 1897. It stands on the site of a previous town hall (1752-1896), which in its turn had replaced the old Guildhall of 1292. Originally planned as a large chamber within the Municipal Building, which once contained council offices, a law court, police station and library, today the whole site is known as the Town Hall and is the seat of local government. The former library on the corner of St Aldate's and Blue Boar

Street has become the Museum of Oxford. Above the doorway, a stone inscription bears a quote from Sir Francis Bacon's *Essays*, which reads in Latin: 'Studies serve for delight, for ornament, and for abilities.'

The façade of the building is richly decorated with sculptures by the architectural sculptor William Aumonier.

Sources:

http://www.chem.ox.ac.uk/oxfordtour/oxfordcitytours/townhall.asp

Hibbert, C. and Hibbert, E. (Eds), *The Encyclopaedia of Oxford*, 1988

Pevsner, N. and Sherwood, J. *The Buildings of England, Oxfordshire*, 1990

Norbury, Wendy, 'Oxford Town Hall: Planning, building, and financing the Oxford municipal buildings of 1898', *Oxoniensia* LXV, 2000

..

PARSONS' ALMSHOUSES NAMED AFTER JOHN PARSONS (1752-1814)
PLAQUES: KYBALD STREET, OXFORD

An inscription set in the centre of a row of almshouses in Kybald Street, off Magpie Lane, and previously known as Grove Street, states:

> In fulfilment of the charitable intention of John Parsons Esq Alderman of this City who died Feb 12 1814 this alms house for four poor men and four poor women was erected and endowed in the year 1816.

A second plaque beneath reads:

> In 1959 the building became part of UNIVERSITY COLLEGE through the generosity of HELEN and FRANK ALTSCHUL of New York City who built a new Parsons' Almshouse in St Clements.

The older plaque refers to a row of eight houses which were built in accordance with the wishes of John Parsons, the son of Thomas Parsons, a merchant, and Grace Godfrey of Oxford. Parsons was twice elected Mayor of Oxford (1788-1789 and 1808-1809). He started his business life as a mercer, before owning Fortnums, an established hatter's shop in the city. In 1781 he entered into partnership with William Fletcher, another mercer, to form the Fletcher & Parsons business, which developed into a bank at 91-92 High Street. The bank lasted for over 200 years before closing. The site is now a hotel. Parsons died at home on 12 February 1814 and is buried in the Church of St Mary the Virgin, across the street from his house in the High Street.

Parsons stipulated that the men and women who applied to reside in the almshouses had to be single people below the age of forty, with incomes of less than £40 a year. They were to attend St Mary the Virgin Church every Sunday. As well as ensuring accommodation for these individuals, Parsons left instructions that they should also receive a small pension.

In the twentieth century, another generous philanthropist – Frank Altschul, founder and chairman of the General American Investors Co. – and his wife Helen, contributed funds for the building of new almshouses in St Clements when the original ones, which belong to University College, were needed to accommodate students. The Altschuls also helped finance the construction of the Goodhart Building at University College, which is named after Helen's brother, Arthur Lehman Goodhart, who was Master of the college from 1951-1963 – the first American to be elected to this post.

Sources:

http://www.british-history.ac.uk/report.aspx?compid=22827#s3

http://www.headington.org.uk/oxon/mayors/1714_1835/parsons_john_1788_1808.htm

http://www.lse.ac.uk/collections/law/wps/WPS2010-01_Goodhart.pdf

WALTER PATER (1839-1894): *Author, scholar* and CLARA PATER (1841-1910):
Pioneer of women's education

BLUE PLAQUE: 2 BRADMORE ROAD, OXFORD

MEMORIAL PLAQUE TO WALTER PATER: BRASENOSE COLLEGE ANTECHAPEL

WALTER:

Walter Horatio Pater was a scholar, writer of essays, and art critic who turned his back
on the prevailing views of his time – which were that art was a vehicle for moral or
educational purposes – and advocated the idea of 'art for art's sake'. He became the leading
champion of the aesthetic movement in the nineteenth century. Pater spent much of his
adult life in Oxford.

Walter Pater was one of four children born to Richard Pater, a surgeon, and his wife
Maria (*née* Hill) at Shadwell near London. Pater was tutored privately at home with his
siblings until 1852, when he attended grammar school before going to King's College,
Canterbury, in 1853. The effect of the beauty of Canterbury Cathedral would stay with
him all his life. He wrote poetry at school, and became an avid reader of authors such as
Tennyson, Dickens, and Ruskin, whose book *Modern Painters* greatly influenced him. He
was a bright pupil and left school for the Queen's College, Oxford in 1858, having gained
prizes for Latin and ecclesiastical history.

After reading Classics at the Queen's College, Pater became a Fellow of Brasenose in
1864 and would remain at the college as tutor for the rest of his life. He was a popular
master who had many friends among his students, including Oscar Wilde, Gerard Manley
Hopkins and W.B. Yeats. When not in college, he would travel to Europe. One such visit
to Italy in 1865 inspired a number of essays, which were collected and published in 1873
under the title of *Studies in the History of the Renaissance*, a work of flawless and rhythmical
prose, which delighted the aesthetes but annoyed more conservative members of the
university, who rejected what they saw as its promotion of hedonism and amorality. Nor
did they like the sexualised language contained in the book, with words such as 'passion'
and 'ecstasy' being used to convey the author's aesthetic philosophy, and the homoerotic
themes which focused on male beauty and friendship. Because of the backlash against his
book, it would not be until 1885 that he would publish his next one, *Marius the Epicurean*.
Other books followed, including *Imaginary Portraits* (1887) and *Plato and Platonism* (1893).

For most of his life, except for a short time spent in Kensington, Pater lived in Oxford,
at No. 2 Bradmore Road (between 1869 and 1885), where he provided a home for himself
and his two sisters, and then at No. 64 St Giles in 1893. Pater died suddenly from a heart
attack on 30 July 1894. He was buried in Holywell Cemetery, Oxford.

CLARA:

Clara Pater was an early professional woman in the field of classics, and an activist for
higher female education. She was an active committee member of the Oxford branch of the

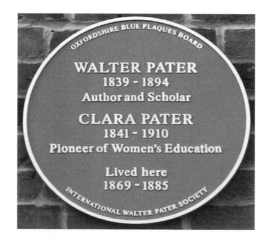

Association for Promoting the Higher Education of Women, and was the first Classics tutor at the newly-founded Somerville College in 1879. She was also the college's first Resident Tutor in 1885. Virginia Woolf was privately tutored by her in Latin, Greek and German.

Clara was the youngest child of Richard and Maria; she was only one year old when her father died, and thirteen years old on her mother's death. Like her siblings, she was privately tutored at home. She and her sister Hester completed their education in Germany whilst under their aunt's care, but when she too passed away they returned to London in 1863 to stay with another relative.

In 1969, Clara and Hester joined Walter in Oxford, and it was while she lived at Bradmore Road that she began to study Latin and Greek in earnest. Her Latin tutor was Henry Nettleship, Fellow of Corpus Christi College, and an eminent Latinist. Her class included Mrs Humphry Ward, Mrs Max Muller, Charlotte Green and Louise Creighton, amongst others. These women would be instrumental in establishing the first two women's halls at Oxford in 1885, Lady Margaret Hall and Somerville. Clara was appointed the first Classics tutor at Somerville, and in 1885 the first Resident Tutor, a post she held for nine years, before resigning in 1894, just before her brother Walter's death. When he died, she left Oxford altogether and returned to Kensington, where she died on 9 August 1910. She was buried with her brother at Holywell Cemetery.

Sources:

Oxfordshire Blue Plaques Scheme

Brake, Laurel, 'Pater, Walter Horatio (1839-1894)', *Oxford Dictionary of National Biography*, Oxford University Press, 2004; online edn, May 2006 (http://www.oxforddnb.com/view/article/21525, accessed 9 Dec. 2010)

..

PEACE STONE, 1814
CARFAX, OXFORD

A stone with the words 'Peace was proclaimed in the City of Oxford' was set in the base of the north wall of Carfax Tower on 27 June 1814, which at that time was part of St Martin's Church. It commemorated the short-lived peace which ensued between England and France after the capture and exile to Elba of Napoleon Bonaparte. Napoleon escaped from Elba, and it was not until 18 June 1815 that he was finally defeated by Great Britain and her allies.

..

PEACE STONE, 1814
ST CLEMENTS, OXFORD

A peace stone at St Clements, with the words 'Peace was Proclaimed in the City of Oxford, June 27 1814' can be found beneath a lamp post on the Plain roundabout. It celebrates

exactly the same event as the Carfax peace stone. The old church of St Clements stood on the site until 1829, when it was knocked down.

The premature celebrations of Napoleon's downfall were not only carved in lasting stone. They were fêted in more animated style when the Tsar of Russia, the King of Prussia, the Prince Regent, and other VIPs including the Duke of Wellington (who later became Chancellor of the university) and General Blucher, all gathered together to enjoy a magnificent celebratory banquet at the Radcliffe Camera!

Sources:

Hibbert, C. and Hibbert, E. (Eds), *The Encyclopaedia of Oxford*, 1988
http://www.oxfordtimes.co.uk/leisureold/pasttimes/4481499.Riots_weren_t_just_Town_versus_Gown/

THE PENICILLIN MEMORIAL TABLET
MONUMENT: PENICILLIN ROSE GARDEN, OXFORD BOTANIC GARDEN, ROSE LANE, OX1 4AZ

A stone monument with the following inscription stands outside the entrance to Oxford's Botanic Garden:

THIS ROSE GARDEN WAS GIVEN IN HONOUR OF THE RESEARCH WORKERS IN THIS UNIVERSITY WHO DISCOVERED THE CLINICAL IMPORTANCE OF PENICILLIN. FOR SAVING OF LIFE, RELIEF OF SUFFERING AND INSPIRATION TO FURTHER RESEARCH. ALL MANKIND IS IN THEIR DEBT. THOSE WHO DID THE WORK WERE

E P ABRAHAM	E CHAIN
C M FLETCHER	H W FLOREY
M E FLOREY	A D GARDNER
N G HEATLEY	M A JENNINGS
J ORR-EWING	A G SANDERS

Presented by the
ALBERT and MARY LASKER FOUNDATION
New York June 1953

Both the inscription and the Rose Garden in which the memorial is situated commemorate one of the greatest scientific breakthroughs of the twentieth century. The names belong to the scientists at Oxford University who developed the antibiotic drug penicillin.

In 1938, following Alexander Fleming's discovery ten years earlier of a mould which killed bacteria, Howard Florey, the new Professor of Pathology at the university, in collaboration with the biochemist Ernst Chain, gathered together a group of scientists from different disciplines to work on the isolation and purification of penicillin. The team worked under difficult circumstances during the Second World War, with little funding and very little equipment, but they succeeded in extracting and purifying the drug and testing it first on mice, when they discovered its life-saving potential, and then on humans. In order to produce penicillin in large quantities, Florey and Heatley had to seek help from the USA, where large-scale production of the antibiotic was achieved in time to be used to treat casualties in the Normandy landings. Thanks to the work of this team, antibiotics have saved the lives of countless numbers of people worldwide.

Howard Florey and Ernst Chain were awarded the Nobel Prize in Physiology or Medicine in 1945, together with Alexander Fleming, for their work on penicillin.

BRIEF BIOGRAPHIES:

HOWARD WALTER FLOREY, Baron Florey, OM, FRS (1898-1968) was an Australian pharmacologist and pathologist. He was Professor of Pathology and Fellow of Lincoln College, Oxford, and headed a team working on extraction and purification of penicillin. Florey was awarded the Lister Medal in 1945, was elected President of the Royal Society

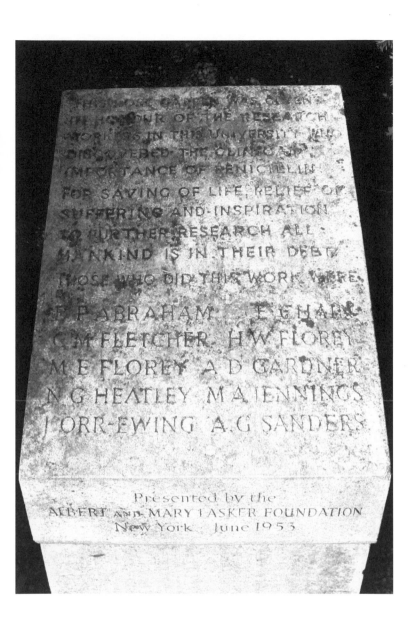

THIS PLAQUE WAS GIVEN IN HONOUR OF THE RESEARCH WORKERS IN THIS UNIVERSITY WHO DISCOVERED THE CLINICAL IMPORTANCE OF PENICILLIN FOR SAVING OF LIFE, RELIEF OF SUFFERING AND INSPIRATION TO FURTHER RESEARCH ALL MANKIND IS IN THEIR DEBT THOSE WHO DID THIS WORK WERE

E P ABRAHAM E CHAIN
C M FLETCHER H W FLOREY
M E FLOREY A D GARDNER
N G HEATLEY M A JENNINGS
J ORR-EWING A G SANDERS

Presented by the
ALBERT AND MARY LASKER FOUNDATION
New York June 1953

in 1959 (the first Australian to ever hold this post), and became Provost of Queen's College, Oxford in 1962. He was made a Life Peer in 1965, with the title of Baron Florey of Adelaide in the Commonwealth of Australia, and of Marston in the county of Oxford. He was also Chancellor of the Australian National University from 1965 to his death in 1968.

SIR ERNST BORIS CHAIN (1906-1979) was a German-born British biochemist whose work covered a large number of areas, including snake venom and tumour metabolism. He was instrumental in rekindling interest in penicillin, having read Fleming's papers on the subject. Together with Howard Florey he investigated natural antibacterial agents produced by organisms, and theorised on the structure of penicillin. Chain received many awards, including the Institut Pasteur Medal in 1946 and the Paul Ehrlich Centenary Prize in 1954. He was elected Fellow of the Royal Society in 1949, and was Commander of the

Legion d'Honneur, and Grande Ufficiale al Merito della Repubblica Italiana. Chain was knighted in 1969.

EDWARD PENLEY ABRAHAM, CBE, FRS (1913-1999) was an English biochemist. Abraham was involved in the purification process and the determination of penicillin's chemical structure. He was one of the first three 'Penicillin' research Fellows at Lincoln College, in recognition of his contribution to the penicillin project. Together with Guy Newton, he developed Cephalosporin C. This was another great breakthrough, since cephalosporins are able to kill penicillin-resistant bacteria. Abraham patented the antibiotic and set up funds which benefited education. In 1958 he became a Fellow of the Royal Society. In 1973 he was appointed CBE, and was knighted in 1980.

CHARLES MONTAGUE FLETCHER (1911-1995), a clinician, demonstrated that penicillin was non-toxic to humans by injecting very sick patients with it. It was his job to carry their urine every day from the Radcliffe Infirmary to the Sir William Dunn School of Pathology, so that the precious substance could be extracted for re-use. In later life he became Professor of Clinical Epidemiology at the Royal Postgraduate Medical School, London. He campaigned vigorously against smoking and for the importance of communication in medicine.

MARY ETHEL HAYTER REED, known as Ethel Florey (1900-1966), was Howard Florey's first wife. A medical scientist, she left Australia to marry Florey. After interrupting her medical career to bring up her children, she first worked for the Oxford Regional Blood Transfusion Service, and then joined her husband, taking part in conducting trials of penicillin in various hospitals, including the Radcliffe Infirmary. She collaborated with Florey on the book *Antibiotics* and authored *The Clinical Application of Antibiotics*.

ARTHUR DUNCAN GARDNER (1884-1977) was Professor of Bacteriology at the Sir William Dunn School of Pathology, under Howard Florey. He studied the effects of penicillin on the microbes which caused the most problems for humans, and confirmed that penicillin was neither an enzyme nor an antiseptic. He was Regius Professor of Medicine at Oxford from 1948-1954.

NORMAN GEORGE HEATLEY (1911-2004) was a biochemist and inventor whose technical skills were vital in isolating the penicillin from the mould. He played a major role in the development of penicillin. (*See* separate entry.)

DR MARGARET AUGUSTA JENNINGS (1904-1994), a histologist who trained at the Royal Free Hospital, was a research assistant and colleague of Howard Florey. She became his second wife in 1967 after the death of his first wife in 1966. She and Florey published thirty papers jointly.

JEAN ORR-EWING (1897-1944) was a pathologist with an additional interest in surgery. She graduated from Lady Margaret Hall, Oxford where she was later elected to a Fellowship. Orr-Ewing worked with Gardner on the effects of penicillin on microbes, and was a valued member of the team.

DR ARTHUR GORDON SANDERS (1908-1980) was chosen by Florey as a specialist in blood transfusion. He was greatly valued also for his technical skills, especially in designing equipment for the manufacture of penicillin.

The memorial was endowed by the Albert and Mary Lasker Foundation of New York. Philanthropists, Albert Lasker and his wife Mary (*née* Woodard) set up the foundation in 1942 to finance medical research. The Foundation states that 'its programmes are dedicated to the support of biomedical research towards conquering disease, improving health and extending life'.

The Penicillin Rose Garden was designed by Dame Sylvia Crowe.

JOSEPH PRESTWICH (1812-1896): *Professor of Geology*

PLAQUE: PRESTWICH PLACE, BOTLEY ROAD, OXFORD
BUST OF PRESTWICH: NATURAL HISTORY MUSEUM, OXFORD
PRESTWICH PLACE: BOTLEY ROAD, OXFORD (NAMED AFTER HIM)

Few individuals in the world have the privilege of having a dinosaur named after them, let alone the most complete skeleton of a genus found in Europe, but *Camptosaurus prestwichii* was named after Joseph Prestwich, the eminent Professor of Geology at the University of Oxford from 1874–1887. Prestwich, a far-sighted scientist, proposed the building of a Channel Tunnel years before it was considered feasible. In Oxford, he was considered one of the prime movers in initiating the drainage of Botley marshes, and in providing clean water to the city. He was also a great advocate of women's education at a time when females were not particularly welcome at the university.

Joseph Prestwich was born in Clapham on 12 March 1812. His father, who was also Joseph, was a wealthy wine merchant and his mother, Catherine (*née* Blakeway), was the daughter of a porcelain manufacturer. Joseph was educated at schools in London and Reading, but spent two years in Paris between the ages of twelve and fourteen where he became fluent in French. Prestwich was passionate about science, amassing a collection of rocks and minerals, and setting up his own laboratory at home, whilst attending University College, London, where he was studying chemistry and natural sciences. Even after joining the family firm after graduating, he spent every spare moment on geological research. In fact, he would combine his business visits to France with studies on the geology of that country.

In 1833, Prestwich became a Fellow of the Geological Society, reporting on his observations of the coalfields of Coalbrookdale in Shropshire in 1834 and 1836. These accounts were later published in the *Transactions of the Geological Society*, as were his studies on the geology and fossils of Scotland. Later on in his life he would put his observations to good use when he wrote a couple of reports pinpointing the possible locations of coal seams. In the 1840s, he concentrated his efforts on the Tertiary geologic period deposits of the London Basin, which he compared with others of the same period in France and Belgium, and then classified. He was awarded the Geographical Society's Wollaston Medal in 1849 for this work. Prestwich became an authority on water, writing a standard work on the subject in 1851 titled *A Geological Inquiry Respecting the Water-bearing Strata of the Country Around London*; he was also elected a member of the Royal Commission on Water Supply. The city of Oxford would benefit from his expertise in the 1880s, when he involved himself in advising on the draining of Botley marshes and on the provision of a clean water supply to the city.

PRESTWICH
PLACE

JOSEPH PRESTWICH,
PROFESSOR OF GEOLOGY
WAS INFLUENTIAL IN
GAINING IMPROVEMENT TO
THE POOR DRAINAGE
OF NEW BOTLEY
IN THE 1880's.

In the course of his many observations on different aspects of geology, he became interested in questions of archaeology and the history of ancient man. In 1858 he visited Abbeville in France, where, together with John Evans, the archaeologist and geologist, he confirmed that flint tools found in bone-bearing gravel deposits in the area were proof of the antiquity of man. This was groundbreaking science, and his papers published in the Proceedings of the Royal Society 1859-1860 were very well received. Prestwich was awarded a Royal Medal by the Royal Society in 1865 for this work.

The year 1870 was important for Prestwich. In February he married Grace Anne McCall, who was the niece of his friend Hugh Falconer, another geologist. Grace was a geologist in her own right, and enjoyed helping her husband with his work and his numerous travels. When Prestwich accepted the post of Professor of Geology at Oxford University in 1874, two years after retiring from his business, they came to live in the city. She helped him prepare his lectures, and published scientific papers in her own right, as well as novels and travel articles. They spent fourteen happy years in Oxford, where he wrote his most important work, *Geology: Chemical, Physical and Stratigraphical* (vol. ii, 1888). For a short time, they leased 34 Broad Street, an elegant house on the corner of Holywell Street and Catte Street. This house was demolished in 1882, however, to make way for the Indian Institute which is now the university's Faculty of History Library. Also in 1870, Prestwich was elected President of the Geological Society.

After retiring from Oxford in 1888, Prestwich and his wife went to live at Darent Hulme in Shoreham, Sussex, the home he had built in the 1860s. A tireless worker, he continued his geological research right up to the end of his life. He died at home on 23 June 1896, a few short weeks after receiving a knighthood, and is buried in Shoreham.

During the severe flooding that affected Oxfordshire in July 2007, the street in the small cul-de-sac in the Botley Road (named after Prestwich) was one of the first in the area to dry out – thanks to efficient drainage.

Sources:

Thakeray, John C., 'Prestwich, Sir Joseph (1812-1896)', *Oxford Dictionary of National Biography*, Oxford University Press, 2004 (http://www.oxforddnb.com/view/article22736, accessed 4 Jan. 2011)

http://www.earth.ox.ac.uk/about_us/history?SQ_DESIGN_NAME=text_only&SQ_ACTION=set_design_name

http://www.earth.ox.ac.uk/about_us/history

http://journals.cambridge.org/action/displayFulltext?type=1&fid=5179732&jid=GEO&volumeId=6&issueId=08&aid=5179728

http://sp.lyellcollection.org/cgi/content/abstract/281/1/251

THE PROTESTANT MARTYRS

THOMAS CRANMER (1489-1556); HUGH LATIMER (1487-1555); NICHOLAS RIDLEY (1500-1555)

PLAQUE: WALL OF BALLIOL COLLEGE, BROAD STREET, OXFORD

COBBLED STONES IN THE SHAPE OF A CROSS, MARKING THE SITE OF THE MARTYRDOM AT THE STAKE: CENTRE OF ROAD IN FRONT OF BALLIOL COLLEGE, BROAD STREET, OXFORD

MARTYRS' MEMORIAL: ST GILES, OXFORD

In 1553 Edward VI, the Protestant only son of King Henry VIII, died. He was succeeded by his half-sister Mary Tudor, the only daughter of Catherine of Aragon, and a devout Catholic. Mary felt it her sacred duty to restore the Roman Catholic Church in England.

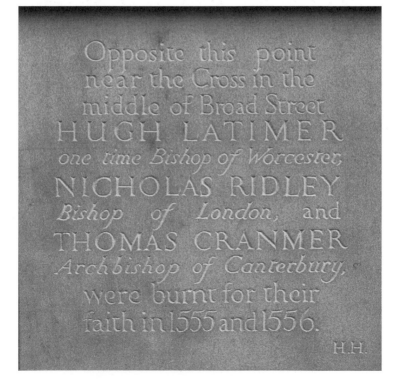

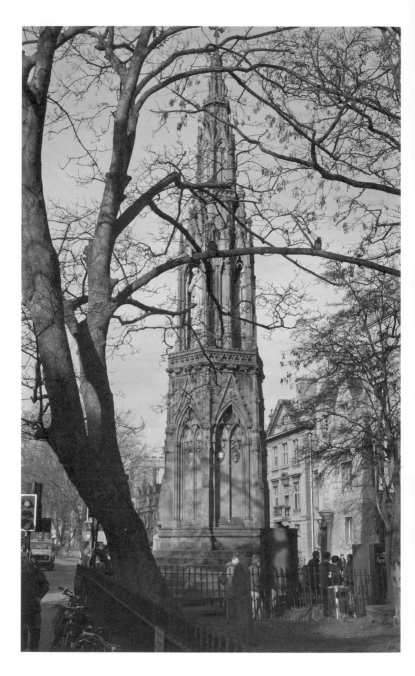

To that end, she abolished all religious laws passed by Edward, and reinstated the heresy laws which allowed individuals judged to be heretics against the Catholic Church to be legally punished. Once found guilty of heresy in court, they would be handed over to the secular authorities for execution.

In 1555, two Protestant bishops, Hugh Latimer and Nicholas Ridley, were burnt at the stake in Oxford after being found guilty of heresy. The following year, Archbishop Thomas Cranmer suffered the same fate. On the wall of Balliol College in Broad Street, is a plaque which commemorates their deaths in. It reads:

Near the Cross in the middle of Broad Street HUGH LATIMER – one time Bishop of Worcester NICHOLAS RIDLEY – Bishop of London THOMAS CRANMER – Archbishop of Canterbury were burned for their faith in 1555 and 1556.

The cross to which the plaque refers is made of cobbles set into the road, and marks the approximate site of the burnings.

In March 1554, Cranmer, Latimer and Ridley were incarcerated in Bocardo Prison (located near the Church of St Michael at the North Gate, Cornmarket, and demolished in 1771) prior to being tried. Before the trial, the three men were allowed to take part in disputations to defend their views. On 14 April they were taken to the University Church of St Mary the Virgin, in the High Street, where they were informed that the subjects they would have to debate would be the Real Presence at Mass and Transubstantiation and the Mass as sacrifice. Additionally, Cranmer would have to give a written statement of his beliefs. On 16 April, and the following few days, the disputations took place in the Divinity School, and on 20 April all three accused were taken to St Mary the Virgin, where they were informed that their arguments had been proved false. They were then given an opportunity to recant. All three refused and were then declared heretics. Latimer and Ridley were excommunicated and were burned at the stake on 16 October 1555, in a ditch close to the northern city wall, with Cranmer witnessing the proceedings from a nearby tower.

Cranmer's ordeal was to continue. Mary had not forgotten that it was he who, as Archbishop of Canterbury, had declared Henry VIII's marriage to her mother Catherine of Aragon void, thereby making her illegitimate in the eyes of the law. Cranmer, too, had married Henry to Anne Boleyn shortly afterwards. To add to his transgression, he had supported Lady Jane Grey as successor to the crown on Edward VI's death. For this last offence he had already been tried and found guilty of high treason, and had been sentenced to be hanged, drawn and quartered. Mary, however, wanted him charged with the greater offence of heresy. Following the April disputations in 1555, he was tried again in September before the Pope's Commissioners, was found guilty, and was allowed to appeal. In January and February 1556 he wrote five separate recantations submitting to papal authority, but before writing his sixth and last one he was told he was to be burned. On 21 March 1556, he was taken to St Mary the Virgin once again and, after a sermon by the Provost of Eton, Dr Cole, he was asked to inform the congregation that he believed in the Catholic faith. Cranmer, however, standing on a raised platform, dramatically repudiated his recantations, saying, 'Forasmuch as my hand offended in writing contrary to my heart, therefore my hand shall first be punished; for if I may come to the fire it shall be first burned.' He was hurried from the church and taken to the stake in front of Balliol College, where it is said he stretched his right hand into the fire, crying out: 'This hand has offended!' As he was dying, he was heard to say: 'I see Heaven open and Jesus standing at the right hand of God.'

In the nineteenth century, an imposing Victorian Gothic stone memorial was raised on the north side of St Mary Magdalen Church, facing St Chiles to honour the memory of the three Protestant martyrs. It was built between 1841 and 1843 to a design by the architect George Gilbert Scott, who modelled it on the thirteenth-century Eleanor crosses. (These monuments were erected by Edward I in memory of Queen Eleanor.) The memorial displays statues of Cranmer, Latimer and Ridley by the sculptor Henry Weekes. Thomas Cranmer is facing north, holding a Bible marked 'May 1541' (which refers to his preface for this particular edition of the Great Bible, written in English). Latimer, with head bowed and arms crossed, is facing west, while Ridley faces east. An inscription with the following words is to be found on the base of the north side of the monument:

To the Glory of God, and in grateful commemoration of His servants, Thomas Cranmer, Nicholas Ridley, Hugh Latimer, Prelates of the Church of England, who near this spot yielded their bodies to be burned, bearing witness to the sacred truths which they had affirmed and maintained against the errors of the Church of Rome, and rejoicing that to them it was given not only to believe in Christ, but also to suffer for His sake; this monument was erected by public subscription in the year of our Lord God, MDCCCXLI.

The Martyrs' Memorial was the brainchild of Revd Golightly and other like-minded Anglican clergy, who were alarmed at what they saw as the Catholic leanings of the

proponents of the Oxford Movement (Tractarians) led by John Keble, John Henry Newman, Edward Bouverie Pusey and others. They launched an appeal to pay for the memorial, which they sited by St Mary Magdalen, the church where most of the prominent members of the Oxford Movement worshipped and preached, in order, it is said, to remind the Tractarians of their Protestant roots.

A plaque commemorating all the martyrs of the Reformation in Oxford, both Protestant and Catholic, can be found inside the University Church of St Mary the Virgin, High Street, Oxford. It is inscribed with the names of twenty-three people who died for their faith between 1539 and 1681.

Sources:

MacCulloch, Diarmaid, 'Cranmer, Thomas (1489-1556)', *Oxford Dictionary of National Biography*, Oxford University Press, 2004; online edn, Jan. 2008 (http://www.oxforddnb.com/view/article/6615, accessed 11 Jan. 2011)

Hibbert, C. and Hibbert, E. (Eds), *The Encyclopaedia of Oxford*, 1988

http://en.wikipedia.org/wiki/Oxford_Martyrs

REWLEY ROAD RAILWAY STATION

PLAQUE: ON THE PAVEMENT IN FRONT OF THE ENTRANCE TO SAID BUSINESS SCHOOL, PARK END STREET, OXFORD

A rather fine plaque, placed on the site of the former Rewley Road railway station, informs the passer-by that:

A station was erected on this site in 1851 by the Buckinghamshire Railway to coincide with the Great Exhibition of 1851, using the same cast iron components. This station was dismantled and re-erected at Quainton Road Station, Buckinghamshire by the Quainton Railway Society as a working museum in December 2000.

Before Rewley Road railway station was opened in 1851, there was a great deal of opposition from the university, the town, and business interests – particularly the Oxford Canal Co. – to routing a railway line through Oxford. When the university finally dropped its opposition, a line from Bletchley to Oxford was opened by Buckinghamshire Railway, with a terminus built on the site of Rewley Abbey. The Buckinghamshire Railway was later owned by the London & North Western Railway (LNWR), which was in turn subsumed in 1948 by the London, Midland & Scottish Railway (LMS). On an adjacent site of what is the present railway station, the Great Western Railway opened its station in 1852, and in 1933 the two stations came under joint management. All railways were nationalised in 1948.

The station was erected by Fox, Henderson Ltd, the same company which built Joseph Paxton's Crystal Palace in London, using cast iron bolt-together components. The roof was glazed in line with Paxton's designs.

Rewley Road closed to passengers in 1951 but the goods yard remained till 1988. The station building was dismantled in 1999, when building started on the Said Business School.

Sources:

Hibbert, C. and Hibbert, E. (Eds), *The Encyclopaedia of Oxford*, 1988

http://wapedia.mobi/en/Oxford_Rewley_Road_railway_station

..

CECIL RHODES (1853-1902): *Mining magnate, politician*
PLAQUE: PORTRAIT BUST ON WALL OF NO. 6 KING EDWARD STREET, OXFORD
STATUE OF RHODES IN THE CENTRE BAY OF THE RHODES BUILDING: HIGH STREET, OXFORD

In this house, the Rt. Hon Cecil John Rhodes kept academical residence in the year 1881. This memorial is erected by Alfred Mosely in recognition of the great services rendered by Cecil Rhodes to his country.

So reads the inscription at the base of the large metal plaque bearing the image of Cecil Rhodes, a former student and benefactor of Oriel College, Oxford. The Rhodes scholarship, which is named after him, is funded by his estate.

Cecil John Rhodes, the fifth son of Francis William Rhodes, a vicar, and his second wife Louisa (*née* Peacock), was born in Bishop's Stortford, Hertfordshire on 5 July 1853. He was educated at the local grammar school, but showed no great enthusiasm to follow his father into the church as was expected of him. When he fell ill, his parents sent him to join his brother Herbert in Natal, where it was hoped that the climate would help him to recover. Rhodes was only seventeen when he arrived in South Africa but soon showed entrepreneurial flair by investing money his aunt had lent him in a diamond mine in Kimberley. A year after he arrived, he left his brother's cotton farm for Kimberley in order to supervise the working of Herbert's mining claim, discovering many diamonds in the process. Diamonds would be the means by which he arrived at his great wealth once he settled permanently in South Africa.

In 1873, Rhodes returned home to complete his education. He was admitted to Oriel College and went to live in lodgings at No. 18 High Street, but fell ill again after taking part in the intercollegiate sport of rowing, and left after only a term. His doctor at the time believed that he would die within six months. After going back to South Africa, he was able to recuperate, and with his health somewhat restored, he returned to Oxford in 1876 where he lived first at No. 116 High Street and then at No. 6 King Edward Street. He finally obtained his degree at the age of twenty-eight. Rhodes by then had acquired a belief that English-speaking people could help establish ideals of justice, liberty and peace in the world – ideas which would eventually lead to the founding of the Scholarships which bear his name.

Rhodes House, which administers the Rhodes Scholarships, was built between 1926 and 1929 as a permanent memorial to Cecil Rhodes. It is situated in South Parks Road, Oxford, and was designed by Sir Herbert Baker. Its distinctive copper-domed rotunda is surmounted by a bronze Zimbabwe bird, which is the national emblem of that country. (Before its independence in 1980, the country had been known as Rhodesia, then as Southern Rhodesia, and lastly as Zimbabwe-Rhodesia.)

IN THIS HOUSE THE RIGHT
HON. CECIL JOHN RHODES
KEPT ACADEMICAL RESIDENCE
IN THE YEAR 1881.
THIS MEMORIAL IS ERECT-
ED BY ALFRED MOSELY
IN RECOGNITION OF THE
GREAT SERVICES RENDERED
BY CECIL RHODES TO
HIS COUNTRY.

Cecil Rhodes suffered from a weak heart for much of his life. He died from heart failure at his home in Muizenberg, outside Cape Town, in 1902, and was buried at World's View, Matobo National Park, Zimbabwe.

Sources:

Marks, Shula and Trapido, Stanley, 'Rhodes, Cecil John (1853-1902)', *Oxford Dictionary of National Biography*, Oxford University Press, 2004; online edn. Oct. 2008 (http://www.oxforddnb.com/view/article/35731, accessed 16 Jan. 2011)

http://www.rhodesscholar.org/

..

JAMES SADLER (BAPTISED 1753, DIED 1828): *Balloonist, chemist, engineer and inventor*

PLAQUE: ON THE WALL OF MERTON COLLEGE, FACING CHRIST CHURCH MEADOW ON DEAD MAN'S WALK

James Sadler, an extraordinarily intrepid and courageous man, was the first Englishman to fly successfully at a time when the international race to take to the skies was in its infancy. That he did so in a hazardous contraption of silk and paper over a contained fire makes the feat all the more extraordinary. This hero of the skies came from Oxford and chose to take his first flight from Merton Field, right in the middle of the city. Today, a plaque on the wall of Merton College, facing Christ Church Meadow, records Sadler's great achievement. It states:

James Sadler
1753 – 1828
First English Aeronaut
who in a fire balloon
made a successful
ascent from near this
place ~ 4th October 1784
to land near Wooderson

James Sadler 1753-1828 First English Aeronaut who in a fire balloon made a successful ascent from near this place – 4th October 1784 to land near Woodeaton.

Sadler was born in High Street, Oxford, the eldest son of James Sadler, a pastry cook and confectioner who ran two shops in the city. From a young age, Sadler showed a great interest in science and engineering, and at the first possible opportunity began to work as a technician in the university's Chemical Laboratory, where his love of science and skill at making things enabled him to carry out various experiments. His interests at this time included studying the properties of gases by filling small balloons with these substances. Sadler was one of the first chemists to use coal gas to make light. The knowledge he gained by his close observations helped him when he began to fly manned balloons.

His fascination with ballooning was no doubt sparked off by the knowledge that the French, who were the leading pioneers in the field of flight at this time, were working on machines which would enable people to take to the air. When the Montgolfier brothers

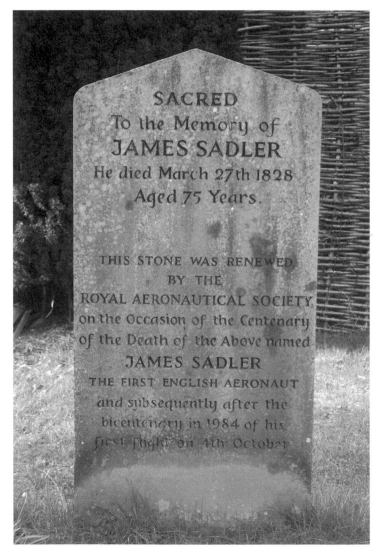

achieved the first ever manned flight in a hot air balloon in 1783, Sadler, inspired by the news of this amazing feat, decided it was time for an Englishman to take to the air.

On 4 October 1784, James Sadler, in a 170ft homemade balloon, made his first ascent from Christ Church Meadow, Oxford. The *Oxford Journal* of that day recorded that the balloon, 'powered by rarefied air', rose to a height of over three-quarters of a mile, flew at that altitude for about half-an-hour and then landed in the village of Woodeaton, six miles away. This glorious achievement ensured Sadler his place in history as England's first aeronaut.

Sadler was not someone who rested on his laurels, however. Just over a month later he made his second ascent, in a hydrogen balloon this time, taking off from the Physic Garden (now the Botanic Garden) and landing badly in Aylesbury nearly twenty minutes later. Sadler went on to fly several more times, experiencing several narrow shaves but miraculously avoiding severe injury. He left ballooning for a while to concentrate on his other scientific and engineering interests.

At Oxford University, Sadler worked with Thomas Beddoes who was Reader in Chemistry there. Beddoes greatly respected Sadler, who he believed was 'a perfect prodigy in mechanics' and encouraged him in his experiments with steam engines. During this time, he worked on driving wheeled carriages using steam power; he also designed and patented a turbine.

In 1793 Beddoes left Oxford, and two years later so did Sadler, when he was appointed Barracks Master at Portsmouth. In 1796 he was appointed Chemist to the Board of Naval Works in London, in whose service he conducted several important experiments. However, after several years of loyal service to the Naval Board he was dismissed in 1809, and found himself without work and heavily in debt.

In order to make a living, Sadler took up ballooning again, joined by his two sons John and Windham. He made several more flights but gave up soon after Windham was killed in a ballooning accident in 1824. Not long after this tragic event, Sadler, a broken and impoverished man, returned to Oxford where he died on 26 March 1828. He was buried four days later at St Peter-in-the-East Church, which is now part of St Edmund Hall. His gravestone, which was renewed by the Royal Aeronautical Society, can still be seen in the churchyard.

This was a sad end for a hugely talented man who had not only participated in the birth of British aeronautics, but whose vital contributions to the fields of science and engineering helped his country achieve prominence in the era of the Industrial Revolution.

Sources:

Torrens, H.S., 'Sadler, James (bap. 1753, d. 1828)', *Oxford Dictionary of National Biography*, Oxford University Press, 2004; online edn, May 2010 (http://www.oxforddnb.com/view/article/37928, accessed 1 Nov. 2010)

http://www.oxforddnb.com/view/article/37928?docPos=1

http://www.chch.ox.ac.uk/news/2007/ballooning-history

http://www.prba.org.uk/page.asp?p_id=16

ST EDWARD'S SCHOOL (TEDDIES) INDEPENDENT SCHOOL, FOUNDED 1863

PLAQUE: NEW INN HALL STREET, OXFORD

The Revd Thomas Chamberlain, a Tractarian (member of the high Anglican Oxford Movement) and vicar of St Thomas the Martyr Church, Becket Street, founded St Edward's School in 1863 in Mackworth Hall, New Inn Hall Street. Unfortunately, the building was badly damaged during a storm, prompting the first warden, the Revd A.B. Simeon, to move it in 1873 to its present site in Summertown, two miles north of the city. The original buildings of the present-day school were designed by William Wilkinson in the Gothic style, and are grouped around a spacious quadrangle. A steep-roofed chapel with an impressive tower, familiar to generations of pupils, dominates the skyline.

Sources:

Hibbert, C. and Hibbert, E. (Eds), *The Encyclopaedia of Oxford*, 1988

Pevsner, N. and Sherwood, J. *The Buildings of England, Oxfordshire*, 1990

ST MARTIN

PLAQUE: CARFAX GARDEN, OXFORD

Over the stone gateway leading into the garden at Carfax (which was once a graveyard, and is now part of a small café), is a copper bas-relief of St Martin. Martin was a Roman soldier who, on seeing a poor beggar out in a snowstorm, instinctively slashed his cloak with a sword in order to share it with him.

The town church of St Martin stood on the site until 1896, when it was demolished. Only the tower and the stone archway are left standing. (*See* section on Carfax Tower.)

DOROTHY L. SAYERS (1893-1957): *Author, scholar and theologian*
PLAQUE: NO. 1 BREWER STREET, OXFORD

Dorothy L. Sayers was a gifted writer and a student of languages. Famous for her detective novels, some of which are set in Oxford and feature the amateur sleuth Lord Peter Wimsey, she was also noted for her short stories, plays, poetry, reviews, essays and translations. A distinguished scholar and Christian theologian, she was one of the first women to be awarded a degree at Oxford University. She also helped found the 'Detection Club' together with G.K. Chesterton, Agatha Christie and others. A woman with a great zest for living and a good sense of humour, Dorothy Sayers was also an enthusiastic motorbike rider and her descriptions of these machines in her writings are technically accurate and clear.

Dorothy L. Sayers was born in the old Choir House at 1 Brewer Street, Oxford on 13 June 1893. She was the only child of Revd Henry Sayers, who was at the time Chaplain of Christ Church and headmaster of the Cathedral School, and his wife Helen Mary Leigh. (The L in Dorothy's name referred to her mother's surname.) When Dorothy was four years old, the family moved to Bluntisham-cum-Earith, an isolated village in East Anglia, where her father was given the living of rector. This part of the world affected her deeply and would later feature as a setting in novels such as *The Nine Tailors*. Schooled at home by governesses in a number of subjects including French and German, and taught Latin by her father when she was six years old, she was a keen and quick-witted pupil. At the age of sixteen she went to Godolphin School in Salisbury, which she did not much enjoy.

Nevertheless, Dorothy continued studying determinedly and was rewarded by obtaining a scholarship to Somerville College in 1912, one of the all-female colleges of Oxford University. She would look back at this time as one of the happiest of her life. A brilliant student, Dorothy flourished at Oxford, relishing her studies, making the most of the social life on offer, joining the Bach Choir and the drama society, and enjoying many friendships. This striking young woman, dressed in flamboyant clothes, would also fall in love at the drop of a hat. She was especially happy when her cousin Ivy Shrimpton, who was like an older sister, moved to Oxford in 1914. She finished her studies in 1915 but had to wait until 1920 before being awarded a First Class Honours degree, since women were not given degrees until that date.

This was not the end of her stay in Oxford. After a short spell working as a teacher in Hull, she returned to the city to work as a publishing assistant to Basil Blackwell, the publisher and bookseller. Her office, which was situated above the shop in Broad Street, faced the Sheldonian Theatre, and she was lucky enough to reside very close by in Longwall and Bath Place. The job and beautiful surroundings were not sufficient inducements to keep her in the city however, and in 1922 she accepted work as a copywriter at S.H. Bensons, the largest advertising agency in London. The following year, her suave and debonair fictional gentleman detective, Lord Peter Wimsey, was introduced to the reading public for the first time when her novel *Whose Body?* was published. In her 'Lord Peter Wimsey' novels,

Dorothy would use Oxford as a backdrop to her tales, making Wimsey an alumnus of Balliol College. In fact, the twelfth book in the series, *Gaudy Night*, is set in the fictional 'Shrewsbury College', which was based on Somerville, and her heroine Harriet Vane is a writer very much like herself. In the novel, Harriet Vane and Peter Wimsey get married in Oxford.

Whilst her publishing life was a success, her private life was most certainly not. On the rebound from one love affair she became involved with Billy White, a motor car salesman, and became pregnant by him. In those days it was shameful to have a baby out of wedlock, and Dorothy, who was a devout Christian, would have found this situation doubly difficult. The baby, John Anthony (Tony), was born in January 1924. She never formally acknowledged her son, not wishing her parents to know of his birth, but arranged for him to be looked after by her cousin Ivy, whom she swore to secrecy. Ivy kept her secret, and it was only after Dorothy's death, when Tony was made sole beneficiary of her will, that her friends found out. She did, however, correspond with her son, and when she married Oswald Atherton 'Mac' Fleming in 1926, Tony assumed the Fleming name and was introduced as their adopted son. Unfortunately the marriage was not a happy one, since Fleming suffered increasingly from ill health as a result of his war experiences and was envious of Dorothy's success, but Dorothy supported him and stayed with him until he died in 1950.

Dorothy stopped writing detective stories in the mid-1930s and turned to drama, producing a number of plays, including *The Man Born to be King*, first broadcast on radio in 1941. Her theological writings became increasingly important to her, with her critically acclaimed essay, *The Mind of the Maker* (also published in 1941), considered a brilliant discourse on the subject of the creative process in the light of the Christian doctrine of the Trinity. She reserved her greatest passion for the poetry of Dante Alighieri, learning ancient Italian in order to produce a verse translation of his 'Divine Comedy'. Unfortunately, she died suddenly on 18 December 1957 from a massive heart attack, and never completed her translation. She was cremated and her ashes were buried at St Anne's Church, Soho, where she had been church warden for many years. Her son Tony died in Florida on 28 November 1984.

Dorothy L. Sayers had a great talent to instruct and amuse. A rumbustious character with a booming voice and a larger-than-life personality, she was at the same time a sensitive and perceptive woman who is still greatly admired for the quality of her writing and the profound themes of her work.

Sources:

Kenney, Catherine, 'Sayers, Dorothy Leigh (1893-1957)', *Oxford Dictionary of National Biography*, Oxford University Press, 2004 (http://www.oxforddnb.com/view/article/35966, accessed 2 Jan. 2011)

http://www.sayers.org.uk/

http://news.bbc.co.uk/local/oxford/hi/people_and_places/history/newsid_8129000/8129149.stm

..

SHELDONIAN THEATRE
BROAD STREET, OXFORD

The Sheldonian Theatre is one of the most important university buildings. It is 'the regular meeting place of Congregation, the body of Masters of Arts which controls the University's affairs'.[2] Commissioned by the Chancellor of the university, Gilbert Sheldon, Archbishop of Canterbury (1663-1677), to provide a secular site for 'the enactment of university business' and ceremonies, it was one of the first buildings to be designed by Christopher Wren, who based his plans on Seraglio's illustrations of the Theatre of Marcellus in Rome. It was the first classical building erected in Oxford, completed in 1669. Its façade faces the Divinity School. The structure, which is in the shape of a capital D, was designed to hold a ceiling that spans 70ft by 80ft without supporting crossbeams. The prominent octagonal lantern in the centre of the roof was erected in 1838 and was designed by Edward Blore.

The inside of the building contains tiered seats which can accommodate 2,000 people at one time, and some finely carved woodwork by Richard Cleer, which includes the Chancellor's Throne and two orators' pulpits. The organ case dates from 1876 and was designed by Sir T.G. Jackson. The wooden columns are painted to look like marble, and the

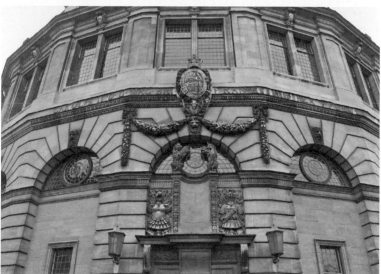

ceiling has an allegorical painting by Robert Streater, which depicts the triumph of Truth descending on Religion, Arts and Sciences in order to expel ignorance in the form of envy, hatred and malice. It is possible to reach a room over the ceiling which once housed the first Oxford University Press. It is well worth the effort of climbing the many stairs for the view from the cupola of the city below.

Today, the building is used for university degree ceremonies, including Encaenia, when honorary degrees are awarded to distinguished men and women, and for lectures such as the annual Romanes Lecture. Musical recitals and concerts are frequently held at the Sheldonian.

The stone heads that stand on pillars in front of the Sheldonian Theatre and the Museum of the History of Science in Broad Street are known as Emperors' Heads, although the official name for them is 'herms'. Each head, which weighs a ton, is distinctive, and sports a different beard to its companions. They are the third set to be carved since the seventeenth century; the present heads are the work of sculptor Michael Black and two assistants, who

completed the work in 1972. The original carvings were by William Byrd, the Oxford stonemason, who was commissioned by Christopher Wren to carve fourteen heads.

Sources:

2. http://www.ox.ac.uk/subsite/sheldonian_theatre/sheldonian_theatre/about_the_theatre/

Pevsner, N. and Sherwood, J. *The Buildings of England, Oxfordshire*, 1990

Hibbert, C. and Hibbert, E. (Eds), *The Encyclopaedia of Oxford*, 1988

...

SIR FRANCIS SIMON (1893-1956): *Low temperature physicist and philanthropist*
BLUE PLAQUE: 10 BELBROUGHTON ROAD, OXFORD

Franz Eugen Simon, one of the foremost physicists of his age, was born into a wealthy Jewish family in Berlin on 2 July 1893, the only son of Ernst Simon and Anna (*née* Mendelssohn). His aptitude for physics was recognised whilst he was still at school, and despite family opposition to the subject, and the interruptions to his studies brought about by compulsory military service, followed by action during the First World War, he gained his doctoral degree from the University of Berlin in 1921.

Simon was part of a research group working on low temperature physics under the leadership of Walther Nernst (discoverer of the third law of thermodynamics), the director of the physics and chemistry institute of the university. By 1927 he was promoted to associate professor, and was considered the most outstanding low temperature physicist of his generation. In 1931 he was appointed Chair of Physical Chemistry at Breslau, and in 1932 travelled to the United States as visiting professor at the University of California, Berkeley. It was whilst there that he devised a simple and cheap method of liquefying helium.

After Hitler came to power, Simon, who had been awarded the Iron Cross first class for his war service and was therefore exempt from being dismissed from his university post, decided to accept an invitation from F.A. Lindemann (later Lord Cherwell), to join the Clarendon Laboratory in Oxford, arriving at the university in August 1933. In 1936 he became Reader in Thermodynamics, and a Student of Christ Church in 1945. It was mainly thanks to his efforts that the Clarendon Laboratory's Thermodynamics School became one of the largest and most important in the world.

During the Second World War, Simon, by now a naturalised UK subject, worked on the 'Tube Alloys' Project, which was later incorporated into the Manhattan Project in the US. He was very influential in Britain's atomic energy developments, both during and after the war. In 1941 he was elected Fellow of the Royal Society, and in 1949 the Chair of Thermodynamics at Oxford University was created especially for him. Simon

was also scientific correspondent for the *Financial Times* (1948-1951), where he took the opportunity to express his forthright views on several topics, including the shortage of scientists and engineers being trained in post-war Britain. Many honours came his way, including the award of the Royal Society's prestigious Rumford Medal in 1948, followed by a knighthood in 1954. In 1956, when Cherwell retired, Simon succeeded him as head of the Clarendon Laboratory, but died of coronary heart disease at the Radcliffe Infirmary, Oxford, on 31 October 1956, less than a month later.

The Simon family home was No. 10 Belbroughton Road, Oxford, within easy reach of the Clarendon Laboratories. It was at this house that Simon and his wife Charlotte entertained their friends, and provided hospitality for numerous refugees and former students. Simon, who had an affinity with young people, was proud of his students and regarded them as members of his family. Lady Charlotte, who outlived her husband, continued to live in the house until her death.

Sources:

Oxfordshire Blue Plaques Scheme

Kurti, Nicholas, 'Simon, Sir Francis Eugen (1893-1956)', rev. *Oxford Dictionary of National Biography*, Oxford University Press, 2004; online edn, May 2008 (http://www.oxforddnb.com/view/article/36096, accessed 9 Dec. 2010)

..

FELICIA SKENE, PSEUDONYM ERSKINE MOIR (1821-1899): *Writer, prison reformer, friend of the poor*

BLUE PLAQUE: NO. 34 ST MICHAEL'S STREET, OXFORD

PLAQUE: OXFORD CATHEDRAL

There is very little in Felicia Skene's early life to suggest that she would spend much of her adult life championing the cause of social outcasts, the poor and the sick, nor that much of her adult life would be spent in Oxford. As the youngest child of James Skene, a Scottish lawyer, and his wife Jane Forbes, the daughter of a baronet, Felicia was born in Aix-en-Provence, France on 23 May 1821. Hers was a privileged upbringing, spent mainly in France, Scotland and Greece, where, at a young age, she mixed with royalty, diplomats and celebrities of the day. Her whole life changed on meeting Thomas Chamberlain, an Oxford vicar and passionate champion of the High Church Movement, and his cousin Marian Hughes, the first Anglican nun to be ordained in England since the Reformation. Much influenced by their religious ideals and their work among the poor and disadvantaged of the city, Skene moved to Oxford with her family in 1849, residing first at No. 28 Beaumont Street and then at Frewin Hall.

It was in Oxford that Skene began to dedicate her life to the service of others. Concerned by the effects that outbreaks of smallpox and cholera were having on the city's population – which she probably witnessed at first hand since one of the worst hit areas was Chamberlain's parish of St Thomas's – she set up teams of nurses to care for the sick. (Some of these women went on to work with Florence Nightingale in Scutari during the Crimean war.) Her organisational abilities were much admired by the likes of Sir Henry Acland, the eminent physician, and Benjamin Jowett, the distinguished academic.

Skene's skills were not confined to practical work alone. She was a prolific writer whose subjects included poetry, travel writing, novels, works on religion, and books on social issues, especially prison reform. Her booklet 'Penitentiaries and Reformatories' (1865) and her novel of 1866, *Hidden Depths*, tackle head-on the problems of prostitution and the appalling conditions of prisons current at the time – causes which were particularly close to her heart. She wrote with authority, having seen for herself the inhumane nature of Britain's penal service. Over the next few years, until the end of her life, Skene devoted herself increasingly to improving conditions for inmates of prisons, especially after being granted official permission to become a regular visitor, the first Englishwoman to be allowed this consideration. She also involved herself in saving girls from prostitution.

In 1869, Skene moved into No. 34 St Michael Street, Oxford, which would be her home for the next thirty years, and from where she would busy herself in many different spheres of activity. From the very beginning she welcomed friends, undergraduates and less fortunate members of society to her house, where they were all made to feel equally welcome. She helped at nearby St Edward's School in New Inn Hall Street, which had been established by her old mentor Thomas Chamberlain, and busied herself with writing; but above all she devoted herself tirelessly to the rejects of society, who, in their turn, took her very much to their hearts.

This compassionate and kindly woman died of bronchitis at her home in St Michael Street on 6 October 1899, and was buried in St Thomas's churchyard, Oxford.

Sources:

Oxfordshire Blue Plaques Scheme

Sanders, Andrew, 'Skene, Felicia Mary Frances (1821-1899)', *Oxford Dictionary of National Biography*, Oxford University Press, 2004; online edn, Oct. 2009 (http://www.oxforddnb.com/view/article/25666, accessed 6 Feb. 2011)

..

SOUTH PARK
STONE PILLAR: HEADINGTON HILL, OXFORD

South Park, located on Headington Hill, East Oxford, is the largest park in Oxford. Until 1932 the land was owned by the Morrell family, who were local brewers and lived at Headington Hill Hall. They sold the land to the Oxford Preservation Trust on the proviso that no building should ever be constructed on the land. In 1959, the Trust sold it on to the City of Oxford to provide a park for the benefit of the community.

The lettering on the stone pillar outside South Park in St Clements is by Eric Gill, one of the most famous stone engravers of the twentieth century. It records the acquisition of the 60 acres of land by the Oxford Preservation Trust through the generosity of The Pilgrim Trust and David and Joanna Randall-MacIver.

The Pilgrim Trust was set up in 1930 by Edward Stephen Harkness, an American philanthropist. According to the Trust's literature, it was decided by the first Trustees that the grants from his endowment were to be used for 'social welfare projects, preservation of buildings and countryside and the promotion of art and learning'. It is named the Pilgrim Trust to signify its ties with the land of the Pilgrim Fathers.

David Randall-MacIver (1873-1945) was a highly-respected British-born archaeologist and anthropologist who graduated from The Queen's College, Oxford with a First Class degree. He established an Oxford University benefaction in the name of his American wife Joanna, who died in 1931. The Joanna Randall-MacIver Benefaction is open only to women candidates.

Sources:

http://www.admin.ox.ac.uk/statutes/354–051d.shtml#_Toc28151656
http://www.thepilgrimtrust.org.uk/about.php
Hencken, T.C., 'MacIver, David Randall – (1873-1945)', rev. S. Stoddard, *Oxford Dictionary of National Biography*, Oxford University Press, 2004 (http://www.oxforddnb.com/view/article/35667 accessed 4 Jan. 2011)
http://www.admin.ox.ac.uk/statutes/354–051d.shtml#_Toc28151656

JOHN STANSFELD (1854-1939): *Parish priest, doctor*
BLUE PLAQUE: FORMER ST EBBE'S RECTORY, PARADISE SQUARE, ST EBBE'S, OXFORD

The Revd Canon John Stansfeld (The Doctor), champion of poor parishioners in Oxford, was the much-loved rector of St Ebbe's between 1912 and 1926. He worked tirelessly at improving living conditions for his flock in Oxford, just as he had at his first parish in Bermondsey, London, where he had established the Oxford Medical Mission to provide free medical treatment and medicine for the poor of the area. In 1919, he set up summer camps on a piece of land at Shotover, for the disadvantaged children of St Ebbe's and of Birmingham. This is now the Stansfeld Outdoor Study Centre, which is run by the Birmingham Education Authority.

John Stansfeld was born in 1854, the son of Alfred and Eliza Stansfeld, and the fourth of six children. At the age of twenty-two he passed his Civil Service exams, obtained employment with the Inland Revenue, and was transferred to Oxford in 1877, bringing with him his widowed mother and his sister Jessie. The three found accommodation at 67 Banbury Road. For the next few years in Oxford, Stansfeld established a rigorous routine of going to work in the city and studying part-time at Exeter College. He also found time to enjoy an active social life. His efforts paid off when he graduated in 1889, having obtained degrees in Theology and Medicine. Shortly after he passed his first MB exam in 1893, the Civil Service transferred him – first to Glasgow, where he was able to work at the Royal Infirmary, and then to the Charing Cross Hospital, London, where he qualified as a doctor in 1897.

In that same year, Stansfeld was invited to set up a medical mission in Bermondsey, London by acquaintances he had previously met when studying for Orders at Wycliffe Hall, Oxford. At the time, Bermondsey was one of the most rundown and deprived areas of London, but Stansfeld was up to the challenge. He provided not only medical treatment but also established boys' clubs and other social facilities for the people of the district. Shortly afterwards he met Janet Marples, a local volunteer, whom he married in 1902. The couple, who were devoted to each other, had two children, Gordon and Janet. Not long after his daughter's birth, Stansfeld achieved his greatest ambition and was ordained. He was appointed Vicar of St Anne's, in Bermondsey very shortly afterwards.

In 1912, Stansfeld was transferred to St Ebbe's, in those days a poverty-stricken and overcrowded area of Oxford. With tremendous energy, he set about improving his parishioners' lives, persuading the City Council to build public baths and encouraging Christ Church to erect a children's playground. He also set up a medical dispensary in the rectory garden and, just as he had done in Bermondsey, he established boys' clubs, recruiting undergraduates to run them. When his wife tragically died from influenza in 1918, he used their scanty savings to buy 20 acres of land at Shotover, to provide a rural retreat and summer camps for the children of his parish and for poor boys from Birmingham, as well as youngsters from Bermondsey.

In 1926 Stansfeld, now seventy-two years of age, went to Kenya, as Principal of Maseno Mission School (an Anglican boarding school), where he stayed for three years, before returning to England on being appointed Rector of All Saints', Spelsbury, Oxfordshire. Here, too, he served his parishioners well and was very popular. This good and kind man, who had devoted his life to others, died after walking two miles to visit a sick parishioner on a cold and rainy December night in 1939. He was greatly missed and was mourned by many, especially at St Ebbe's and in Bermondsey, where he had done so much good.

Sources:

Oxfordshire Blue Plaques Scheme

Lisle, Nicola, *The Oxford Times*, 3 Sept. 2009

http://www.headington.org.uk/history/famous_people/stansfeld.htm

··

STAR INN OXFORDSHIRE YEOMANRY (1794)

BLUE PLAQUE: ENTRANCE TO FREWIN COURT, NO. 34 CORNMARKET STREET (CLARENDON CENTRE), OXFORD

The Clarendon Centre, on the west side of Cornmarket, covers the site of what was once the Star Inn, where the Oxfordshire Yeomanry used to meet. This inn was one of the oldest in Oxford, having a recorded history which goes back to 1337, when a building known as Marshall's Inn was granted to Oseney Abbey by Thomas the Marshall. In 1469, the name was changed to the Star. It became one of Oxford's leading coaching inns in the eighteenth century, welcoming several distinguished guests, including Frederick, Prince

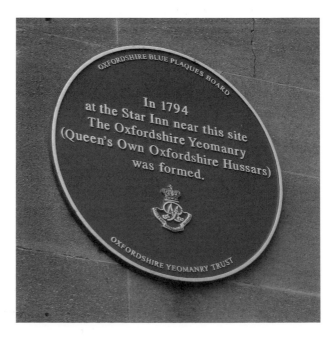

of Württemberg. The exiled Louis XVIII of France stayed at the inn in 1808. With the coming of the railways in the 1850s its fortunes declined for a while, but revived in the 1860s when the university and the town expanded. In 1863 it was acquired by the Oxford Hotel Co. and renamed the Clarendon, when it gained a reputation as one of the best hotels in the area. In 1939 the building was bought by Woolworth & Co., who tore down the building in 1954 in order to build their store. This, in turn, was demolished in 1983 to make way for the Clarendon Centre.

The Star Inn's connection with the Oxfordshire Yeomanry began in 1794, when a meeting of 'Nobility, Gentry, Freeholders and Yeomanry' was called at the inn. This was in answer to the government's appeal to the people of England to form troops of volunteers in the shires, to meet the perceived threat of invasion by French Revolutionary forces, and by insurgents in this country. This led to the formation, in 1798, of the first Yeomanry troop in Oxfordshire, under the command of the Earl of Macclesfield. Other troops in the county followed. In 1803, Lord Francis Churchill formed the First Regiment of Oxfordshire Yeomanry Cavalry, which became the Queen's Own Oxfordshire Hussars (QOOH) after a visit to Oxford by Queen Adelaide in 1835. The Churchills have always taken a keen interest in the regiment, and it was not unusual for several members of the family to serve at the same time. Winston Churchill joined the QOOH in 1902, and was in charge of the Henley Squadron between 1905 and 1913. The regiment was given a special place of honour at his funeral in 1965. Sir Winston had left instructions that the QOOH should march ahead of the coffin in the state funeral procession.

The men of the QOOH served with honour in all the major conflicts of the nineteenth and twentieth centuries. Today, 5 Squadron is the successor of the QOOH. It is a Royal Signals unit of the Territorial Army and serves a special communications role. In 1998, the squadron was granted the Freedom of Banbury to commemorate the bicentenary of the formation of the first Yeomanry Troops.

Sources:

Oxfordshire Blue Plaques Scheme
Hibbert, C. and Hibbert, E. (Eds), *The Encyclopaedia of Oxford*, 1988
Oxfordshire County Council Records, 'Oxfordshire Yeomanry'

SUB-FOUR MINUTE MILE BY ROGER BANNISTER (1954)
BLUE PLAQUE: OXFORD UNIVERSITY SPORTS GROUND, IFFLEY ROAD, OXFORD

One of the most exciting sporting events in the history of British and world athletics took place on 6 May 1954, when Roger Bannister, a young medical student at Oxford University, achieved what had been thought impossible until then, which was to run a mile in less than four minutes. He broke the record in 3.59.4 seconds. This was done on a track which Bannister, several years earlier, had campaigned to have renovated and refurbished, since the original one was bumpy and uneven.

Roger Bannister was born in Harrow, Middlesex on 23 March 1929. He enjoyed running, and, when he went up to Exeter College, Oxford to study medicine, he decided to take up the sport seriously, running his first mile race on the Iffley Road track in 1946. He came second on that occasion, but the following year, whilst representing Oxford University at the White City Stadium, he came first. The ease with which he won this race made him realise that he had a talent for running. Over the next few years he participated in several races, fitting his training around his medical studies and using the knowledge he had acquired from his studies to help him in his training sessions. When he failed to get a medal at the 1952 Olympic Games, however, he decided to concentrate on becoming the first man to run the sub-four minute mile, realising that it would be feasible to run the distance in record-breaking time. With a fierce determination to succeed, and knowing that he had a worthy competitor in John Landy, an Australian runner, Bannister intensified his training. By early May 1954, he was ready.

What he hadn't anticipated on the chosen day, 6 May, were gale-force winds, but they abated just before the race began. Bannister, running for the Amateur Athletics Association against his *alma mater* Oxford University, and paced by his two friends, Christopher Brasher and Chris Chataway, was watched by a crowd of 3,000 spectators. They were not

disappointed. Bannister ran the race of his life that day to come first, and, more importantly, to break all records for the mile.

Less than seven weeks later the record was broken again, by John Landy this time, racing in Finland. However, on 7 August 1954, during the Commonwealth Games in Vancouver, Canada, Bannister beat Landy to win the gold medal in a nail-biting race which both men ran in under four minutes. At the end of August, he won the metric mile (1.500 metres) race in the European Championships in Berne in a record time of 3.43.8 seconds.

After running in Berne, he left competitive sport to concentrate on medicine. Bannister became a pioneering neurologist, and was knighted in 1975 for his services to medicine. From 1985 until his retirement in 1993, Sir Roger was Master of Pembroke College, Oxford. He was also the first chairman of the Sports Council (now Sport England).

Sir Roger, who is now in his eighties, continues to run for pleasure and jogs in the University Parks a couple of times a week, running in Kenyan shoes made from car tyres.

Sources:

Oxfordshire Blue Plaques Scheme

http://www.telegraph.co.uk/sport/othersports/athletics/5033439/Roger-Bannister-80-years-old-but-still-plenty-left-in-the-tank.html

..

SWINDLESTOCK TAVERN ST SCHOLASTICA'S DAY RIOTS, 10 FEBRUARY, 1355

PLAQUE: ABBEY HOUSE, 121 CARFAX, OXFORD

In medieval times, relations between the town and the University of Oxford were extremely uneasy and frequently violent. An innocuous plaque bearing the words 'This was the site of the Swindlestock Tavern 1250-1709', located on the wall of a building in Carfax, gives no indication of the tragic events which were set in motion there on St Scholastica's Day, 10 February 1355.

On that fateful day, several students were drinking in the tavern, when two of them, Walter Spryngeheuse and Roger de Chesterfield, who were probably the worse for wear, started a brawl after complaining about the quality of the drink. Things turned nasty after they threw their quart pots at the publican, John Croydon. The locals, not surprisingly, came to his aid, and a vicious fight ensued, with both sides spilling into the streets. Some students went to St Mary's, the University Church, and rang the bells for reinforcements, while the townspeople did the same at St Martin's, calling the citizens to arms.

The mayor, John de Bereford, and the bailiffs, who were worried at the seriousness of the situation but had no jurisdiction over the students, sought the help of John Charlton, the Chancellor of the university – but he did nothing to help; the following day, several members of both communities died in violent circumstances. The mayor then went to Woodstock, where King Edward III was in residence, hoping to gain the monarch's support. Meanwhile, the townsmen rallied villagers in the surrounding countryside to come to the aid of the town, and they, spoiling for a fight, poured into Oxford, shouting, 'slay, slay, havoc, havoc, smite fast, give good knocks' – before running amok and causing mayhem. The violence intensified yet more the following day, which was a Thursday, and many scholars were brutally killed. Some were actually scalped and their bodies thrown on dung heaps. University buildings, too, were ransacked, and property was stolen and destroyed. When the riots came to an end after three tumultuous days, sixty-three scholars had died, and many more had fled Oxford.

The king, once he had reviewed the events, came down firmly on the side of the university, granting them a new Charter which gave them dominance over the town. The rioters were severely punished, and many citizens, including the mayor, were fined and thrown into prison. The mayor, bailiffs and aldermen were further humiliated when they

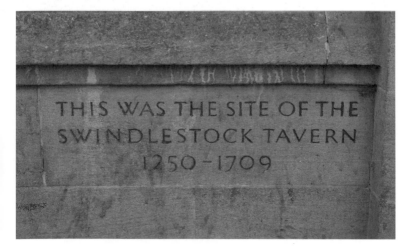

were ordered to attend a Mass in the University Church every St Scholastica's Day, to pray for the souls of those killed during the riots, and forced to make an offering of a penny apiece. They were further obliged to swear an annual oath to observe the university's privileges. After the Reformation, the ceremony was modified but the annual penance was observed (except for a short while during the Civil War). It was finally abolished in 1825.

Those three infamous days of riot led to an uneasy relationship between town and university, with both sides regarding each other with suspicion. For the most part, the notorious events which took place on St Scholastica's Day 1555 have not been repeated, as citizens and students have learnt to live side-by-side.

N.b. St Scholastica was the twin sister of St Benedict of Nursia.

Sources:
Hibbert, C. and Hibbert, E. (Eds), *The Encyclopaedia of Oxford*, 1988
http://users.trytel.com/~tristan/towns/florilegium/government/gvpoli18.html
http://www.oxford.gov.uk/Direct/MuseumStoryofOxford.pdf

..

HENRY TAUNT (1842-1922): *Photographer*
BLUE PLAQUE: 393 COWLEY ROAD, OXFORD

'Artist in watercolours, photographer, author, designer, lecturer, lantern-slide maker, picture-frame maker, gold-blocker and printer, publisher, mount cutter, ornamental card maker, entertainer, gilder', is how Henry Taunt described his occupations in the 1891 Census. He is best known to posterity as a prolific and innovative photographer, a writer of guidebooks, and a publisher of picture postcards.

Henry Taunt was born in Penson's Gardens, St Ebbe's, Oxford on 14 June 1842. His father Henry was a plumber and glazier, and his mother Martha (*née* Darter) came from the village of West Ilsley, Berkshire, where he attended school. He left school early, and in 1856 went to work for the pioneering photographer Edward Bracher, who had premises in central Oxford. Under Bracher's supervision, Taunt learnt the art of photography, becoming expert at taking photographs outdoors. He took his first photograph in about 1858.

By 1869, Taunt owned his own business at 33 Cornmarket Street, from where he sold a series of photographic views of the Oxford area and the River Thames. Thanks to his technical expertise, keen aesthetic sensitivities and clever marketing skills – he advertised them through magic-lantern talks – these pictures were very popular and sold in large numbers, forcing him to move to larger premises in Broad Street, and then to the High Street.

Taunt had, by now, gained a reputation as a photographer of great talent, and in 1871 was invited to become official photographer of the Oxford Architectural and Historical Society, an offer he readily accepted. The following year he published *A New Map of the River Thames*, his survey of the river between Oxford and London. Taunt, who had a great love

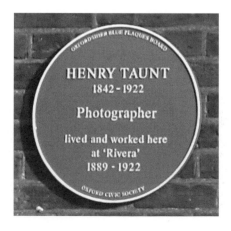

for the Thames, bought a houseboat in 1890 from where he carried out business, dressed in nautical clothes and sporting a yachting cap. He would travel on the water, taking numerous photographs, and these images would be used in his local histories and guidebooks as well as picture postcards. He conveyed his passion for the wonders of the river to thousands of people over the years, and he mapped it so accurately that he was elected a Fellow of the Royal Geographical Society in acknowledgement of his achievement.

Taunt was so passionate about the river that he even renamed Canterbury House, the house he leased in the Cowley Road in 1889, 'Rivera'. In 1906, after giving up his High Street premises, he ran his business from Rivera, where he established a photographic and printing works, and storage for his thousands of glass negatives. By the time he died in 1922, he had amassed a collection of 60,000 glass plates.

This hard-working, self-made man, who had left school at the age of ten, was very community-minded and involved himself in many different areas of life in Oxford. He attended St Mary Magdalen Church in Oxford, where he was choir leader and organist, and, although he and his wife Miriam, whom he had married in 1863, were childless, Taunt would put on annual entertainments for local children. He engaged in various local issues, campaigning for clean water in the city and against electric trams.

Taunt died at Rivera on 4 November 1922 and was buried in Rose Hill Cemetery. His assistant, Randolph Adams, tried to keep the business going but soon gave up, and Oxford City Library bought the photographs in 1924/25, where they can be seen at the Centre for Oxfordshire Studies. The archive of surviving glass-plate negatives is held at the National Monuments Record Centre, Swindon. Images of Taunt's work can be viewed at the English Heritage 'viewfinder' website (*see* sources).

Sources:

Oxfordshire Blue Plaques Scheme

Graham, Malcolm, 'Taunt, Henry William (1842-1922)', *Oxford Dictionary of National Biography*, Oxford University Press, 2004 (http://www.oxforddnb.com/view/article/38438, accessed 8 Feb. 2011)

Hibbert, C. and Hibbert, E. (Eds), *The Encyclopaedia of Oxford*, 1988

http://viewfinder.english-heritage.org.uk

..

J.R.R. TOLKIEN (1892-1973): *Author and scholar*

BLUE PLAQUE: 20 NORTHMOOR ROAD, OXFORD

PLAQUE: 76 SANDFIELD ROAD, HEADINGTON

PLAQUE: EAGLE AND CHILD PUB, ST GILES, OXFORD

ASTEROID: 2675 TOLKIEN

J.R.R. Tolkien, twice Professor of Anglo-Saxon at the University of Oxford, and creator of the fictional Middle-Earth, is one of the most-read authors of modern times. His books regularly top the bestseller lists more than thirty-five years after his death.

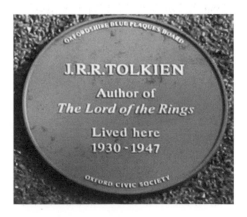

John Ronald Reuel Tolkien was born on 3 January 1892 in Bloemfontein, South Africa, the elder son of Arthur Reuel, a bank manager, and Mabel (*née* Suffield), who both came from Birmingham. He first arrived in England at the age of three, with his mother and brother, and remained in the country, receiving his education first from his mother and then at King Edward's School, Birmingham. It was while he was a pupil at this school that he began to study languages, especially Old and Middle English and Norse, and, just for fun, made up his own. Tolkien was only twelve when his mother died of diabetes; his father had died when he was four. Tolkien found solace in his schoolwork and among his friends.

Tolkien's association with Oxford began when he came up to Exeter College in 1911; but it wasn't until his return from active service after the First World War, and after being offered work on the Oxford English Dictionary, that he started collecting together some of his short stories. Encouraged by the response to one of his stories at a public reading, he continued to write after leaving Oxford in 1920, when he was appointed Reader in English Language at the University of Leeds. In 1925 he was back at Oxford again, having accepted the post of Rawlinson and Bosworth Professor of Anglo-Saxon with a Fellowship at Pembroke College. It was during his time at Pembroke, and whilst he was living at No. 20 Northmoor Road, that Tolkien wrote *The Hobbit* and the first two volumes of *Lord of the Rings* – books which would bring him huge literary success. In 1945 he was appointed to the Merton Chair of English.

He fitted into academic life with little difficulty, enjoying the intellectual stimulation of fellow scholars, such as his friend C.S. Lewis and other like-minded men. Together with Lewis, he was a member of the literary circle known as the Inklings. This band of writers would frequently meet, usually at their favourite pub, the Eagle and Child (known locally as the Bird and Baby), in St Giles, for conversation, drink and to read their works out to one another.

Tolkien, who had married Edith Bratt – a young woman he had met several years before – was now a family man with three small sons, John, Michael and Christopher. A daughter, Pricilla, was born in 1929. A devoted father, he would tell them bedtime stories and illustrate letters, especially the annual Yule missives from Father Christmas, with their cast of ever-increasing characters. The most significant tale, however, turned out to be the story of 'The Hobbit', which was an immediate success when it was published in 1937 and has never since been out of print.

As a family the Tolkiens led quiet, unremarkable lives, but moved house a number of times. Tolkien and his family resided first at No. 22 Northmoor Road, Oxford from 1926-1930, moving to No. 20 Northmoor Road in 1930, where they stayed until 1947. He would move twice more, to Manor Road in 1947 and then in 1953, just before his retirement in 1959, to Sandfield Road, Headington. It was while living at his home in Headington that the following stories were published: *The Fellowship of the Ring* (1954), *The Two Towers* (1954) and *The Return of the King* (1955). However, as a result of the popularity of his books and the attention he was attracting from fans who would turn up at his house uninvited, Tolkien decided in 1968 to leave Oxford for Bournemouth. He returned to Oxford three years later, on Edith's death in 1971, and lived at Merton College, having been elected an Honorary Fellow of the college. In 1972 he was awarded the CBE, but died on 2 September 1973, only twenty-one months after his wife. Both of them are buried in the same grave in Wolvercote Cemetery.

Since his death, his books have continued to sell in their millions. They have been translated into more than forty languages and have been adapted into films and television series. The New Zealand director Peter Jackson's adaptation of *The Lord of the Rings*, which proved to be one of the most popular film trilogies ever made, highlights the universal appeal of Tolkien's work in the modern world.

Sources:

Oxfordshire Blue Plaques Scheme

Shippey, T.A., 'Tolkien, John Ronald Reuel (1892-1973)', *Oxford Dictionary of National Biography*, Oxford University Press, 2004; online edn, Oct. 2006 (http://www.oxforddnb.com/view/article/31766, accessed 2 Dec. 2010)

http://www.tolkiensociety.org/

WILLIAM TURNER 'OF OXFORD' (1789-1862): *Artist*
BLUE PLAQUE: 16 ST JOHN STREET, OXFORD
MEMORIAL CHANCEL SCREEN PLAQUE: SHIPTON-ON-CHERWELL CHURCH, OXFORDSHIRE

This highly talented artist was known as William Turner of Oxford to distinguish him from his more famous contemporary, J.M.W. Turner. Many of his landscapes were of the countryside around Oxford (where he spent most of his life) and are watercolours, although he occasionally painted in oils. The famous art critic John Ruskin praised his 'quiet and simple earnestness and tender feeling'. Turner developed a distinctive style of beautifully balanced compositions which evoke a sense of timelessness.

William Turner was born on 12 November 1789, in Black Bourton, Oxfordshire. He was the eldest son of Robert Turner and his wife Mary (*née* Cox). On his parents' death, Turner went to live with his uncle, also William Turner, who resided at the Manor House, Shipton-on-Cherwell, near Woodstock. The young boy showed an interest in drawing and was sent to London to study with John Varley, the watercolour artist, who was a very well-known drawing master. Varley liked his pupils to draw and paint out of doors, and Turner demonstrated skill in painting landscapes, exhibiting his first three at the 1807 Royal Academy Exhibition. Turner showed so much promise as an artist that he was elected an Associate of the Royal Society of Painters in Water Colours when he was only seventeen years old, and was made a full member the following year. He contributed works to the Royal Academy for the rest of his life.

Turner had to make a living, so returned to Oxfordshire in 1810 in order to teach – but he also managed to sell his work regularly, as his local landscapes were popular with Oxford academics. One of his best-known paintings of Oxford is the view of the city from Hinksey Hill. He did, however, travel beyond his local area every summer on sketching tours, and ventured as far as the Lake District, Wales, the Peak District, Scotland and the Western Isles, choosing picturesque and atmospheric sites to depict.

Throughout his Oxford years, Turner lived at different addresses in the city, settling in London Road, St Clements in 1824 when he married Elizabeth Ilott; from 1853 until his

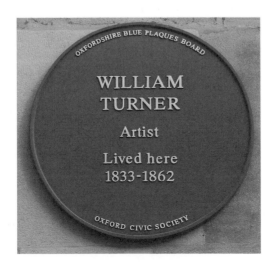

death he lived at No. 16 St John Street, Oxford. It was in the garden of this house that Turner, who was meticulous in his representation of the natural world, grew plants so that he could refer to them. Turner died at his home on 7 August 1862 and was buried in the churchyard of Shipton-on-Cherwell. The present church, which replaces an earlier one, was built to his design.

During the latter part of his lifetime Turner was ignored by the art establishment, much to the annoyance of John Ruskin, who felt that his art deserved more appreciation, but Turner himself seemed content to be considered a provincial artist. He received posthumous recognition in 1895 when many of his watercolours were exhibited at the Ashmolean Museum, Oxford, which today holds a collection of more than 100 of his works, including drawings, oils and watercolours. His art can also be found at Exeter College, Worcester College and Oxford Town Hall. Turner's paintings can additionally be found further afield, at the Tate Gallery (London), the Metropolitan Museum of Art (New York City), and Dunedin Public Art Gallery (New Zealand).

Sources:

Oxfordshire Blue Plaques Scheme

Wilcox, Timothy, 'Turner, William (1789-1862)', *Oxford Dictionary of National Biography*, Oxford University Press, 2004 (http://www.oxforddnb.com/view/article/27880, accessed 15 Dec. 2010)

Hibbert, C. and Hibbert, E. (Eds), *The Encyclopaedia of Oxford*, 1988

..

VICTORIA FOUNTAIN

PLAQUE: THE PLAIN, OXFORD, FACING MAGDALEN BRIDGE

The Victoria Fountain was built as a (belated) tribute to Queen Victoria on the occasion of her Diamond Jubilee in 1897 and was inaugurated by her daughter, Princess Louise, in 1899. The drinking fountain was designed to be used by people, while the outside troughs were for horses. It stands on the site of the old St Clement's Toll House, which was demolished in 1874. The tiled octagonal roof is supported by eight columns and is surmounted by a four-faced clock and weather vane. The Grade II listed structure was designed by Edward Prioleau Warren, an architect who practised mostly in Oxford (and who designed, among his many local projects, the nearby Eastgate Hotel in the High Street). It was funded by the brewer, G.H. Morrell.

Restoration work on the whole structure was completed in 2009.

Sources:

Hibbert, C. and Hibbert, E. (Eds), *The Encyclopaedia of Oxford*, 1988

http://www.oxfordpreservation.org.uk/projects/victoria.php

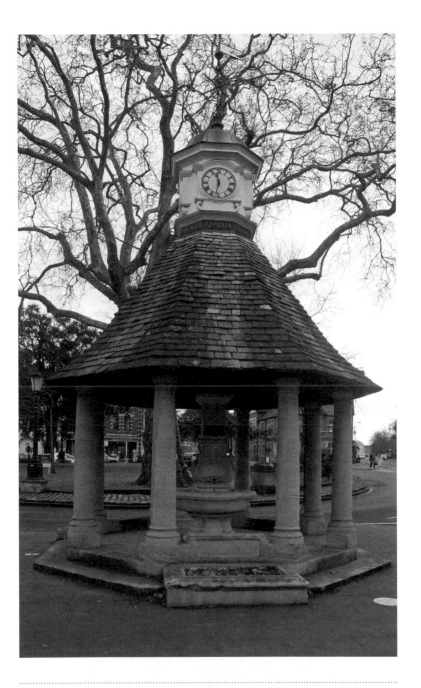

THOMAS WILLIS (1621-1675): *Neurologist and Sedleian Professor of Natural Philosophy*

PLAQUE: BEAM HALL, 4 MERTON STREET, OXFORD

Thomas Willis, who spent much of his life in Oxford, was one of the most brilliant pioneering scientists of his time. Associated with a small group of scientists with Royalist sympathies, who included Christopher Wren, Robert Boyle and Robert Hooke, he was

a founder member of the Royal Society. He is considered by many to be the father of neuroscience, with the Circle of Willis in the brain named after him. He spectacularly 'resurrected' Anne Green, who had been hanged for infanticide but was resuscitated by him on the dissecting table after he noticed that she was still alive. Willis was meticulous in making detailed and accurate medical observations. He was the first to use the terms 'reflex action' and 'diabetes mellitus'. He treated poor people for free but charged the wealthy handsomely for his services. In 1660, he was appointed Sedleian Professor of Natural Philosophy at the University of Oxford.

Thomas Willis was born on 27 January 1621 at Great Bedwyn, Wiltshire. He was the eldest of three sons born to Thomas Willis and his wife Rachel Howell, who came from North Hinksey, a village two miles from Oxford. When he was nine years old, his mother inherited some land in the village and the family moved back there in 1630, but unfortunately she died the following year and, not long afterwards, his father married again. Willis was educated at Edward Sylvester's school in the centre of Oxford, and at Christ Church, Oxford. He appears to have taken an interest in medicine through assisting the wife of Canon Thomas Isles at Christ Church, who was well-known for her skills in healing and in making remedies.

Willis graduated with a BA in 1639 and obtained his MA in 1642, just before the outbreak of the Civil War. He experienced personal tragedy when both his father and stepmother died of camp fever in 1643, and the family farm was requisitioned by Parliamentarian forces. It may have been these incidents which spurred him on to study medicine, but since the war was disrupting his studies Willis, a staunch Royalist, joined an auxiliary regiment defending Oxford for the king. In 1646 he was awarded his BM on the recommendation of Thomas Clayton, the Regius Professor of Medicine at the university, despite missing out on several years of university study. During Cromwell's Protectorate, he studied and practised medicine from his rooms in Christ Church, and once a week he would travel to nearby Abingdon to offer medical advice and help. By careful observation, he was able to make fundamental discoveries. One of these was the detection of high blood sugar in the urine of diabetics, which he termed 'diabetes mellitus'.

His interest in chemistry and anatomy brought him into contact with some of the scientific luminaries of the time – individuals such as Robert Hooke (*see* separate entry), who was employed by him to assist with chemical experiments, and Christopher Wren, who would provide the illustrations for his seminal work *Cerebri Anatome*, published in 1664, which was a remarkably accurate description of the nervous system. He also collaborated with Richard Petty, Tomlins Reader in Anatomy at the university, who in 1650 helped Willis resuscitate Anne Green after she was hanged. Willis made many discoveries by anatomical dissections, especially of the brain, the spine and the autonomic nerves. He

kept case histories of his patients – to which he would refer – and dissected their bodies and those of animals in order to obtain both medical and theological knowledge. Willis, a lifelong Anglican, believed that anatomy could prove that man has a soul and possesses a higher intelligence than animals. His work on the brain led him to believe that that organ provided a basis for understanding the soul. Willis published all but one of his seven books in Latin, the language of the university, of royalty and of the Church.

His reputation greatly enhanced by Anne Green's recovery, Willis's practice began to flourish, and it was not long before he found himself a substantially wealthy man. In 1657 he bought Beam Hall, in Merton Street, not far from Christ Church, where he lived with his wife Mary (daughter of Samuel Fell Dean of Christ Church), their children and servants. John Hemmings, his apothecary, also lived in the house for a time. Willis would live here until 1667, when he left Oxford to establish a practice in London.

At the Restoration of Charles II in 1660, Willis was appointed Sedleian Professor of Natural Philosophy thanks to the patronage of Gilbert Sheldon, Warden of All Souls and one of the most powerful men in England. In 1663 he was elected Fellow of the Royal Society, and in 1667 he left Oxford for good in order to establish a practice in London, again encouraged by Sheldon, who was by then Archbishop of Canterbury. In October 1670, his beloved wife Mary died. Two years later Willis married Elizabeth Calley, a widow. Willis himself died in London on 11 November 1675, and is buried in Westminster Abbey together with Mary and his daughter Katherine.

Sources:

Martensen, Robert L., 'Willis, Thomas (1621-1675)', *Oxford Dictionary of National Biography*, Oxford University Press, 2004; online edn, Oct. 2007 (http://www.oxforddnb.com/view/article/29587, accessed 14 Jan. 2011)

http://www.nature.com/nrn/journal/v5/n4/full/nrn1369.html

http://www.ncbi.nlm.nih.gov/pmc/articles/PMC539424/

ANTHONY À WOOD (1632-1695): *Antiquary*
BLUE PLAQUE: POSTMASTERS' HALL, MERTON STREET, OXFORD

Anthony à Wood (Anthony Wood) was, by all accounts, a bad-tempered, argumentative, stubborn man, fond of gossip – perfect attributes for someone who spent his life collecting facts, keeping detailed accounts of what he had learnt, and recording the lives of most of the prominent individuals of the seventeenth century.

Wood was born in Postmasters' Hall, Oxford, opposite Merton College gate on 17 September 1632. The house was leased from Merton College by his wealthy father Thomas, who lived there with his wife Mary and all his children. Wood lived in this house for most of his life, occupying rooms in the attic. It was from here that he would set off on his sallies to do his research or to buy his books.

Wood was educated at New College School, and Lord Williams's School, Thame, before entering Merton in 1647, where he achieved a lacklustre BA after five unremarkable years of study. Aware that he would not obtain a Fellowship, he turned his energies to historical studies and antiquarian research. Living in a university city he had ready access to libraries, parish records, museums and bookshops – and to academics he could call on for help or advice.

Wood reached a turning point in his life when he discovered William Dugdale's book *The Antiquities of Warwickshire*, published in 1656, which filled him with the desire to produce a similar work on Oxfordshire. Not long afterwards, he came upon documents on Oxford collected by an earlier antiquary, Bryan Twyne. Inspired by his findings, Wood set about researching and obtaining information on all aspects of the university. This was a monumental project which would take him several years to complete, and which would see him quarrelling with almost everyone with whom he was associated, including Dr John Fell, Dean of Christ Church, who had helped him get his books published and had contributed to the costs of publication. He fell out too with his family, the Fellows of Merton and even John Aubrey, his mild-mannered collaborator, who had supplied him with a great deal of his biographical material. Aubrey remonstrated with him: 'I thought you so deare a friend that I might have entrusted my life in your hands and now your unkindness doth almost break my heart.'

His first work, *The History and Antiquities of the University of Oxford*, was published in 1674, followed in 1691 by *Athenae Oxoniensis*, a record of the lives and publications of writers and clergymen connected with the university from the year 1500. These publications, with their meticulous records of every aspect of the city, make Oxford the best documented city in England before 1695, and are a marvellous source of material for scholars and researchers today. He wrote his books for the glory of Oxford University, not claiming any credit for himself, and the university gave him very little recognition while he was alive. Indeed, it was to let him down.

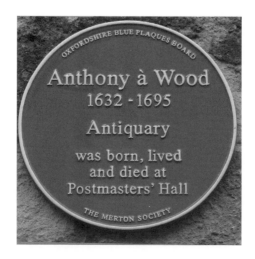

Wood's last few years were ones of sadness and humiliation. The second Earl of Clarendon took proceedings against him for suggesting in *Athenae Oxoniensis* that the first Earl had taken bribes. He was tried in the Vice-Chancellor's Court and, in July 1693, found guilty. Not only was Wood expelled from the university but the pages of his book relating to the subject were torn out and publicly burned, and he was obliged to pay the costs of the court case himself.

His public disgrace brought him a great deal of embarrassment and discomfiture. His health suffered after his ordeal and, realising that he was dying, he put his affairs in order, disposing of his notes to other antiquaries and willing all his books and manuscripts to the Ashmolean Museum, which transferred them to the Bodleian Library in the nineteenth century. Not only did he disperse his papers, but it appears that Wood even supervised the digging of his own grave in Merton Chapel, stipulating its depth and instructing that it should be 'close to the wall, next to the north door'. He died at Postmasters' Hall on 29 November 1969 and is indeed buried exactly where he specified, just a few yards away from where he was born and where he had lived most of his life.

Sources:

Oxfordshire Blue Plaques Scheme

Parry, Graham, 'Wood, Anthony (1632-1695)', *Oxford Dictionary of National Biography*, Oxford University Press, 2004; online edn, Jan. 2008 (http://www.oxforddnb.com/view/article/29864, accessed 4 Dec. 2010)

http://www.day-books.com/diaries/a_wood.pdf

OXFORD
City Plan

A40

A40

A40

A40

A34

A420

A34

Oxford City Central

R Thames

R Cherwell

South Parks Road

St Giles

Broad St

Holywell St

High St

Long Wall St

Merton St

Queens St

St Aldates

Station

R Isis

43

44
45

42
41
40
39

37
38

35 36
29
27

28

24
23 22
21

26
25

31 30

32

33

34

58

57

56
65

54

52

53
50 51

46
42
48 49

5 6
4
19
9 8
3 2 1
7

18
10 11
12

16 13

15
14

Oxford City East

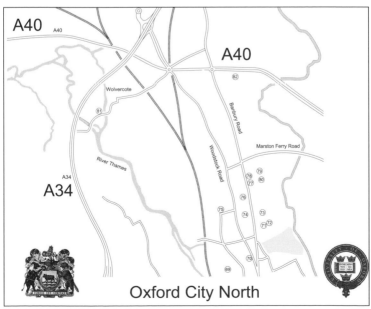

Oxford City North

BIBLIOGRAPHY

Adams, R.H., *Latin in Oxford: Inscriptiones Aliquot Oxonienses*, The Perpetual Press, 1994

Goldman, L., (Ed), *Oxford Dictionary of National Biography*, Oxford University Press, 2004–11)

Harwood, D., *Portrait of a Stunner – The Story of Jane Burden*, Self-published, 2000

Hibbert, C. and Hibbert, E. (Eds), *The Encyclopaedia of Oxford*, Papermac, 1998

Ignatieff, M., *Isaiah Berlin, A Life*, Henry Holt & Co. Inc., 1998

Law, B.R., *Building Oxford's Heritage*, Prelude Promo, 1998

Rennison, N., *The London Blue Plaque Guide*, The History Press, 2009

Sherwood, J., and Pevsner, N., *The Buildings of England, Oxfordshire*, Penguin Group, 1990

CONTEXTUAL IMAGE SOURCES

Subject	Source
Bacon	http://www.nndb.com/people/582/000114240/
Bannister	http://commons.wikimedia.org/wiki/File:Roger_Bannister_3.jpg
Berlin	http://yarnblog.co.cc/blog/wp-content/uploads/Isaiah-Berlin.jpg
Boyle	http://www.chemheritage.org/discover/collections/collection-items/fine-art/the-shannon-portrait-of-the-hon.-robert-boyle-f.-r.-s.-.aspx
Burden	http://en.wikipedia.org/wiki/Jane_Burden
Burden	http://www.ibiblio.org/wm/paint/auth/rossetti/prosperine.jpg
Chaudhuri	http://www.telegraphindia.com/1080930/jsp/frontpagestory_9907433.jsp
Chavasse	http://commons.wikimedia.org/wiki/File:N.G._Chavasse,_VC.jpg
Combe	http://preraphaelitepaintings.blogspot.com/2009/01/thomas-combe-patron.html
Girdlestone	Oxfordshire Health Archives, Oxfordshire, UK
Haldane	http://www.escafandra.org/E08-HALDANE.htm
Halley	http://commons.wikimedia.org/wiki/File:Edmund_Halley.gif
Halley	http://theamazingwhitebread.wordpress.com/
Heatley	http://news.bbc.co.uk/local/oxford/hi/people_and_places/history/newsid_8828000/8828836.stm
Hooke	http://todayinastronomy.blogspot.com/2009/07/july-18-robert-hooke.html
Jackson-Cole	http://www.andrewsonline.co.uk/about-us/unique-history.aspx
Krebs	http://en.wikipedia.org/wiki/File:Hans_Adolf_Krebs.jpg
Lawrence	http://en.wikipedia.org/wiki/File:T_E_Lawrence.jpg
Levellers	http://www.bilderberg.org/land/
Lewis	http://pastorandpeople.files.wordpress.com/2007/12/cs-lewis-2.jpg
Marten	http://en.wikipedia.org/wiki/Henry_Marten_(regicide)
Merton	http://getglue.com/topics/p/walter_de_merton
Morris	http://www.nuffield-place.com/lordnuffield.htm
Nash	http://www.world-war-pictures.com/war-artist-paul-nash.htm
Prestwich	http://en.wikipedia.org/wiki/Joseph_Prestwich
Rhodes	http://en.wikipedia.org/wiki/Cecil_Rhodes
Sadler	http://en.wikipedia.org/wiki/File:James_Sadler_-_12_Aug_1811_ascent.jpg
Simon	http://en.wikipedia.org/wiki/Francis_Simon
Swindlestock	http://www.dailyinfo.co.uk/reviews/feature/5627/St_Scholasticas_Day
Tolkien	http://en.wikipedia.org/wiki/Tolkien
Wesley	http://commons.wikimedia.org/wiki/File:Wesley.jpg
Willis	http://en.wikipedia.org/wiki/File:Thomas_Willis.jpg

PLAQUE & MAP INDEX

OXFORD PLAQUES DATABASE

Page	Ref	Title	Name	Forenames	Dates	Description	Location	Map Ref
18-19	18	Fr	Bacon	Roger	1214 -1292	Franciscan Friar, philosopher and scientist	South wall, Westgate Centre	C
121-124	65		Bannister	Roger	1954	Sub-Four Minute Mile	Oxford University Sports Ground	E
19-20	27		Baptist Meeting House		1715		Pacey's Bridge, Park End Street	C
20-21	37		Beaumont Palace		1157 - 1167	Birthplace of King Richard I	Pillar at the west end of Beaumont Street	C
21-22	60	Sir	Berlin	Isaiah	1909 - 1997	Historian of ideas	Headington House, Old High Street, Headington	E
16-17	81		Airmen	Bettington and Hotchkiss	1912	Royal Flying Corps	Airmen's Bridge, Wolvercote	N
22-23	39		Blackfriars		1921	The Dominican Priory of the Holy Spirit	64 St Giles, Oxford	C
24-25	49		Bodleian Library			University Library	Catte Street	C
25-26	25		Bonn Square		2009	Several memorial Plaques	Between Queen Street and New Inn Hall Street	C
27-29	5		Boyle and Hooke	Robert	1627 - 1691, 1635 - 1703	Scientists	University College Shelley Memorial wall, High Street	C
29-32	50		Burden	Jane	1839 - 1914	Mrs William Morris	St Helen's Passage, off New College Lane	C
32-33	19		Carfax Tower Clock			Clock and Quarterboys	Carfax	C
33-34	53		Catholic Martyrs		1589		100 Holywell Street	C
34-35	74		Chaudhuri	Nirad	1897 - 1999	Writer	26 Lathbury Road	N
36-37	64		Chavasse	Noel	1884 - 1917	Royal Army Medical Corps	Magdalen College School, Cowley Place	E
38	13		Christ Church		1914 - 1918	War Memorial	Christ Church garden gate pavement	C
16-17	10		City of Oxford			Arms	Oxford Town Hall and many others	C
38-39	26		City of Oxford High School for Boys		1881 - 1966		Oxford University Faculty of History, George Street	C

Page	Ref	Title	Name	Forenames	Dates	Description	Location	Map Ref
39-41	69		Combe	Thomas and Martha	1796 - 1872, 1806 - 1893	Founders of St Barnabas	St Barnabas' Church, Jericho	N
41-42	33		Combe's Charity School		1702		St Thomas's Churchyard	C
42-43	6		Cooper	Sarah Jane	1848 - 1932	Marmalade maker and grocer	83 High Street	C
43-44	82		Cutteslowe Walls		1934 - 1959		34 Aldrich Road	N
45	44		Darwin Plinth				Oxford University Museum of Natural History, Parks Road	C
46-47	52	St	Edmund	of Abingdon	1175 - 1240	Archbishop of Canterbury (1234 - 1240)	Queen's Lane, facing St Edmund Hall Library	C
111	23	St	Edward's School		1863	Independent school	New Inn Hall Street	C
48-49	41		Evans and Symm	Daniel and Joshua	1769 - 1846, 1809 - 1887	Oxford builders	34 St Giles'	C
49-50	22		First Wesleyan Meeting House		1783	Methodist Church	32 - 34 New Inn Hall Street	C
50-51	75		First World War Memorial			St Margarets Church	St Margaret's Church, Kingston Road	N
51	43		Gandhi	M.K.	1869	Indian Independence leader	University Parks	C
51-52	62		Girdlestone	G.R.	1881 - 1950	Pioneering orthopaedic surgeon	72 - 74 Old Road, Headington	E
53-54	67		Greening Lamborn	E.A.	1877 - 1950	Headmaster, local historian	34 Oxford Road, Littlemore	E
54-56	71		Haldane	J.S.	1860 - 1936	Physiologist	11 Crick Road	N
56-57	51	Sir	Halley	Edmund	1656 - 1742	Astronomer and mathematician	7 New College Lane	C
58-59	59		Heatley	Norman	1911 - 2004	Biochemist	12 Oxford Road, Old Marston	E
60-62	45		Hodgkin	Dorothy C.	1910 - 1994	Chemist	Physical Chemistry Laboratory, South Parks Road	C
63-65	46		Jackson-Cole	Cecil	1901 - 1979	Philanthropist and founding member of Oxfam	17 Broad Street	C
65-67	12		Jewish Oxford				Botanic Garden and 84 High Street	C
67-69	61		Kimber	William	1872 - 1961	Morris dancer	Sandfield Cottage, Headington	E
69-71	66	Sir	Krebs	Hans	1900 - 1981	Bio chemist and Nobel Laureate	27 Abberbury Road	E
71-74	76		Lawrence	T.E.	1888 - 1935	Author, scholar, soldier	2 Polstead Road	N
74-75	36		Levellers	The		Soldiers	On wall facing Gloucester Green	C
75-77	63		Lewis	C.S.	1898 - 1963	Academic and author	The Kilns, Lewis Close, Headington Quarry	E

Page	Ref	Title	Name	Forenames	Dates	Description	Location	Map Ref
78-80	3	Sir	Marten	Henry	c. 1601/2 - 1680	Regicide, Parliamentarian	3 Merton Street	C
112	20	St	Martin			Roman soldier	Carfax Garden	C
80-81	7		Merton	Walter de	1205 - 1277	College founder, Lord Chancellor of England	Above front doorway, Merton College	C
81-83	73		Morfill	William Richard	1834 - 1909	First Professor of Russian and Slavonic Languages	42 Park Town	N
83-84	15		Morris	William	1877 - 1963	Car-maker, and philanthropist	16 James Street, Cowley	E
62-63	14	Inspector	Morse		2006		Oxford Police Station, St Aldate's	C
84-85	34		MRI Scanner		1980	Magnetic Resonance Imaging	King's Centre, Osney Mead	C
86	77	Sir	Murray	James	1837 - 1915	Lexicographer and Editor of the OED	78 Banbury Road	N
86-87	30	Blessed	Napier	George	1550 - 1610	Catholic priest and martyr	Oxford Castle	C
87-90	78		Nash	Paul	1889 - 1946	Artist	106 Banbury Road	N
90-91	29		Old Fire Station	The	1896		George Street	C
91	35		Old School	The	1898 - 1934	Central Boys School	Gloucester Green	C
92-93	31		Oxford Castle		2005	Regeneration Project	Former prison site	C
94	70		Oxford Playhouse		1923 - 1938	Theatre	12 Woodstock Road	N
94-95	11		Oxford Town Hall		1893	Town Hall	Corner of St Aldate's and Blue Boar Street	C
95	4		Parson's Almshouses		1752 - 1814		Kybald Street	C
96-97	72		Pater	Walter and Clara	1839 - 1894, 1841 - 1910	Author and scholar, Pioneer of women's education	2 Bradmore Road	N
97-98	56		Peace Stone		1814		Carfax and St Clements	C
98-100	54		Penicillin Memorial		1953	Penicillin research workers	Oxford Botanic Garden, Rose Lane,	C
101-103	58		Prestwich	Joseph	1812 - 1896	Professor of Geology	Prestwich Place, Botley Road	C
103-106	38		Protestant Martyrs		1555		Wall of Balliol College, Broad Street	C
106-107	28		Rewley Road Railway Station		1851		In front of entrance to Said Business School, Park End Street	C
107-109	9	Sir	Rhodes	Cecil	1853 - 1902	Politician and business man	On wall of No. 6 King Edward Street	C
109-111	8		Sadler	James	1753 - 1828	Balloonist, chemist, engineer and inventor	On the wall of Merton College	C
113-114	16		Sayers	Dorothy L.	1893 - 1957	Author, scholar and theologian	No. 1 Brewer Street	C

Page	Ref	Title	Name	Forenames	Dates	Description	Location	Map Ref
114-116	47		Sheldonian Theatre			University Theatre and Concert Hall	Broad Street	C
116-117	79	Sir	Simon	Francis	1893 - 1956	Low temperature physicist and philanthropist	10 Belbroughton Road	N
117-118	24		Skene	Felicia	1821 - 1899	Writer, prison reformer	34 St Michael's Street	C
118-119	57		South Park			City Parkland	Headington Hill	C
119-120	32		Stansfeld	John	1854 - 1939	Parish priest, doctor	St Ebbe's Rectory, Paradise Square	C
120-121	21		Star Inn		1794	Oxfordshire Yeomanry	Entrance to Frewin Court	C
123-124	17		Swindlestock Tavern		1355	St Scholastica's Day Riots	Abbey House, 121 Carfax	C
124-125	68		Taunt	Henry	1842 - 1922	Photographer	393 Cowley Road	E
125-127	80		Tolkien	J.R.R.	1892 - 1973	Author and scholar	20 Northmoor Road	N
127-128	40		Turner	William of Oxford	1789 - 1862	Artist	16 St John Street	C
17-18	48		University of Oxford			Arms	Divinity School and many others	C
128-129	55		Victoria Fountain		1899		The Plain	C
129-131	2		Willis	Thomas	1625 - 1671	Sedleian Professor of Natural Philosophy	4 Merton Street	C
132-133	1		Wood	Anthony à	1632 - 1695	Antiquary	Postmasters' Hall, Merton Street	C

MAP INDEX ARRANGED AS CONVENIENT WALKS

Map	Ref	Name	Location
Central	1	Anthony à Wood	Postmasters' Hall, Merton Street
Central	2	Thomas Willis	4 Merton Street
Central	3	Sir Henry Marten	3 Merton Street
Central	4	Parson's Almshouses	Kybald Street
Central	5	Robert Boyle and Hooke	University College Shelley Memorial Wall, High Street
Central	6	Sarah Jane Cooper	83 High Street
Central	7	Walter de Merton	Above front doorway, Merton College
Central	8	James Sadler	On the wall of Merton College
Central	9	Sir Cecil Rhodes	On wall of No. 6 King Edward Street
Central	10	City of Oxford	Oxford Town Hall and many others
Central	11	Oxford Town Hall	Corner of St Aldate's and Blue Boar Street
Central	12	Jewish Oxford	Botanic Garden and 84 High Street
Central	13	Christ Church Memorial Garden	Christ Church garden gate pavement
Central	14	Inspector Morse	Oxford Police Station, St Aldate's
East	15	William Morris	16 James Street, Cowley
Central	16	Dorothy L. Sayers	No. 1 Brewer Street
Central	17	Swindlestock Tavern	Abbey House, 121 Carfax
Central	18	Fr Roger Bacon	South wall, Westgate Centre,
Central	19	Carfax Tower Clock	Carfax
Central	20	St Martin	Carfax Garden
Central	21	Star Inn	Entrance to Frewin Court
Central	22	First Wesleyan Meeting House	32 - 34 New Inn Hall Street
Central	23	St Edward's School	New Inn Hall Street
Central	24	Felicia Skene	34 St Michael's Street
Central	25	Bonn Square	Between Queen Street and New Inn Hall Street
Central	26	City of Oxford High School for Boys	Oxford University Faculty of History, George Street
Central	27	Baptist Meeting House	Pacey's Bridge, Park End Street
Central	28	Rewley Road Railway Station	In front of entrance to Said Business School, Park End Street
Central	29	The Old Fire Station	George Street
Central	30	Blessed George Napier	Oxford Castle
Central	31	Oxford Castle	Former prison site
Central	32	John Stansfeld	St Ebbe's Rectory, Paradise Square
Central	33	Combe's Charity School	St Thomas's Churchyard
Central	34	MRI Scanner	King's Centre, Osney Mead
Central	35	The Old School	Gloucester Green
Central	36	The Levellers	On wall facing Gloucester Green
Central	37	Beaumont Palace	Pillar at the west end of Beaumont Street
Central	38	Protestant Martyrs	Wall of Balliol College, Broad Street
Central	39	Blackfriars	64 St Giles, Oxford
Central	40	William of Oxford Turner	16 St John Street
Central	41	Daniel and Joshua Evans and Symm	34 St Giles'

Map	Ref	Name	Location
Central	42	Irene Frude	End of Little Clarendon Street
Central	43	M.K. Gandhi	University Parks
Central	44	Darwin Plinth	Oxford University Museum of Natural History, Parks Road
Central	45	Dorothy C. Hodgkin	Physical Chemistry Laboratory, South Parks Road
Central	46	Cecil Jackson-Cole	17 Broad Street
Central	47	Sheldonian Theatre	Broad Street
Central	48	University of Oxford	Divinity School and many others
Central	49	Bodleian Library	Catte Street
Central	50	Jane Burden	St Helen's Passage, off New College Lane
Central	51	Sir Edmund Halley	7 New College Lane
Central	52	St of Abingdon Edmund	Queen's Lane, facing St Edmund Hall Library
Central	53	Catholic Martyrs	100 Holywell Street
Central	54	Penicillin Memorial	Oxford Botanic Garden, Rose Lane
Central	55	Victoria Fountain	The Plain
Central	56	Peace Stone	Carfax and St Clements
Central	57	South Park	Headington Hill
Central	58	Joseph Prestwich	Prestwich Place, Botley Road
East	59	Norman Heatley	12 Oxford Road, Old Marston
East	60	Sir Isaiah Berlin	Headington House, Old High Street, Headington
East	61	William Kimber	Sandfield Cottage, Headington
East	62	G.R. Girdlestone	72 - 74 Old Road, Headington
East	63	C.S. Lewis	The Kilns, Lewis Close, Headington Quarry
East	64	Noel Chavasse	Magdalen College School, Cowley Place
East	65	Roger Bannister	Oxford University Sports Ground
East	66	Sir Hans Krebs	27 Abberbury Road
East	67	E.A. Greening Lamborn	34 Oxford Road, Littlemore
East	68	Henry Taunt	393 Cowley Road
North	69	Thomas and Martha Combe	St Barnabas' Church, Jericho
North	70	Oxford Playhouse	12 Woodstock Road
North	71	J.S. Haldane	11 Crick Road
North	72	Walter and Clara Pater	2 Bradmore Road
North	73	William Richard Morfill	42 Park Town
North	74	Nirad Chaudhuri	26 Lathbury Road
North	75	First World War Memorial	St Margaret's Church, Kingston Road
North	76	T.E. Lawrence	2 Polstead Road
North	77	Sir James Murray	78 Banbury Road
North	78	Paul Nash	106 Banbury Road
North	79	Sir Francis Simon	10 Belbroughton Road
North	80	J.R.R. Tolkien	20 Northmoor Road
North	81	Airmen (Bettington and Hotchkiss)	Airmen's Bridge, Wolvercote
North	82	Cutteslowe Walls	34 Aldrich Road

DATE D'

Demco. Inc. 36-293

Visit our website and discover thousands of other History
Press books.

www.thehistorypress.co.uk